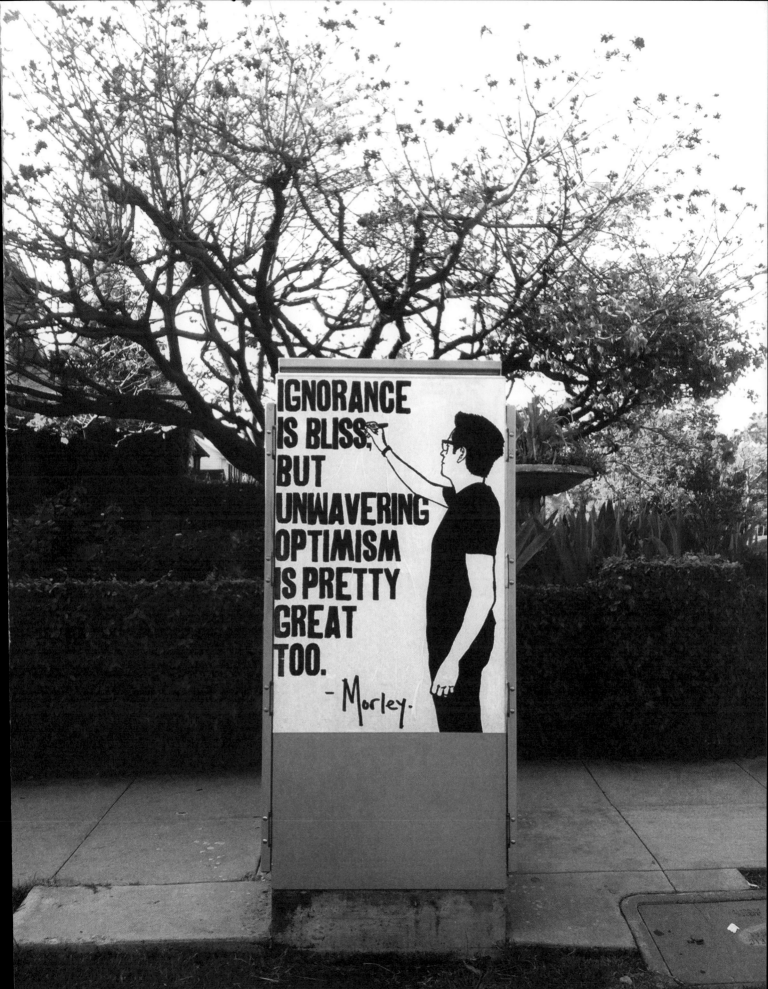

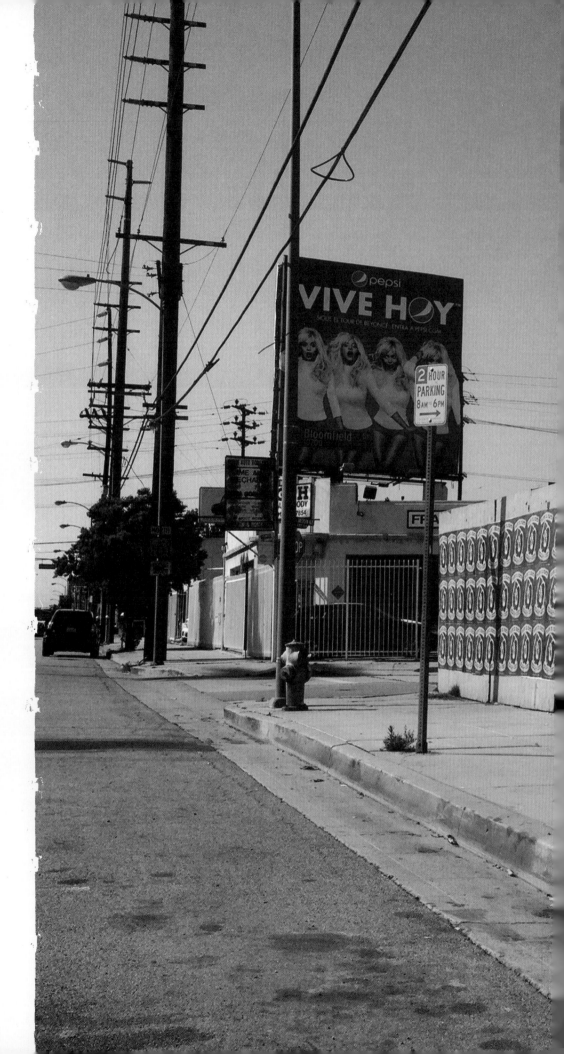

IF YOU'RE READING THIS, THERE'S STILL TIME.

Library of Congress Control Number:
2013952736

ISBN: 978-1-937359-58-4

Printed and bound in China

10 9 8 7 6 5 4 3 2 1

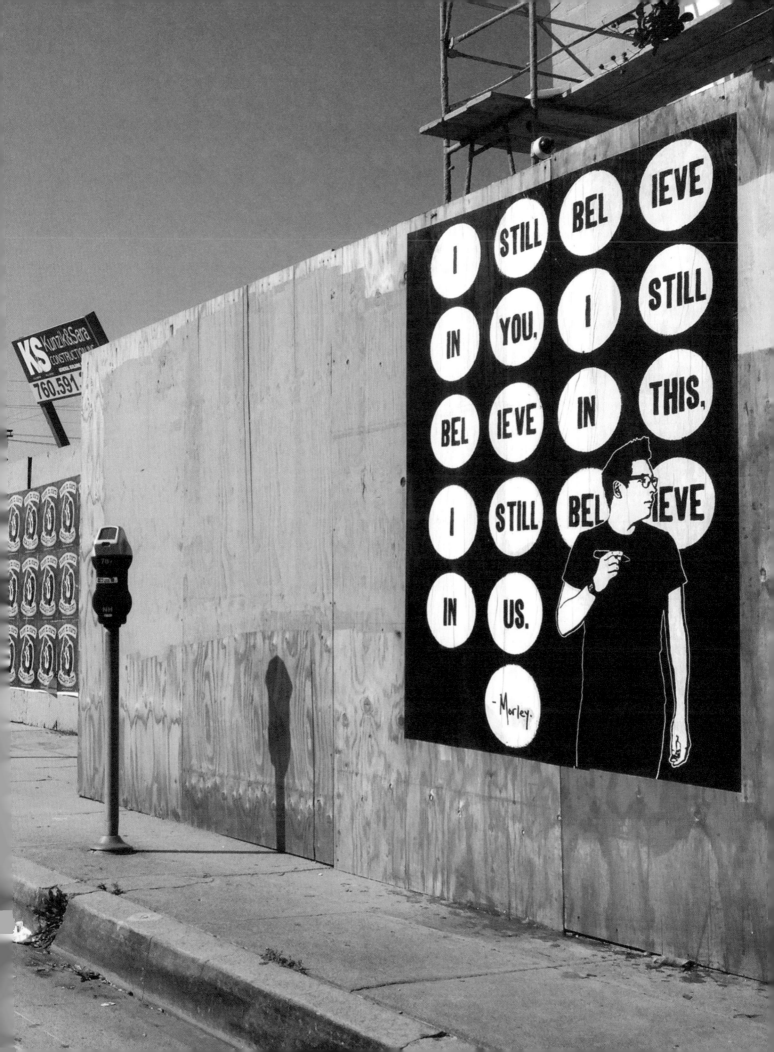

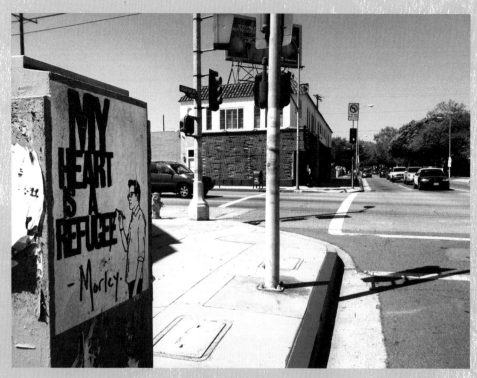

This book is dedicated to Kate...
My wife, my muse, my support system, my best friend, and my emergency contact.
Thanks for everything. Keep that bail money handy.

ARTWORK & TEXT BY

MORLEY

FOREWORD BY

FRANK WARREN

BOOK DESIGN BY

MORLEY & IAIN R. MORRIS

CAMERON + COMPANY

PETALUMA, CA

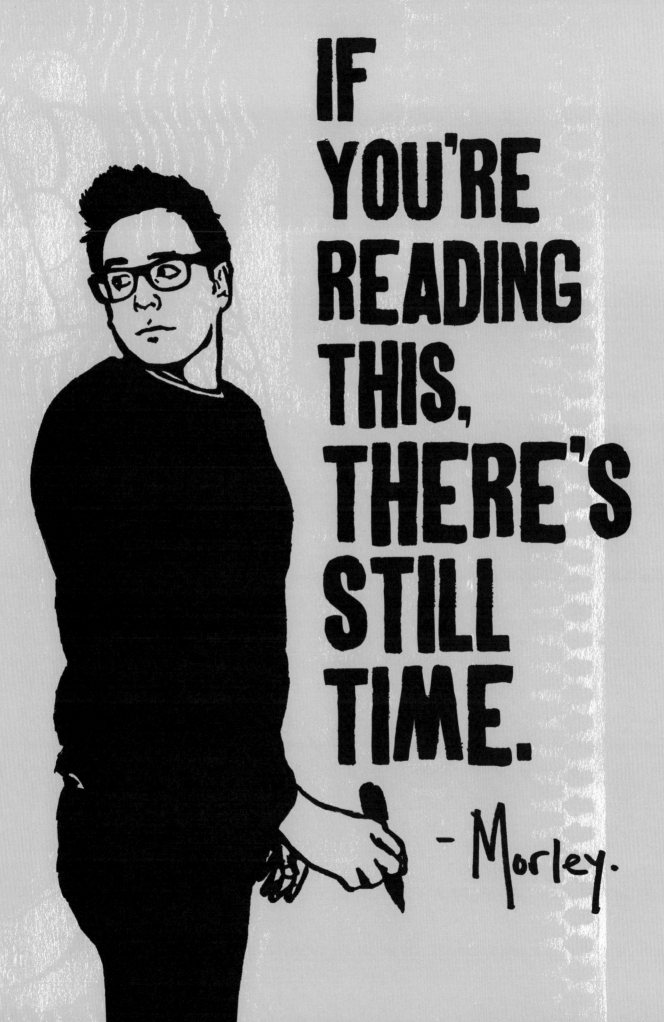

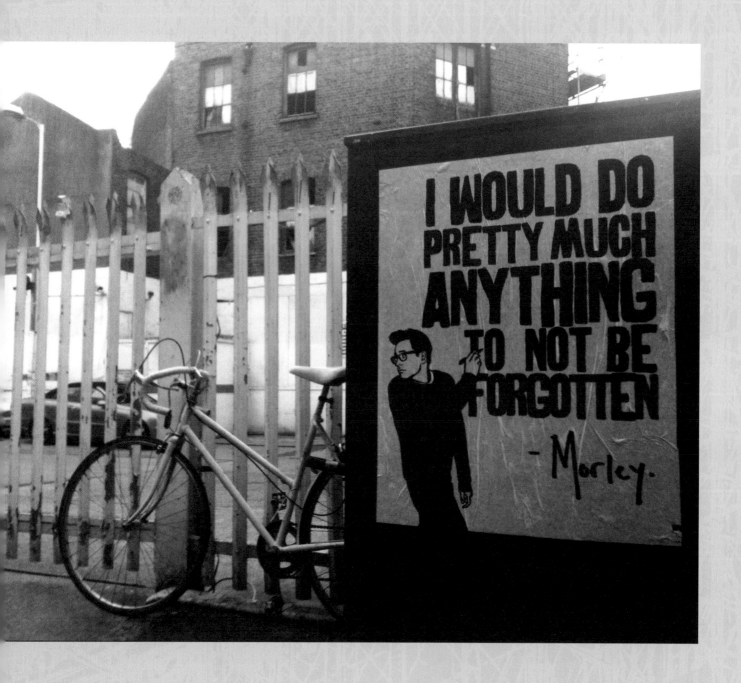

CONTENTS

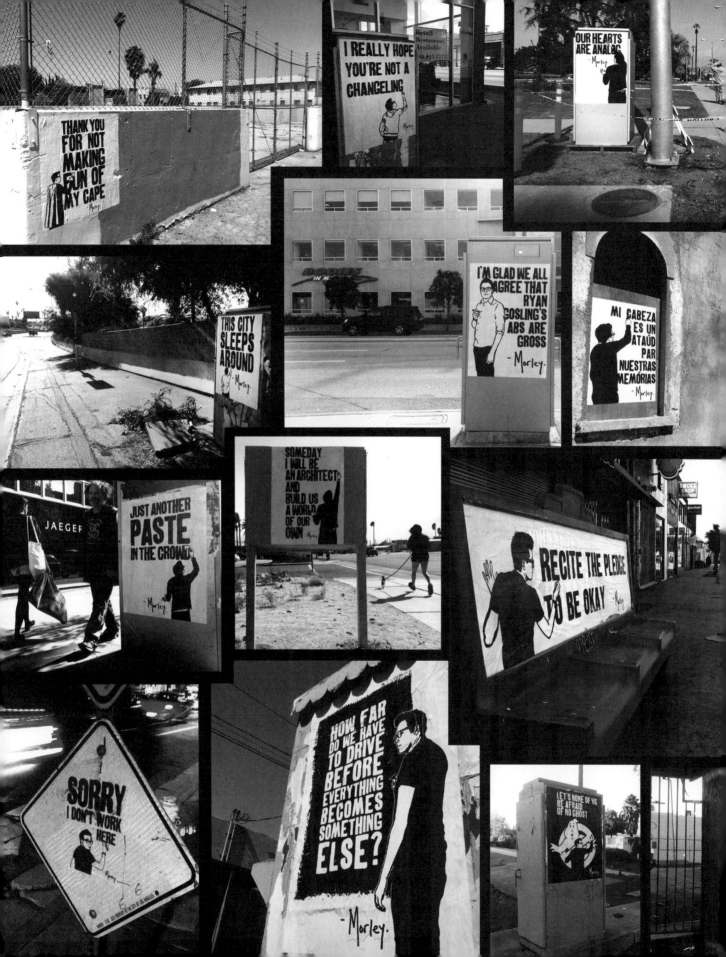

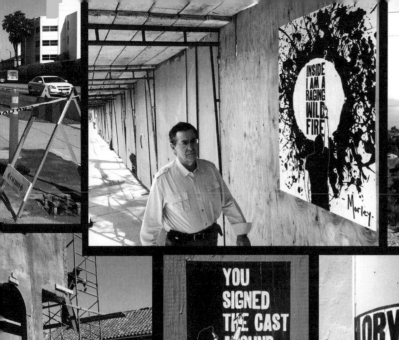

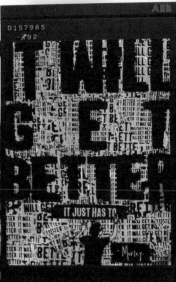

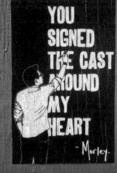

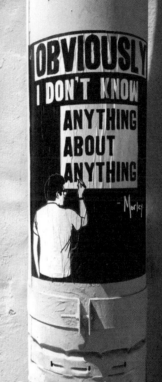

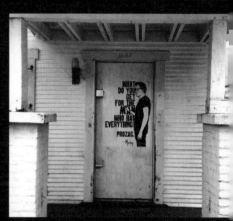

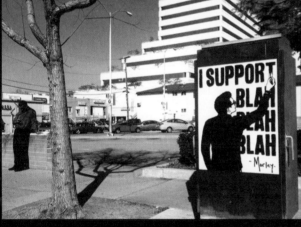

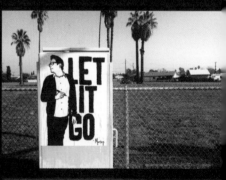

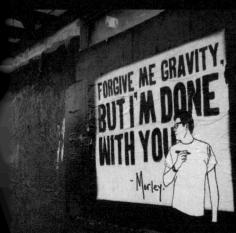

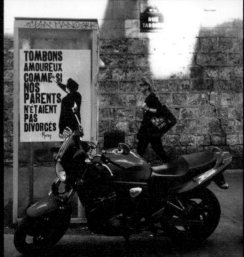

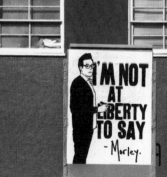

FOREWORD BY FRANK WARREN

MAYBE MY NORMAL CLOTHES ARE THE COSTUME.

When I was a kid, I rode my skateboard around Los Angeles writing graffiti. My stuff was simple—a line from a *Talking Heads* song or a message for my girlfriend, now wife.

That was a lifetime ago. Now I collect secrets from strangers with a project called PostSecret. Ten years ago, I invited strangers to write their secrets, artfully, on postcards and mail them to my home. The idea spread around the world. Hundreds of artful secrets continue to find their way to my mailbox every week, nearly a million in total.

My ancient adventures in street art are a secret even Morley doesn't know, until now.

Maybe my past connection to the City of Angels and graffiti are why Morley's work seems so extraordinary to me—but probably not, because his art is appreciated by those who have never smelled spray paint or wheat paste, and the name Morley is recognized far outside California.

LET'S LIVE LIKE WE ONLY HAVE 50 OR 60 YEARS LEFT

Morley's artwork touches people far beyond the streets of LA, all the way through the digital world. The day I posted a Morley street image that had inspired me on my Facebook page over ten thousand people liked it. There is universality to the city life that Morley's street art speaks to, but all of his work shows a strong tether to the heart of Los Angeles. Every slogan you will read in this book is more than that; it is a conversation between the artist and LA, between LA and us, between who we are as we walk the street and who we aspire to be.

Los Angeles has long been a place of dreams where anything is possible—a place where you can remake yourself, but with the cost of cutting loose friends and leaving home. The sunshine, beaches, and palm trees draw people from all over the world, but beneath the artificial lawns LA is a desert. Walking the hot sidewalks (yes, people walk in LA) in a city of millions, it's easy to feel lost and lonely. . .but then you see it.

IF YOU'RE READING THIS THERE'S STILL TIME

It wrests your attention from your smartphone, your harried pace, the corporate billboards. It looks like a familiar friend caught in the act of writing you a personal message. You peer over the shoulder of Morley's self-portrait and see it. Art. Not domesticated art preserved and petrified in a museum, but living art that breathes and dies in the wild without a description or an audio guide. It calls like an encouraging whisper from a friend.

Most people never get the message, but you did, if you are taking the time to read this, and so did some of the people photographed in this book. Their expressions captured in that moment of serendipitous connection tell the story. Balanced between sentimentality and skepticism, cheerfulness and chiding, Morley's works can feel like love notes, private jokes, public secrets, or a last testament. He provides a cool tonic for the heat and isolation of Los Angeles.

I WILL STEAL MY HEART BACK FROM THIS MACHINE IF IT'S THE LAST THING I DO

Not long ago, I was in California talking about PostSecret when a young university student shared her confession with me. *Sometimes when I get depressed or start feeling isolated I go buy a package of Post-it notes and write positive messages on each one. Then I wait until nighttime and go all over campus sticking them up for my classmates to discover anonymously.* She went on to say, *This always makes me feel better.*

I hope Morley feels better too as he walks the street at night, the Johnny Appleseed of hope, calling out to others who need to hear a voice reminding them of the small voice deep inside each of us that can sometimes get lost in the din of the city.

WELCOME TO THE MOMENT YOU'VE BEEN WAITING FOR

Frank Warren has been called *the most trusted stranger in America*. He is the founder of PostSecret, an art project he started in 2004. Since then, nearly a million people have written their anonymous secrets on postcards and mailed them to his home. Frank is the author of five bestselling books. His website, PostSecret.com, has received more than 650,000,000 visitors and his TED talk is one of the most watched for the year. Frank is a recipient of the Lifetime Achievement Award from Hope Center for his work on suicide prevention. Frank continues to collect secrets and travel the world sharing them.

FIRST THINGS FIRST . . .

This book is not about me. At least not completely. Contrary to what you may think from viewing hundreds of posters with my name and image on them, my work isn't just an exercise in vanity. More accurately, it's about the people who encounter it. It's about the relationship that they have to the messages they've stumbled upon—basic, yet intimate, messages aimed at a city full of people and the dreams they've deferred, the loves they've lost, and the jobs they hate.

This book is also not really about the fashionably rebellious nature of street art. While the work of a traditional artist may be perfectly at home in a gallery, my work is significantly less effective without the context of the landscape it exists within and the populous of strangers who interact with it. My intention was never to come across as a hip outlaw or an urban folk hero. I just wanted to contribute a few positive words to the staticky white noise that vies for our attention on a minute-by-minute basis. Frustration, inadequacy, disappointment, condemnation, and impotent rage are the products of the sound that rings in our ears, echoes in our hearts, and screams in our heads. Their sources can be traced back to any number of personal experiences, and need only a moment of silence to convince us of the soul-crushing solitude and failure that's surely predestined for us.

Don't worry; I hear it, too.

I wanted the messages in my posters to provide a slight glimmer of hope, motivation, humor, and relief for anyone they apply to. One of my methods of achieving this was through confessing my own fears, flaws, and idiosyncrasies to anyone who might be able to relate. For that reason alone, it seemed imperative to sign my work. To shield myself from judgment behind protective anonymity seemed counter to the purpose of putting my posters out there in the first place. I believe that speaking with any kind of intimacy into people's lives is a privilege earned only through honesty and vulnerability. I wanted my words to be the words of a friend, comrade, and kindred spirit.

I was not trying to manufacture a viral campaign to build fame and fortune as an artist; I was just trying to make some people smile. That's why this book isn't really about me. It's about you. Its quality is dependent almost completely on how much the messages mean to you. Maybe you're a wealthy, attractive, confident person who's never failed or known rejection. If so, congratulations. Also, I'm sorry that my book is kinda boring and doesn't even have any workout tips.

Admittedly, my talents are limited. I've never claimed to be the best at any aspect of what I do. There are wittier wordsmiths and better illustrators in the world. Too many to count, actually. This isn't to feign humility; it's to explain that no, I don't think I'm Banksy. I don't think I'm anyone but myself, imperfections and all. I started doing what I do to communicate with the world around me, and I never considered whether I was qualified. Now here I am, with enough pieces to fill a book and only one apology for not doing a better job. I hope you find it satisfactory.

Thank you for giving my work a chance. Thank you to everyone who has ever passed something I did on the street and glanced at it long enough to ingest the words and their meaning. Some are meant to be profound, some just silly, but all of them were meant as a gift. I hope at least a few of them fit you, because I lost the receipt.

Enjoy.

I PUT THAT THERE

When I was a kid I thought only thugs did graffiti. That is to say, that they "did" graffiti in much the same vague way that they "did" drugs. At the hardware store I saw cases of spray paint kept in little tiny jails, padlocked and protected from the clutches of sinister teenagers with mohawks and switchblades and piercings with little chains connecting their nose to their ears. The first time I saw real graffiti was when I moved to New York City. I was eighteen, fresh off the bus from Iowa to attend college at the School of Visual Arts as a screenwriting major. At the time, I responded to it much the same way as the first time a friend showed me a *Playboy* magazine: stifled awe and a feigned cavalier shrug as if to say, "Oh that? Yeah—that's no big deal, I'm totally comfortable with all that. But let's study it for a few hours just 'cause."

As fascinated as I was, my untrained suburban eyes couldn't make out the words or their meaning, and in truth, I didn't really understand what the point was. No matter how punk I tried to be, the idea of destruction for the sake of destruction or the giddy thrill of petty rebellion didn't appeal to me, and the idea of a trucking around an ego so large that your goal was simply to scrawl your name on every conceivable object seemed exhausting.

Anthropological motives notwithstanding, I still didn't quite get what it added beyond an urban aesthetic and an anti-authority statement. My perspective changed when my more cosmopolitan art school peers introduced me to what was being redefined, at the time, from "vandalism" to "street art." This wasn't just tagging a wall or carving curse words on the stall doors of a public bathroom—this was an actual message. This was art for the sole purpose of offering a gift to anyone who ran across it. As a screenwriting major, this was a revelation. No longer were there a million filters to your audience, a million approvals required before you were able to begin telling your story. It wasn't a flyer to come to see your band play; it WAS your band playing.

The ability to reach the end of an artistic journey, in which you create something for a purpose and then actually get to see it live out that purpose, was intoxicating. Another appealing aspect was that street art wasn't as much about celebrating the artist, but rather the art itself. Instead of just seeing a name in bubble letters, it was an image that interacted with the environment; it asked the passerby to approach, to touch, to consider the statement it was making without conditions or setting intellectual standards. This was art by and for the people. It didn't have to be crafted in a studio by an artist deemed professional by the hallowed white walls of a disinfected gallery or a restrictive museum keeping you six feet from the work at all times. It could come from anyone with something to say and the balls to say it. Maybe, I thought, even some wide-eyed kid from Iowa.

I started small, silk-screening phrases I would later identify as "slogans" onto contact paper. I would then cut these up and stick them around the subways as I traversed the city. I loved imagining who might see them and what kind of reaction they would have. Just the possibility that my little stickers could have an impact on someone was enough to make me feel gratified and productive, two rare phenomena for the average student at art school. The best part of all was that I didn't need permission from anyone, so there was very little risk of rejection or disparagement. If I assumed the best possible response, there was no proof of the contrary. The stickers themselves were benign enough; unoffensive to the more conservative citizen and easy to peel off, they would be the training wheels for what lay ahead.

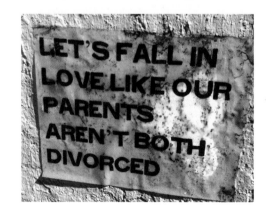

(above) A slightly weather-damaged pre-Morley sticker. Luckily I figured out the importance of word placement early on as without shifting the word BOTH the sticker could appear to be endorsing incest.

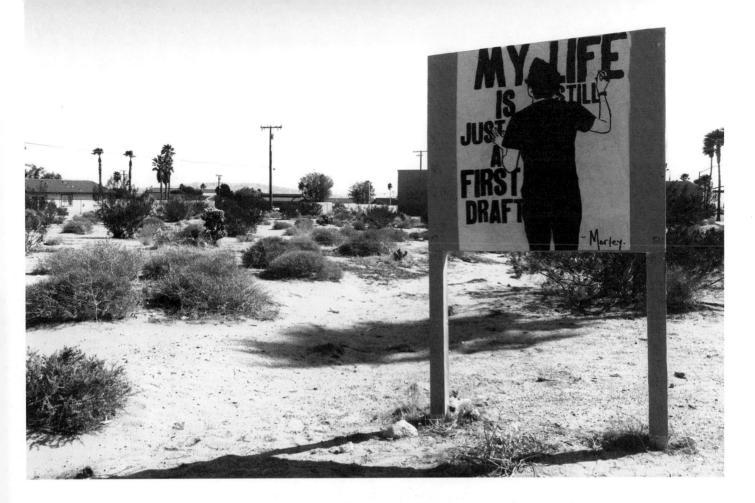

When I moved to Los Angeles, I discovered an entirely different emotional environment. It seemed as though I was surrounded on all sides by either disenfranchised dreamers or marginalized immigrants and the families they struggled to support. We mingled in the streets amongst the wealthy populous of the world beyond the velvet rope and created a fascinating social concoction. Perhaps this was a myopic way of looking at the city, but after graduating college and joining the ranks of the wage slaves, it became clearer what I wanted to say and who I wanted I wanted to say it to. I quickly discovered that the majority of LA's inhabitants neglect public transportation, so I decided my artwork needed to be bigger in order to be visible from a passing car or a speeding bike. Additionally, it was then that I decided

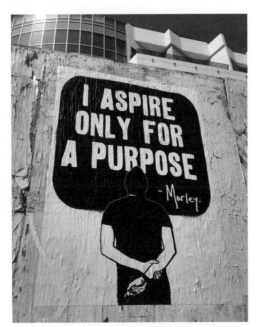

I wanted to give a name and a face to the voice. I wanted to create the comfort of familiarity and recognition. I wanted the people to know who it was that was writing to them. To me, using myself as the model was the only choice; it was an attempt to bring more humanity and personal investment to each poster. I wanted to stand by the words in a literal way, instead of just a figurative one. With no experience to speak of with a spray can or a stencil, I opted for the wheatpaste method most associated recently with Shepard Fairey's *Obey* campaign. This involves a cheap paste made with white flour, shellacked over a poster printed at any local copy shop.

Picking my street artist pseudonym was actually easier than I had expected. While I had hoped to define my work by being as open and honest as possible, I assumed that the posters would be, shall we say, less than warmly regarded by local law enforcement. I needed something that would hide my identity while representing me in a genuine way. Morley is actually my middle name. It's a family name that, as a kid, I was embarrassed of. To me, it sounded old-fashioned, dorky, and uncool. Not at all the middle name I would have picked for myself. Laser, maybe. Or Fang.

Robocop would have been good, too.

As I grew older, it started to dawn on me just how appropriate a dorky and uncool name actually was for me. One of the most important steps in an artists' growth is when they learn to embrace the individuality of their own voice—when they can look back at all the great and awful stuff that helped define who they are. Their victories and their humiliations, mixing together like paint in a glass full of water and brushes. Though it may not be the prettiest color, it would be impossible to perfectly replicate. It's what gives the artist a unique perspective on the universal. In that spirit, I could wear my goofy middle name as a badge of honor—a symbol of everything I am and everything I secretly wish I wasn't.

Plus, I think there was already an artist named Fang. So, yeah.

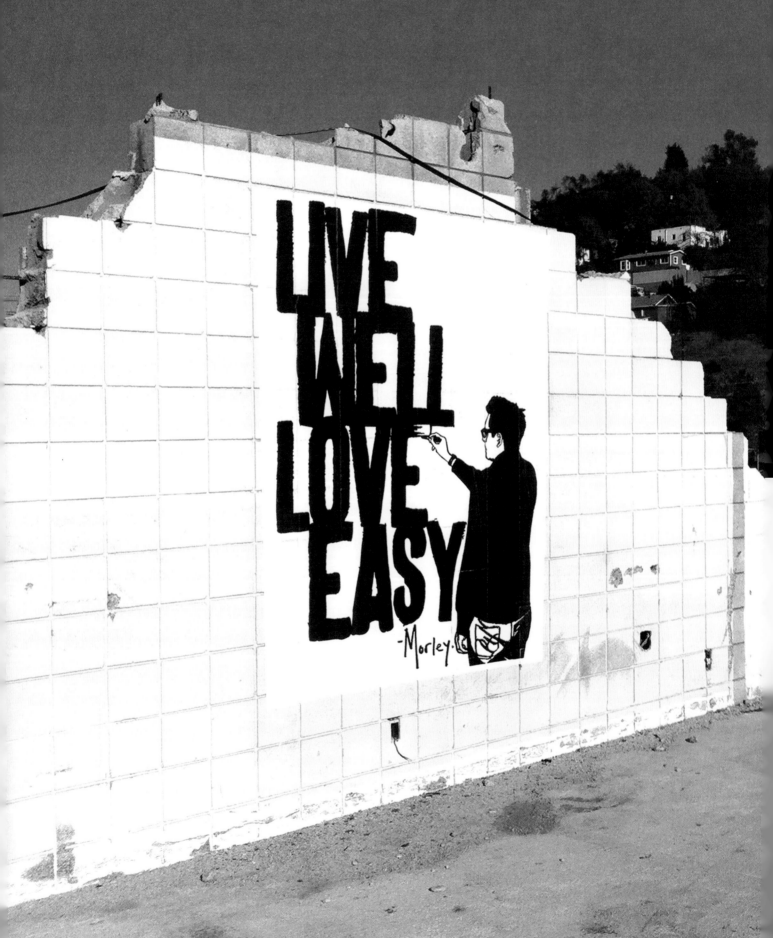

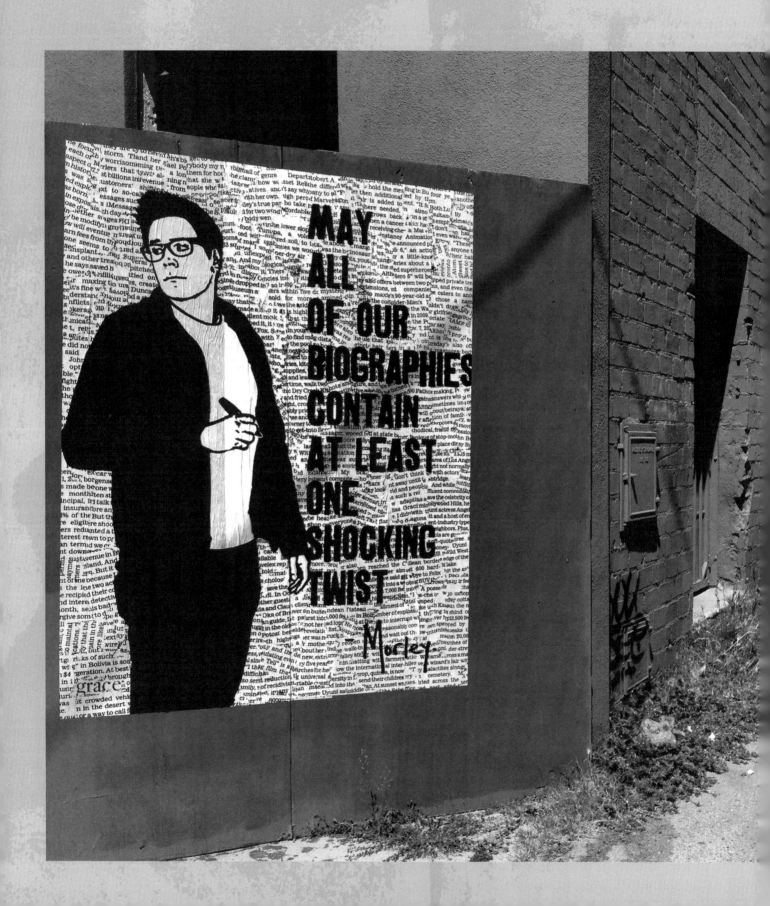

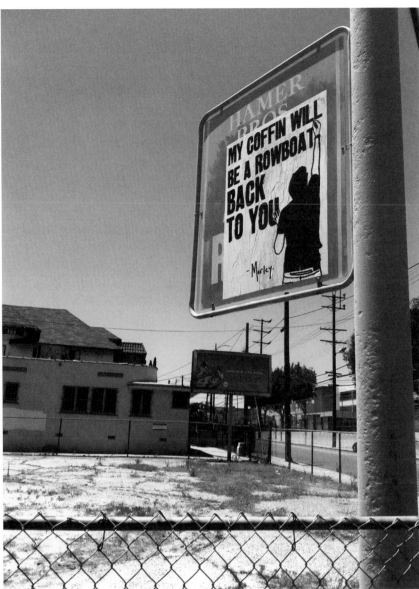

When I first started this book, I was a little concerned with how to fill it. Being unsure of just how much of my incoherent rambling someone would tolerate, I decided to ask visitors to my site, **www.IAmMorley.com** to send me questions. I'll answer some of them throughout the book.

How do you usually come up with your ideas? —Richard Lo

I wish I could say I have a scientific method for it, but basically, I just sit in front of a notepad and jot things down that pop into my head. Often, they'll come to me as I'm driving or stuck in traffic. When I get an idea, I write it down and then start finding the exact phrasing I want to use. How can I express the idea in as few words as possible? What words will have the most impact or feel the most relatable? Should they be colloquial or proper English? How can I use the words visually, and how will they play on the page with the Morley drawing?

Now that I think about it, I guess it is a *little* scientific.

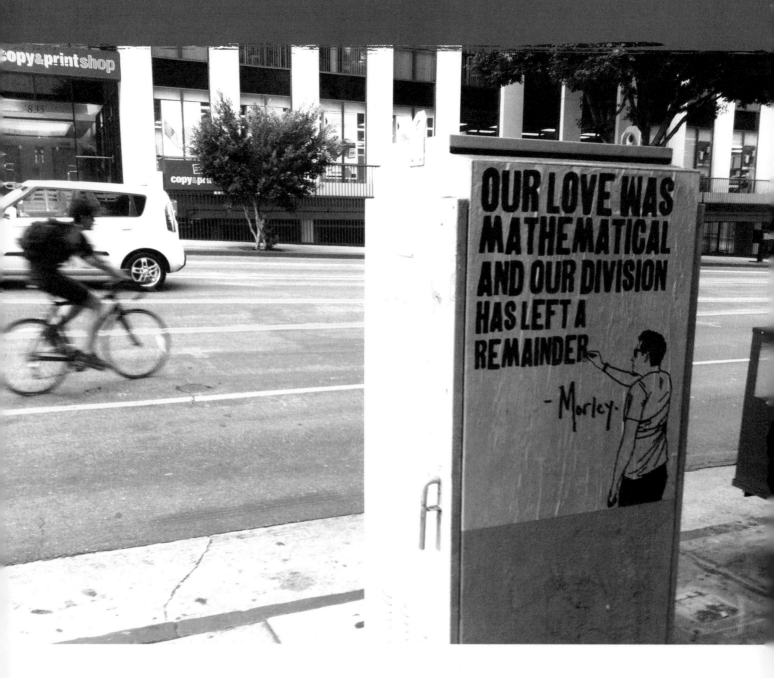

Would you consider yourself an artist or writer first?
—Grant Phillips

I have a very hard time calling myself an artist. I'm much more comfortable calling myself a writer. In fact, the first time I was contacted by Steve Lazarides and The Outsiders to sell prints of my work, I was overcome by a sense of being unworthy to join the roster of artists that he's worked with. I assumed that kind of attention would invite a level of criticism I wasn't sure my little posters could withstand. I hadn't considered that anyone would ever want to buy my work, and the notion of losing the freedom from rejection that compelled me to make street art in the first place was unnerving.

I became terrified that, at some point in the process of working with The Outsiders, someone would discover what a fraud I was—would uncover the relatively limited potential I have as an "artist."

I shared this with my friend Andrew, who took a moment to consider before saying, "Charles Schulz created *Peanuts* in the fifties. No one would confuse one of his strips with a Rembrandt, or even claim it's the best-drawn comic in the Sunday paper. It's his unique voice that makes it so classic." His statement was comforting, and reminded me that a person's emotional connection with art is what defines the quality of it. I didn't decide who my favorite artists were based on how technically gifted they are. I decided based on how much their work spoke to me.

Since then, I've become slightly less afraid of being confused with an artist, but I'd like to think I'm growing.

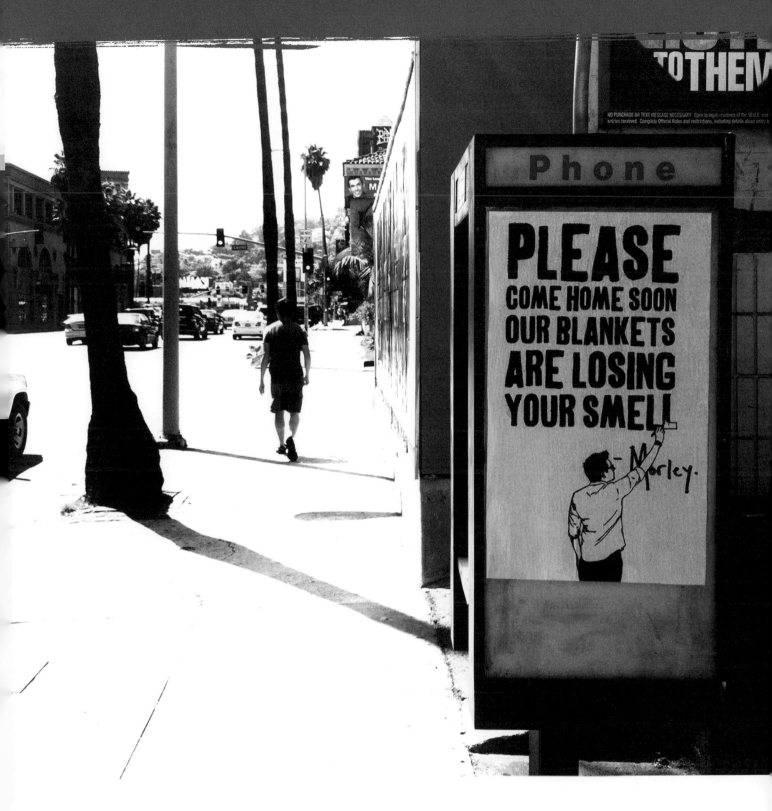

Have you ever felt self-conscious about putting yourself out there in public places? —Ricky Poulton

All the time. It's funny, actually, because when I started, I hadn't really considered the consequences that come with putting up pictures of yourself in public. I draw heavily on my own struggles and experiences to make my posters, which makes for a much more intimate feeling of scorn when someone draws a penis on your face.

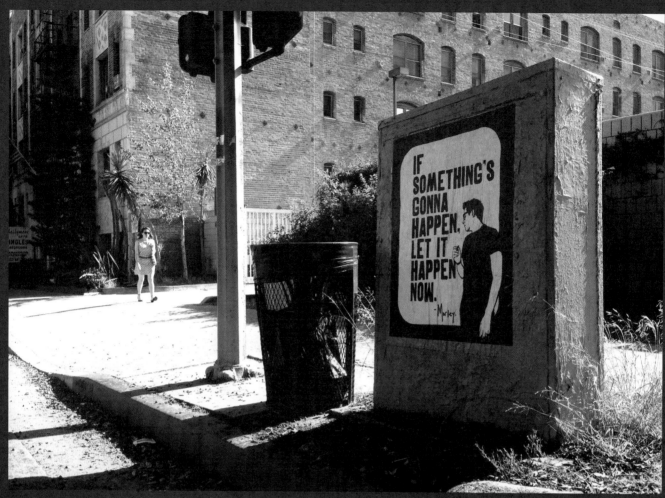

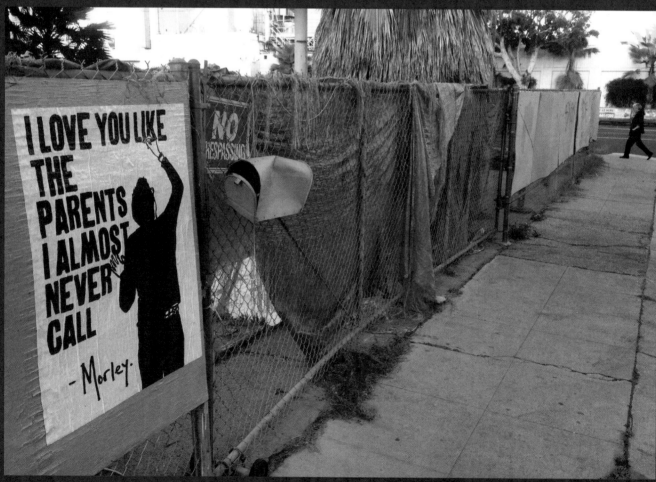

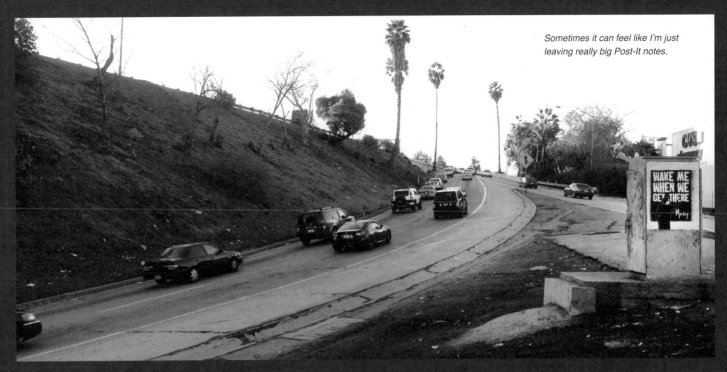

Sometimes it can feel like I'm just leaving really big Post-It notes.

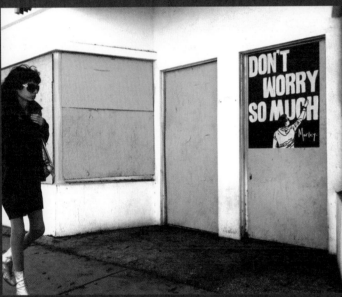

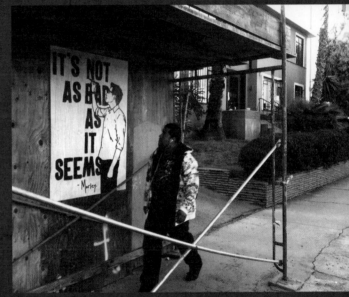

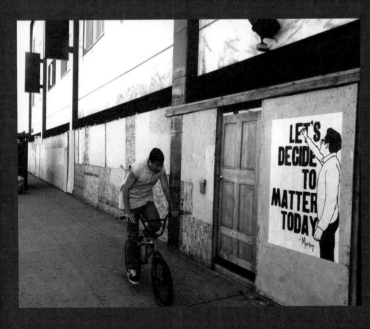

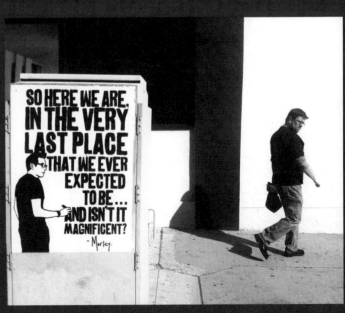

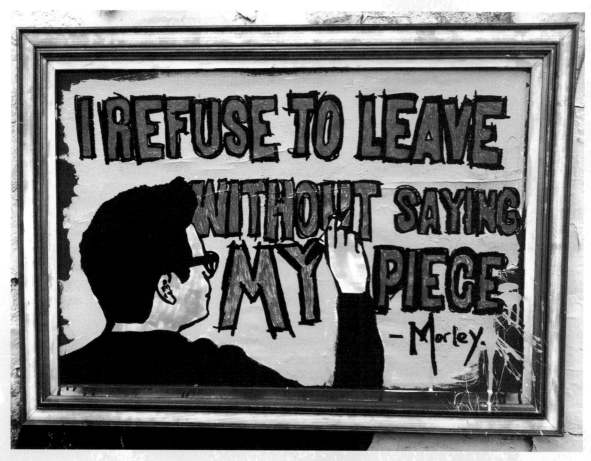

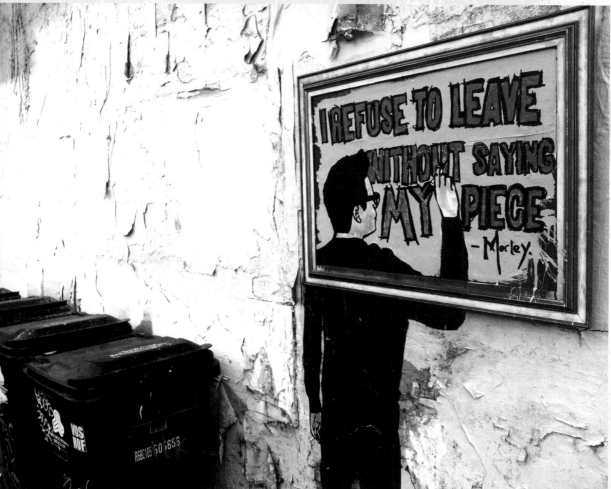

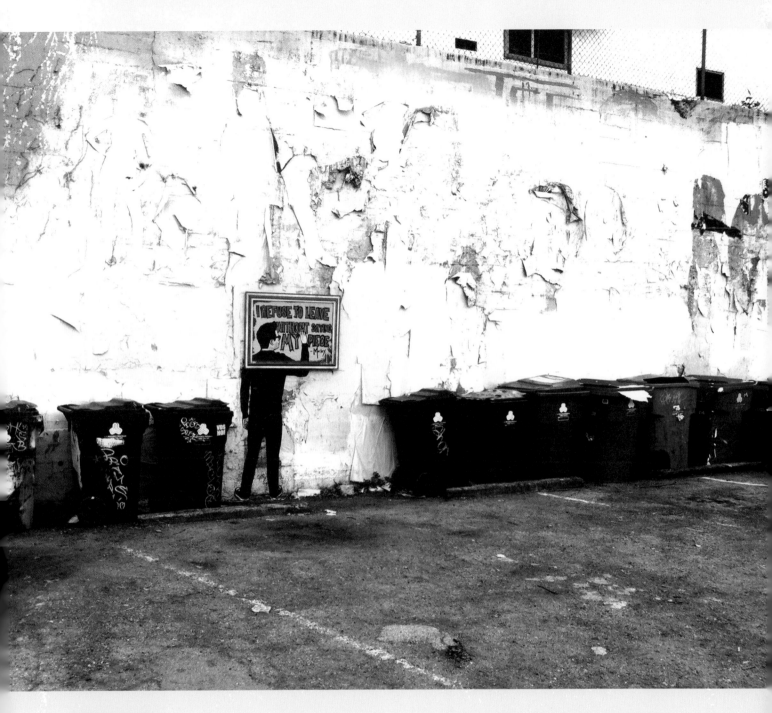

RECYCLED ART

Inspiration can come from anywhere. For example, while driving home you might see an old oil painting with a deep slash through it on the side of the road. You could stop and tell your wife that you will be right back. You could load it into your car, ignoring her lack of enthusiasm as you tell her to move her seat up so you can fit the oil painting in the back. At this point, you'll notice the awful smell. This is urine, and it coats pretty much the entire painting, no doubt from any number of animals who happened upon it.

You assume their preference in bathroom facilities was either in critique of the painting's lack of visual depth and creative nuance, or maybe just because they're animals. You then tape up the canvas, splash some paint on it, write a few words, and take it back into the cruel world in which you found it. Voila: public expression through recycling. I can only hope that whoever happened upon it didn't assume the urine smell was also my contribution.

Formerly, this spot had been quite a hub for street art. Once it was discovered that no one seemed to care if a poster went up or a bit of graffiti, it was almost completely plastered with art in no time. Apparently, it became a problem for someone, because one day the entire wall was painted over.

Only the beige, tattered remains of posters that clung to the wall defiantly remained, making what had once resembled a public art gallery into a kind of cemetery.

This seemed like the perfect place for this statement.

"I never noticed the stars before. I always thought of them as great big diamonds that belonged to some one. Now they frighten me. They make me feel that it was all a dream, all my youth."

"It was a dream," said John quietly.

"Everybody's youth is a dream, a form of chemical madness."

"How pleasant then to be insane!"

—F. Scott Fitzgerald
"The Diamond as Big as the Ritz"

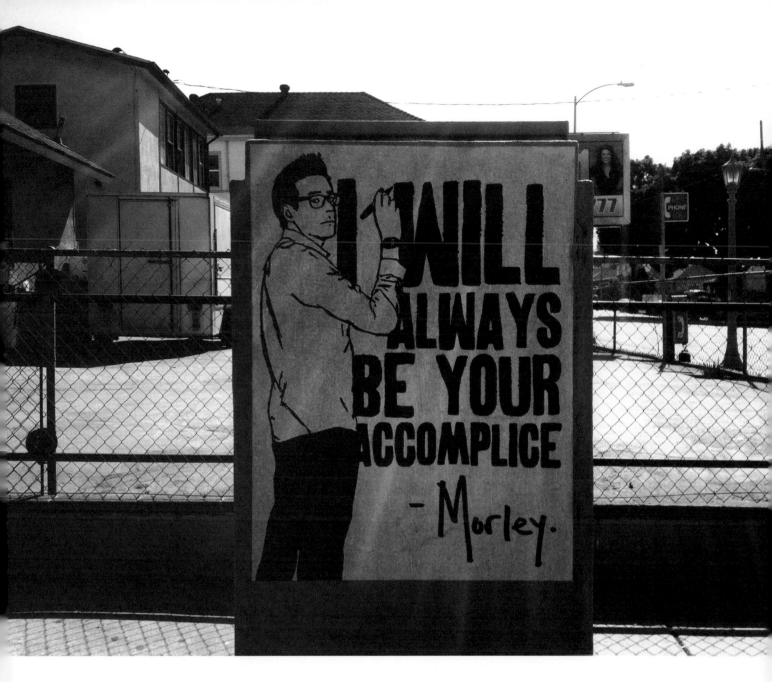

ACCESSORY TO THE CHILDHOOD

I became straight-edge (a subculture based on a drug-free lifestyle) my freshman year of high school. I remain so to this day. For my friends and me, as teenagers in the Midwest who didn't drink or do drugs, weekend activities usually consisted of driving around aimlessly. Without the benefit of having someplace to go or some party to be at, we would spend our time sharing our hopes and lamenting the frustration of feeling stifled by the limits of our small town. When you're that age, it's enough to just be driving around in a car with a few friends and some good music, looking for some kind of adventure you will never actually discover.

It's only in retrospect that this memory seems both beautiful and silly. I wanted to reflect on that duality and play with the notion of what would have happened if I had stayed in my hometown after the friends who had been so vital in getting me through high school left. I wanted to reflect on the idea of feeling lost without someone—of feeling lost in a town whose every crack and crevice you know. The idea of suddenly figuring out how unproductive driving around with no destination is without the people who once gave it purpose.

Do people do this in Los Angeles? Can they feel stifled in a city with this much magnitude and hype? Do they yearn for something better? A place where better bands tour, and they don't have to drive an hour to see an art-house flick in a theater? Do people living in Los Angeles feel like the only thing holding them back from the future they're surely destined for is being stuck in a city full of people who can't understand, the feeling that if someone just gave you the chance, you'd change the world? I'm not sure. As much as I welcome distance from an awkward and often painful adolescence, it's nice to have a perspective that maybe only a select few can really appreciate.

The truth is, I'm glad to have had a youth preoccupied with wasting gas and cycling through mixtapes.

I wouldn't trade it for the world.

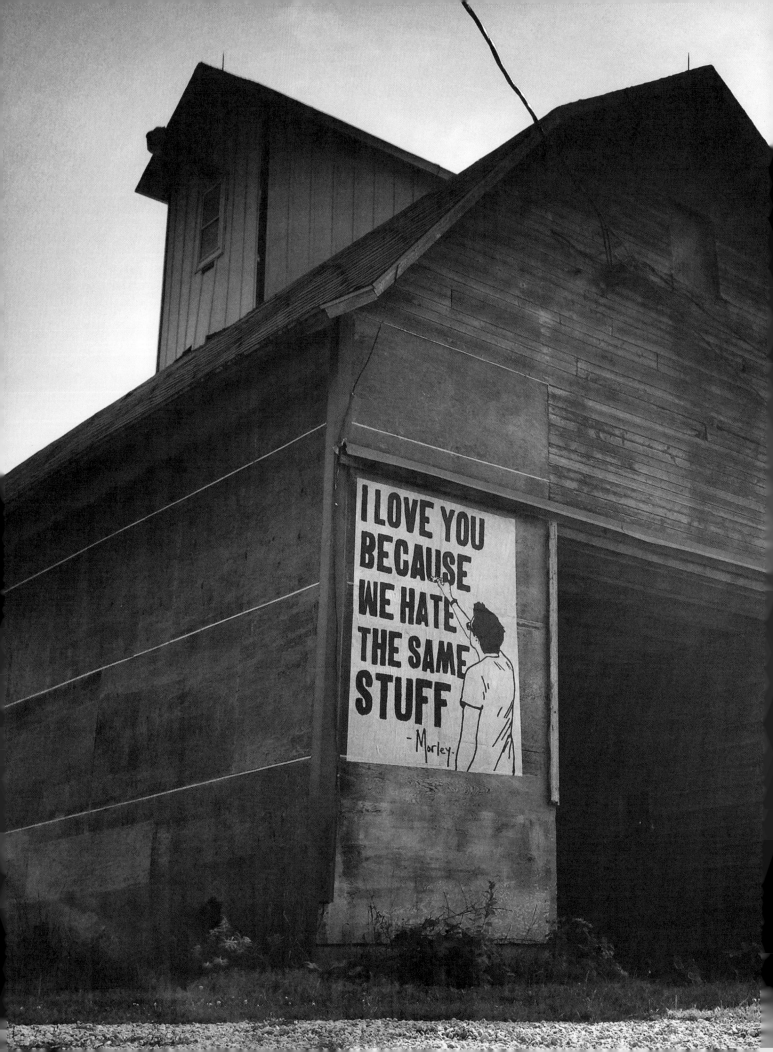

"One of the most beautiful qualities
of true friendship is to understand
and to be understood."

—Lucius Annaeus Seneca

NEED A MINUTE?

I t was my hope that as people took these tabs, they would
actually stop for a solid minute and focus on the moment they
were given permission to appreciate. As I watched from a distance,
a few actually did. Perhaps those who just took one and kept
walking were saving it for later. Luckily these minutes don't spoil.

Print your own: ***http://www.flickr.com/morleyart***

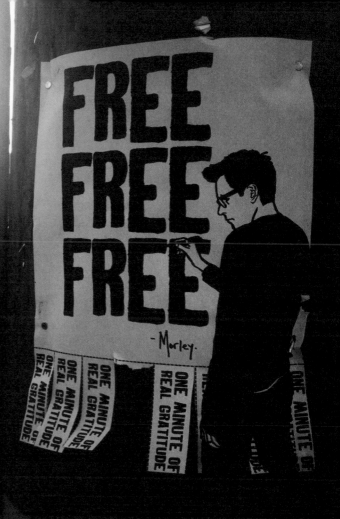
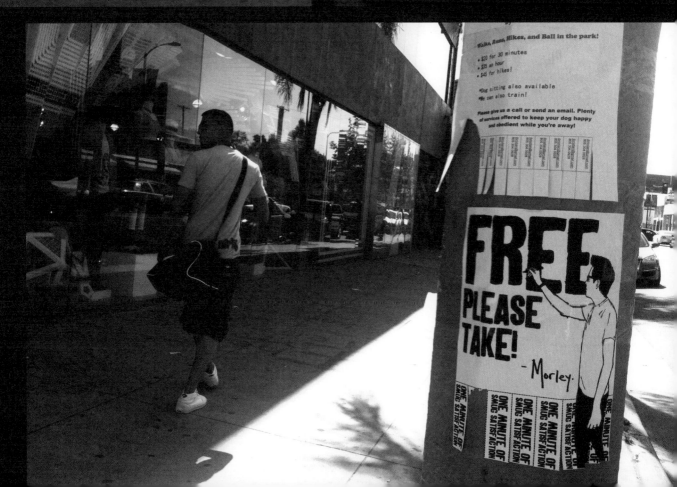

If you could give yourself some advice using one of your posters, what would it be and why? —Laura Burton

I think that each of my posters is, in a way, a piece of advice to myself. Whether it's something confessional, a piece of encouragement, or an attempt at humor, the first level of deciding if the poster works is whether it holds some kind of resonance with me.

If I can't relate to it, how can I expect anyone else to?

Even if my posters seem bent on motivating, it doesn't mean I don't suffer the same kinds of self-doubt and frustration that everyone else does. I just use it as fuel. This way, my posters aren't like a well-toned fitness instructor shouting demands for more sit-ups.

Instead, they're a commiseration from someone else in the trenches.

CONFEDERACY

John Kennedy Toole was an aspiring writer. After finishing a novel, he began submitting it to publishers for consideration, but it was roundly rejected. Toole took the rejection as a tremendous personal blow. Years of subsequent rewrites and dismissals followed until, at the age of thirty-one, John Kennedy Toole committed suicide.

Two years later, Thelma Toole, John's mother, found a copy of her late son's manuscript. Determined to prove John's talent, she resumed submitting it to publishers. Once again it was met with a resoundingly negative reception.

"Each time it came back I died a little," she said.

After five years of rejection, Thelma became aware that author Walker Percy was becoming a faculty member at the nearby college. Thelma began a campaign of phone calls and letters to Percy to get him to read the manuscript. Percy even complained to his wife about a peculiar old woman's attempts to contact him. With time running out on Percy's term as professor, Thelma pushed her way into his office and demanded he read the manuscript. Initially hesitant, Percy agreed to read the book to stop her badgering. He admitted to hoping it would be so bad that he could discard it after reading a few pages. "In this case I read on. And on. First with the sinking feeling that it was not bad enough to quit, then with a prickle of interest, then a growing excitement, and finally an incredulity; surely it was not possible that it was so good."

Despite Percy's great admiration for the book, he too would face three more years of struggling before a publisher agreed to print the novel.

A Confederacy of Dunces was published by Louisiana State University Press in 1980, eleven years after John Kennedy Toole killed himself. Toole's first draft of the book was published with minimal copyediting and no significant revisions.

A year later, Toole was posthumously awarded the Pulitzer Prize for Fiction. *A Confederacy of Dunces* has since sold more than 1.5 million copies in eighteen languages.

The title derives from the epigraph by Jonathan Swift: "When a true genius appears in the world, you may know him by this sign, that the dunces are all in confederacy against him."

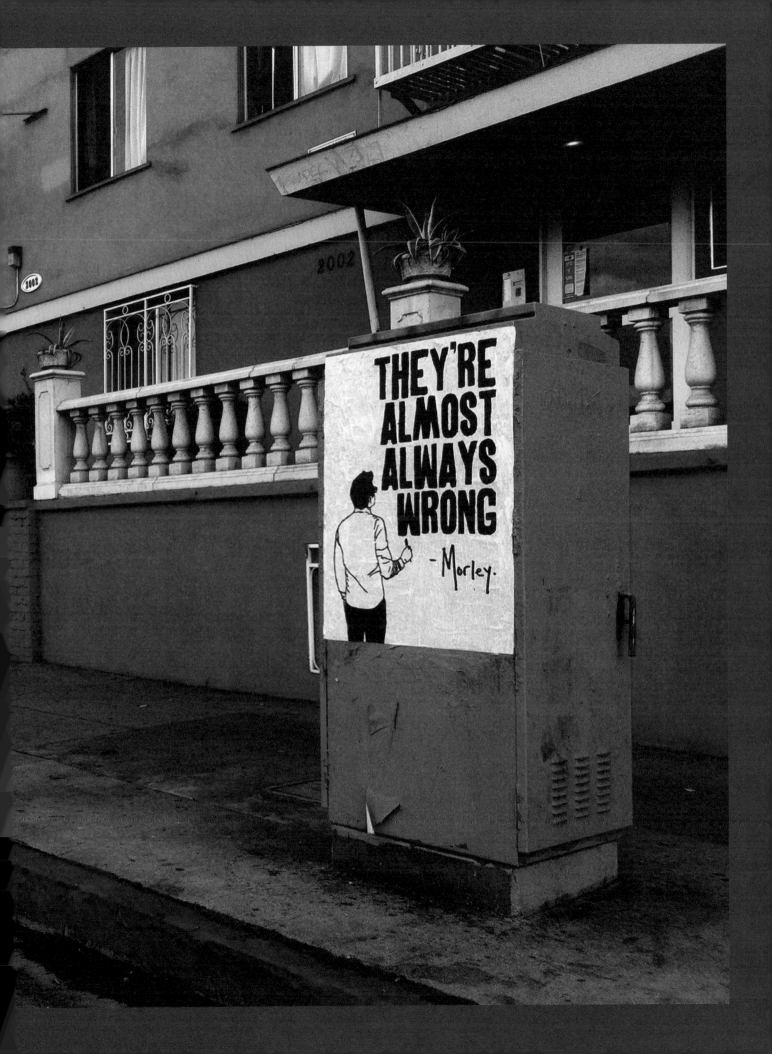

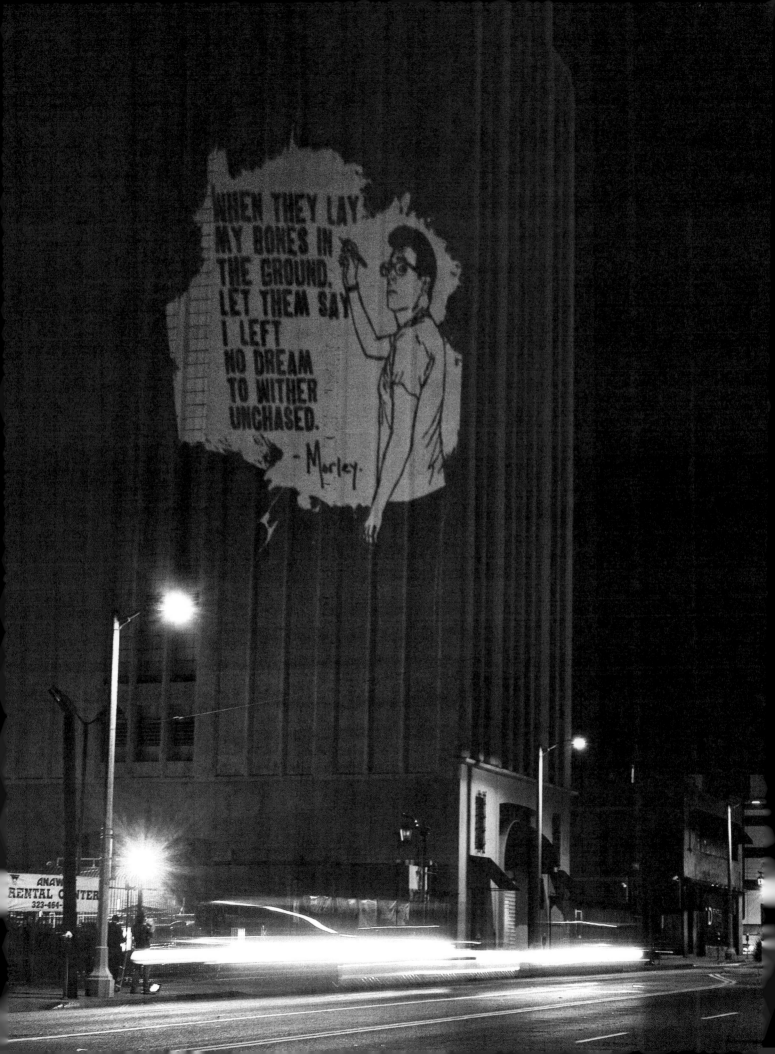

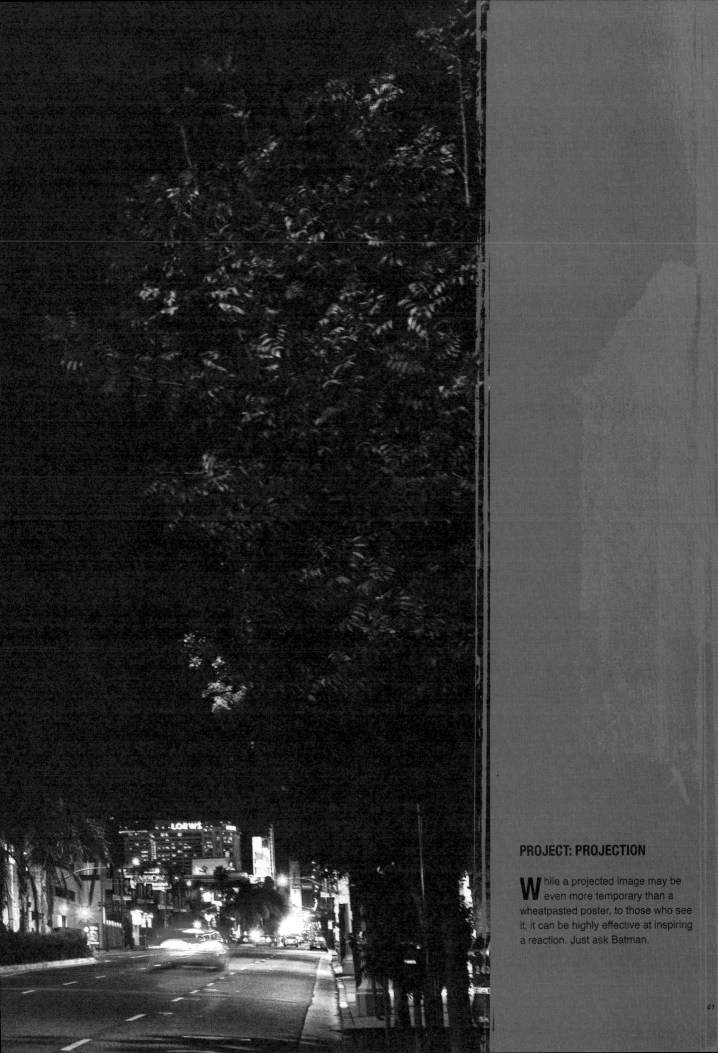

PROJECT: PROJECTION

While a projected image may be even more temporary than a wheatpasted poster, to those who see it, it can be highly effective at inspiring a reaction. Just ask Batman.

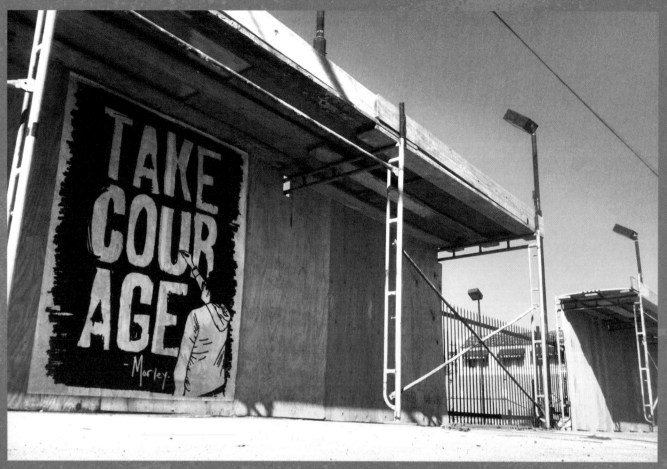

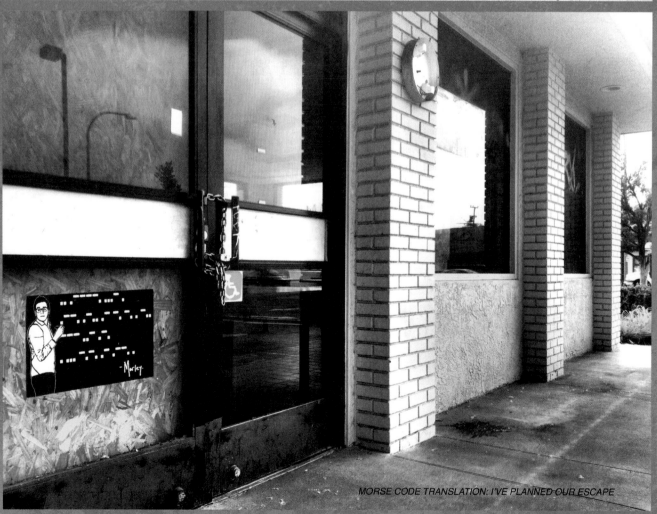

MORSE CODE TRANSLATION: I'VE PLANNED OUR ESCAPE

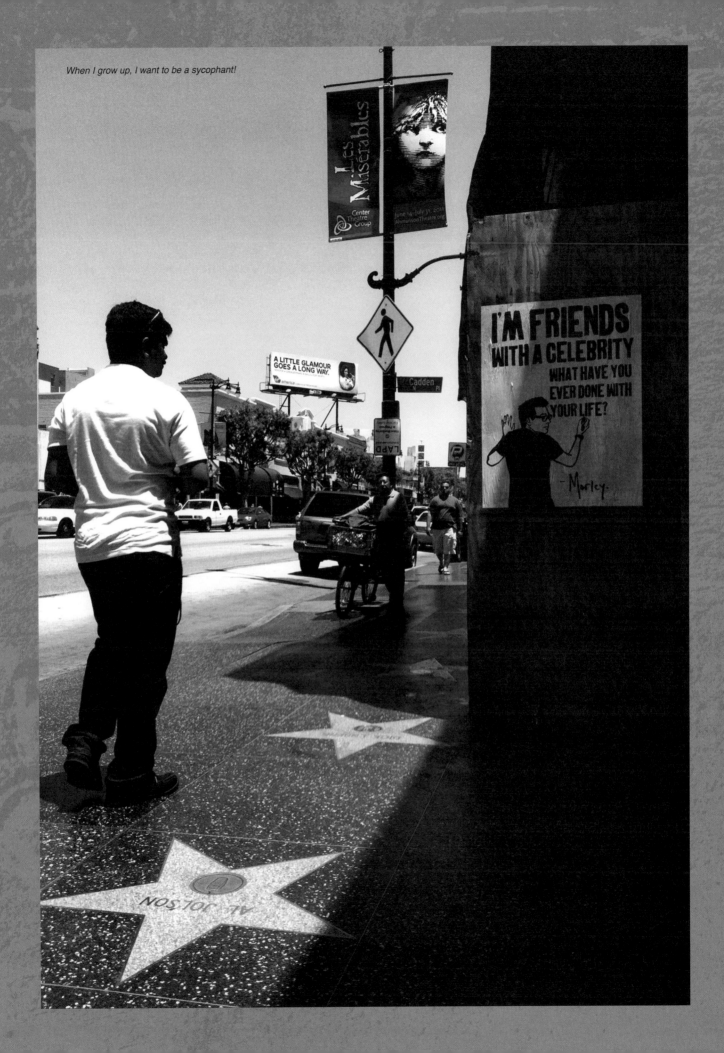

When I grow up, I want to be a sycophant!

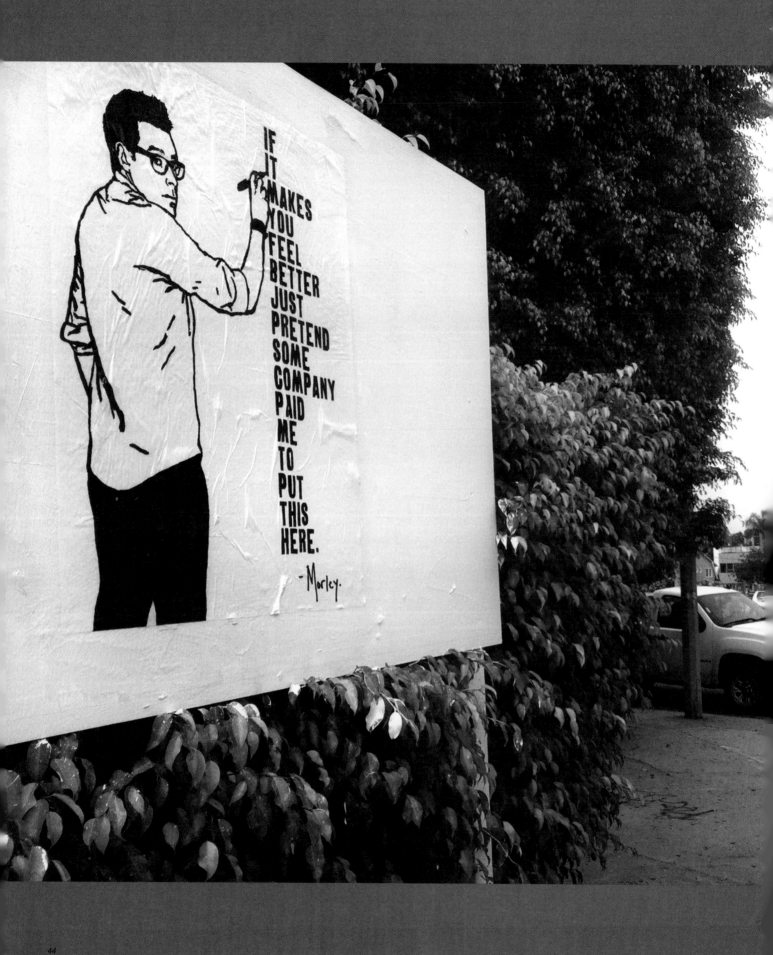

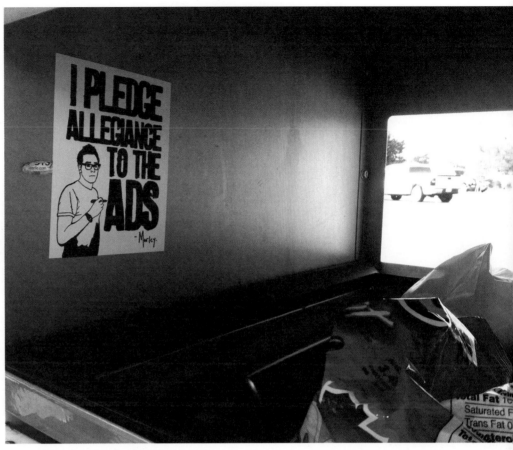

GREAT TASTE, LESS FILLING!

It is impossible to escape the all-powerful hand of advertising. If you live in a major city, you are forever bombarded with images that scream promises of fulfillment in some way, shape, or product. Massive billboards pepper the skyline with the same subconscious message that we are all somehow incomplete because we don't have whatever they offer. They illustrate this with impossibly perfect people doing their very best to convince us that they were once just like us before they discovered the beer in their hand or the underwear they recline in.

Once, not long ago, they were unhappy or frustrated or worried that they might never find someone they could trust enough to receive love from—but that all changed! Hooray for them! And hooray for cell phones and energy drinks! These advertisers couldn't care less if they produce a generation of women who hate their inadequate bodies or men who have lost all concept of identity to a glut of mixed messages. My feeling is that with all these ads selling the unattainable, why not give something positive away for free?

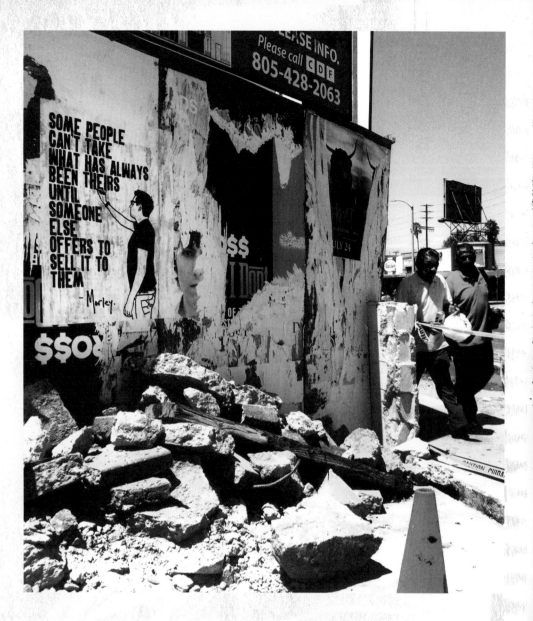

"Nothing is enough for the man to whom enough is too little."
—Epicurus

O CAPTAIN! MY CAPTAIN!

After graduating from college, I worked as a substitute teacher for two years in Baltimore, Maryland, and two years in South Central Los Angeles. Before I started, I anticipated my experience being almost exactly like *Dead Poets Society*, going so far as to ponder how I would react when the high school students, thirsty for inspiration derived from passionate literature, would stand atop their desks and triumphantly quote Walt Whitman as I left. I assumed I would simply turn to them and say, "Oh, children, I know that in the span of this sixty-five-minute eleventh-grade English class, I've altered the course of your lives forever, but now I must leave to shape yet another group of teenagers ripe with untapped potential. Carpe diem!" Then I'd fade away as a wistful voiceover says, "We never saw him again, but we all knew…we'd never be the same."

Of course, what actually happened was significantly different. Instead of being thought of as the inspirational teacher who plays by his own rules, it was decided that I was simply Fall Out Boy. Not because I look particularly like any member of the band; it's just that I was a young, white guy and thus, Fall Out Boy. In every class of every school, mysteriously, I would be called Fall Out Boy (sometimes Mr. Fall Out Boy). Great minds think alike, but these great minds refused to be even slightly interested in the poetry of Dylan Thomas, no matter how much I tried to relate it to rap music.

Surprisingly, I bonded with a different age group: kindergartners. Fresh-faced, optimistic, and free of the predisposition to hate anyone who would disrupt their sexting, these kids were excited to start each day and investigate its wonders. They didn't care about Dylan Thomas either, but at least they weren't jerks about it.

One of my favorite qualities was their endearingly unabashed need for validation. One kid would run up and show me the picture he drew, and as soon as I complimented it, all the other kids would show me their drawings, hoping for similar flattery. As adults, we also do this, but we conceal it with false modesty.

Practiced long enough, this evolves into a pathological need for praise in order to give us the distinction of a value we can't give ourselves. We all do it. You might think you're different, but you're not. The only difference is the amount of emotional gymnastics we perform daily to trick ourselves. I think that's why observing the children's shameless need for praise seemed so refreshingly honest.

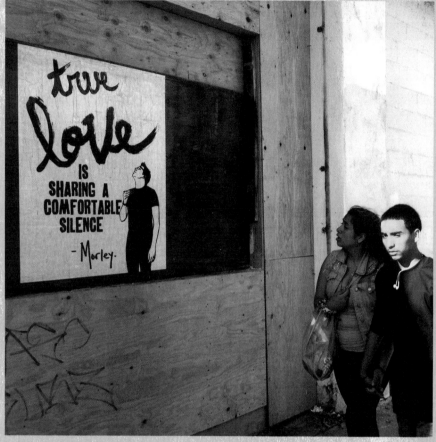

BODY/LANGUAGE

From time to time, I consider how amazing the human body is. Imagine a car that runs twenty-four hours a day. Even when it's not moving, it idles and continues to cycle various fluids throughout its machinery. It requires fuel every day but can endure terrible weather and unspeakable wear and tear, and the average model lasts around seventy-five years.

I think about that, and then I think about how much more amazing the human brain is and what it's capable of. It has the capacity for enormous levels of loyalty, compassion, and ingenuity. Of all those things, perhaps the most impressive is its ability to compute the impossibly illogical concept of love. Its biggest flaw, however, is its inability to properly translate it back to us.

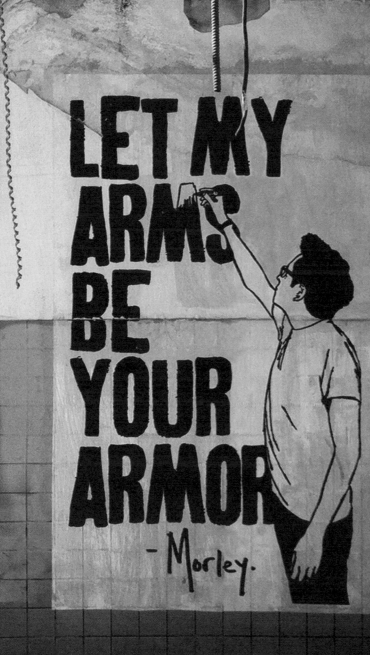

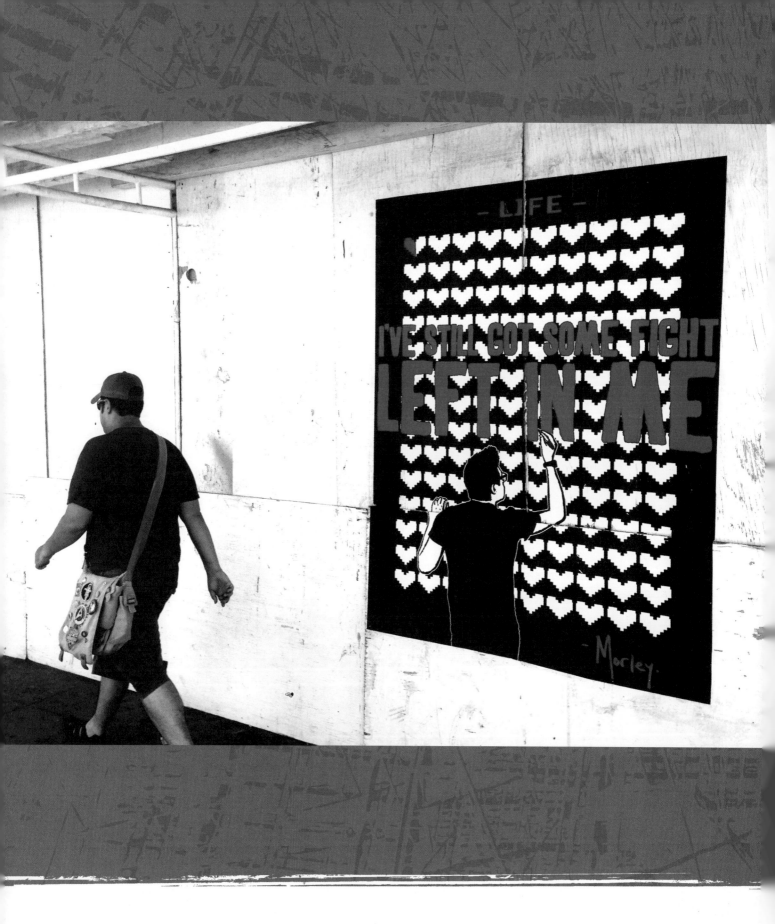

As I finished pasting this piece up an elderly woman walked by and looked at it. Her confused expression led me to the conclusion that she was not, in fact, an old-school Zelda fan.

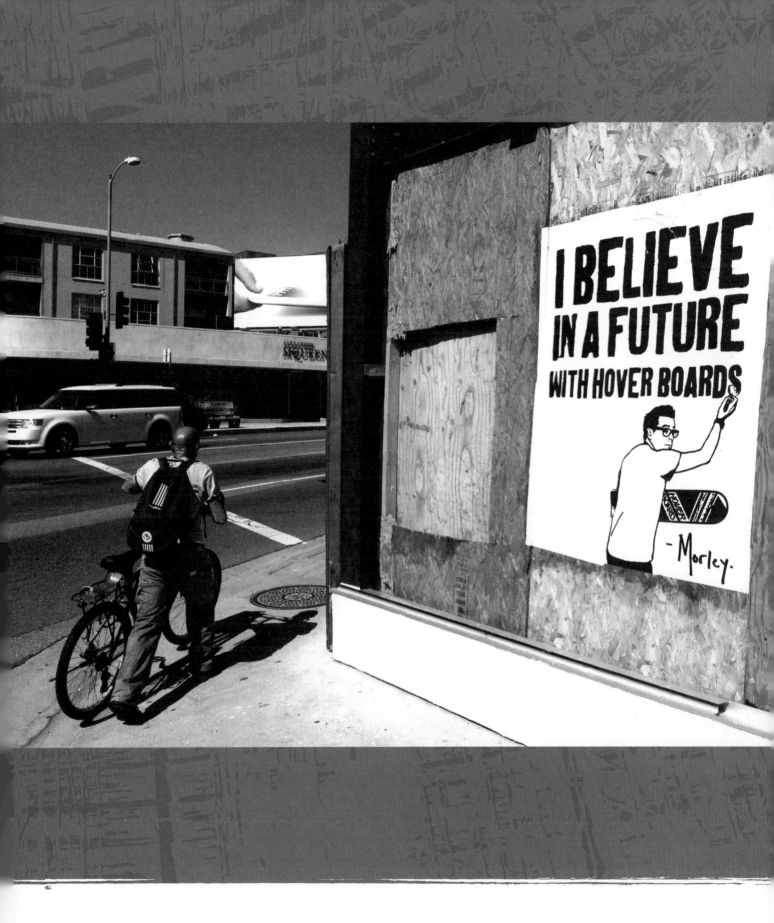

Sometimes, having an optimistic outlook just depends on what sci-fi movie you're watching.

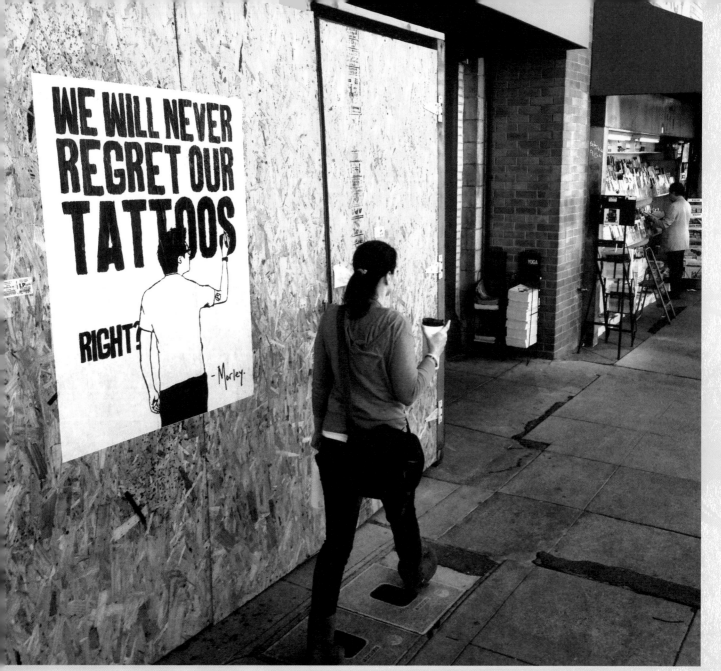

If you were able to meet any famous person, dead or alive, and hang out with them for a day, who would it be? What would you two talk about? – Lance Dayandayan

I would meet Jesus. Or maybe Hugh Jackman. If Jesus could make time for me, I'd ask Him about the meaning of life and why bad things happen to good people. If it was Hugh Jackman, we'd probably just ride a two-seater bicycle all day or run on the beach together like that scene in *Rocky III*.

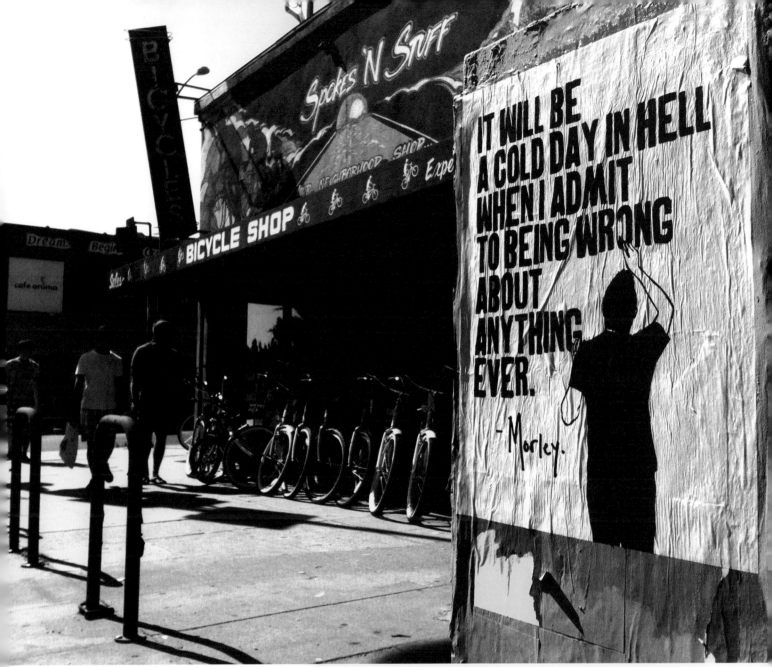

"How few there are who have courage enough to own their faults, or resolution enough to mend them."

—Benjamin Franklin

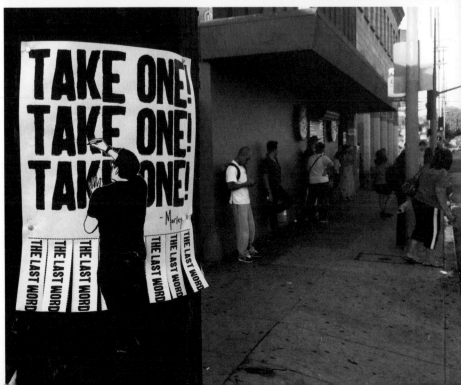

WHEATPASTING 101

I get a lot of e-mails asking me for tips on wheatpasting. Here is a simplified how-to for aspiring pasters.

FIRST AND FOREMOST:

I always recommend that if you're playing with the notion of making street art, read up on your city's vandalism laws. Figure out what kind of risk you're putting yourself in. If you aren't prepared to face the full extent of punishment your city doles out for these activities at any time, you might want to rethink how you want to express yourself. I have a few methods for creating street art that aren't technically illegal, and they can be just as satisfying as wheatpasting posters.

THE PASTE:

There are many ways to make paste. The cheapest method is to buy a bag of white flour. Some people buy potato flour, some people buy rice flour—it doesn't really matter what kind, but make sure it's white flour (brown flour can leave an ugly tint). When I started out, this was what I used, but I found that I wanted something with a little more durability. After trying pre-made wallpaper paste from The Home Depot (a much more expensive route, at $20 a gallon), I began ordering boxes of paste powder. My brand of choice is Zinsser Sure Grip. You can find it online for around $2.50 a box on Amazon.com, so don't get suckered into paying more from certain sites.

You'll need a large, industrial-style bucket, preferably with a lid and handle. It should be able to hold between one and five gallons. Avoid neon-colored buckets that will draw additional, unwanted attention.

In your bucket, mix one part powder (or flour) to three parts cold water. I find that sort of "dusting" the powder into the water, while at the same time mixing with your brush, helps avoid clumping. The more even the consistency of the mixture, the better the paste will be. Clumpy blobs of goo may form in the paste; these aren't great because they don't spread on a surface easily, and if trapped under a poster will create an unattractive bump.

Once you've finished combining the powder with the water, mix for an additional two to five minutes. Again, consistency is key. Adding a few teaspoons of sugar makes the paste a bit stickier, and I add a little bit of wood glue (for unvarnished wood surfaces).

Five to ten minutes later, the mixture will have firmed up to a sort of clear, pudding-like substance. This is your paste. Wheatpaste isn't like Elmer's glue or Super Glue; it won't harden until it's spread thinly over a surface. It also washes off clothing and hands quite easily, so don't worry too much about getting a little messy.

After a few days, depending on how well you've mixed it, your remaining wheatpaste will either stiffen to a sticky, sort of rubbery thickness (this can be used again by adding more water and mixing), or it can dissolve into a cloudy liquid that you will need to add more powder to for further use.

THE BRUSH:

Artists can be pretty picky about what kind of brush they use. There really isn't a best option, beyond personal preference. While many use modified sweeping brooms, cutting down the bristles and handle, I find that my preference is a thick, soft-bristled brush used for washing cars. It really soaks up the paste and spreads it pretty evenly. Whichever you choose, make sure you get a brush that you can attach to an extending painter's pole. You should be able to screw your brush head onto the pole, allowing you to extend your arm's reach substantially. Some poles even extend up to sixteen feet.

THE POSTER:

Printing your posters will not be cheap. My original artwork is on standard 8.5 x 11 paper, which I bring to FedEx Office (or Kinko's, if you're old like me). They have enlargers, which are generally used to make big printouts for architects and the like. My 8.5 x 11 paper is enlarged 350% to equal the width of an electrical box. These enlargers are black and white laser printers. Often, I'm asked why I use black and white so prominently in my work. Well, it's because the printers I use don't print in color. Simple as that.

The cost fluctuates depending on where you go. At FedEx Office, it's 75¢ per foot. The average poster that I put up on an electrical box normally runs me around $4.50. At this point, you might be doing the math and realizing that spending that much money is a real commitment. You're right—it is, so make sure you believe in what you're spending your money on.

APPLICATION:

To apply a poster to a wall, simply coat the surface of an area, put your poster on it, and then coat the front of it. As you coat the front, you want to push out any air bubbles from under the poster. Be sure to coat all edges and corners of the poster thoroughly, because that will be the first place that will begin to peel, as well as where someone will attempt to rip it down.

To put up something out of reach with your extension pole, cover the surface with glue, and apply the bottom of the poster first, pasting from the bottom up, bit by bit. Trying to post a large piece from the top down is tricky and can go wrong very fast. Wind and gravity are not your friends, and you won't have as much control with your pole extension, so get as much of the poster as you can fully applied before pasting the out-of-reach parts. I've learned this lesson after having dozens of posters fall on me, thanks to a slight breeze.

NOTE: If you're working from a rooftop going down, reverse my instructions.

If properly applied, the paste should protect your poster from the weather fairly well but not completely. Wheatpasting is by no means permanent. However, most posters will get covered up, painted over, or taken down long before they fall off a wall.

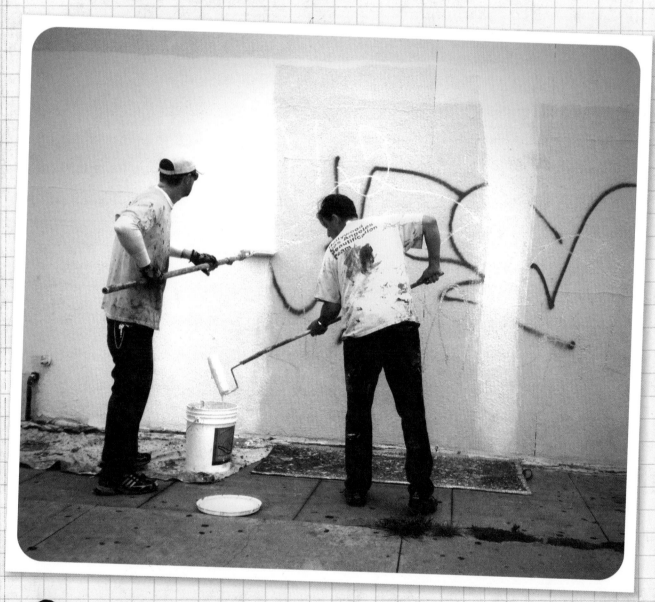

"Changing Environments, Changing Lives" is the motto of the Hollywood/Los Angeles Beautification Team. Never take getting "buffed" personally, these guys are just doing their jobs. Some of them are even fulfilling community service requirements for vandalism offenses. So keep wheatpasting and one day this could be you.

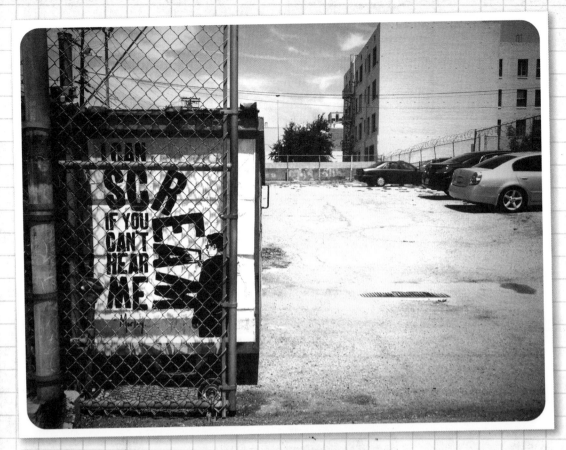

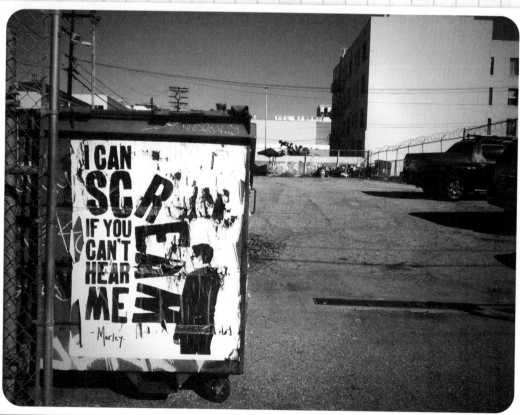

Most of my work tends to have a relatively short lifespan. It usually takes about a week before it's painted over torn down or another artist covers it. That's just the name of the game. However, now and again, a piece will last, and while Southern California is known for its mild weather, paper is only paper. Here's a piece I put up and a subsequent shot of it about a year later.

DOCUMENT:

Because of the short-lived nature of street art, it is important to take a photo as soon as you've hit your spot. I wouldn't recommend lingering too long after your poster is up, but make sure to snap a photo or two before you leave. Posters can sometimes last only hours unmolested. You could get buffed, tagged, or capped (which is when another artist covers your work) sooner than you might imagine. Thanks to the Internet, a photo of your poster can last forever and be circulated across the globe long after the actual piece has been removed. Almost every single one of the posters in this book is gone, but luckily, they can still be appreciated because I took a photo of each one. I recommend you do the same.

Many artists go out at night. I don't. I prefer daylight for safety and better photographs. I've found that cops are usually a lot more vigilant for vandals at two in the morning than at noon. It's also difficult to feign ignorance of vandalism laws if you're caught in the wee hours.

Artists can work in teams or with a friend as lookout. I generally work alone because I prefer not to put anyone else at risk of getting in trouble. Also, I move faster on my own.

LEGALITY:

This is a tricky issue. A key piece of advice I can offer is that if a cop catches you doing something illegal, don't run. If you see the police coming, you should quickly and quietly walk away, but if they approach you, don't try to run. This will only escalate the situation and raise hostilities. If cops have to pursue you, they're going to be obligated to arrest you and perhaps use force doing so. The nice thing about wheatpaste is that it takes about half an hour to fully set, so if you're stopped, you can just take the poster down. You'll lose the poster, but hopefully not your freedom.

The biggest trick in not getting caught is behavior. If you can pull off a calm, confident demeanor, you'd be surprised how easy it is to confuse you with someone who's not doing anything wrong.

MATERIALS YOU MAY WANT TO KEEP WITH YOU

ROPE:
If climbing is involved, rope comes in handy to haul your bucket up and down from a spot.

GLOVES:
If climbing an old rusty fence, these may come in handy, no pun intended. Okay, the pun was intended.

STEP STOOL/LADDER:
Depending on what you can fit in your trunk, a step stool or stepladder can help you scale a fence more easily, or just give you the height needed to paste up something bigger. This will make you a lot less inconspicuous, so use with caution.

PAPER TOWELS & SPRAY BOTTLE:
Getting some paste on yourself is unavoidable, and it's good to have a spray bottle that can wet your hands, arms, face, etc., and some paper towels to clean them. Once, after hitting a spot, I neglected to clean some glue off my arms. When I returned to my car, I put a jacket on, and an hour later found myself ripping my arm hair free of its sleeve. That was unpleasant.

ADDITIONAL POWDER/WATER:
Running out of paste in the middle of a great hit is the worst. Make sure you can make some extra paste on the go. I keep a few boxes of powder and a pair of gallon milk jugs full of water in my trunk.

FIRST-AID KIT:
Scrapes and scratches are common, and it's good to have Band-Aids and rubbing alcohol with you. Few of the locations where you'll be posting will be particularly clean, so avoid infections.

"THE MEDIUM IS THE MESSAGE"

This was a concept developed by communication theorist Marshall McLuhan. The idea is that the form of a medium embeds itself in the message, creating a symbiotic relationship by which the medium influences how the message is perceived.

A *median* is defined as "the strip of land separating the lanes of opposing traffic on a divided highway."

While it's doubtful that Mr. McLuhan had street art in mind when he coined his phrase, I imagine there are few other examples where it's more applicable.

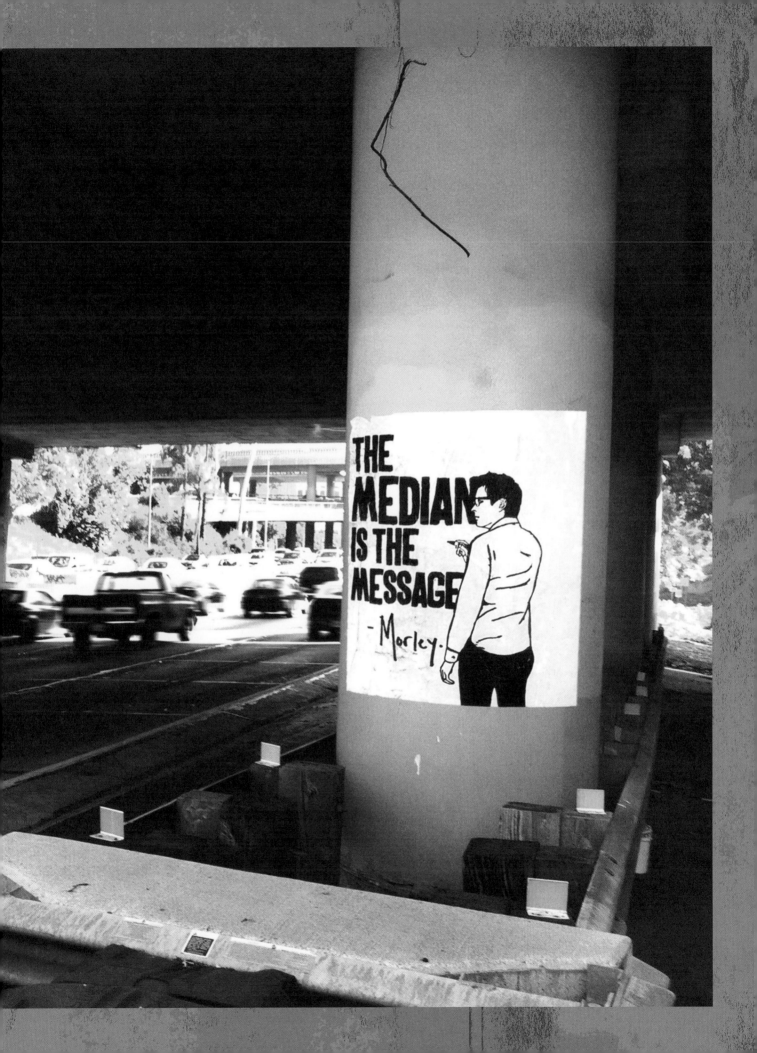

MIRROR, MIRROR

The goal with this piece was to try to include the viewer as much as possible—to personalize it somehow and bring everyone who passed it "into the message." I went to a glass-cutting shop and had a pair of mirrors made to the size I wanted, then cut a stencil of the words, spray-painted them on, created the drawing of me holding it, blew it up to the right scale, pasted it up, and used a caulking gun to make the mirror stick to the wall. I was happy with the result and had planned to do a second one. However, the following morning I went to my car and found that it had been broken into...for the second time in a month. My stereo had been stolen and my dashboard ripped out. I had hidden the stereo face, so the whole car was ransacked. The thief even took some spare change I had in my cupholder.

And then I saw it. Sitting on the passenger's seat were the cracked remains of the other mirror. I couldn't decide if it was intentional or just collateral damage from a hasty robbery.

Looking back now and imagining the scenario, it seems almost comically tragic. Someone desperate enough to break into my junked-out '97 Honda Civic and steal a $50 stereo and a handful of loose change, only to be faced with a mirror saying "IT WILL GET BETTER." Nothing stings like good-natured encouragement when you're in the midst of a really low moment. Looking at your own reflection as you rob some stranger, seeing words of hope sprayed across it.

If it was me, I might have smashed it, too.

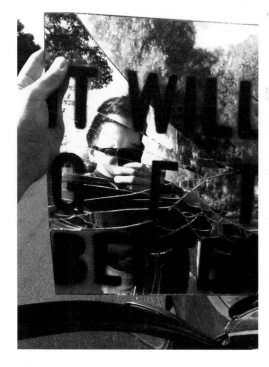

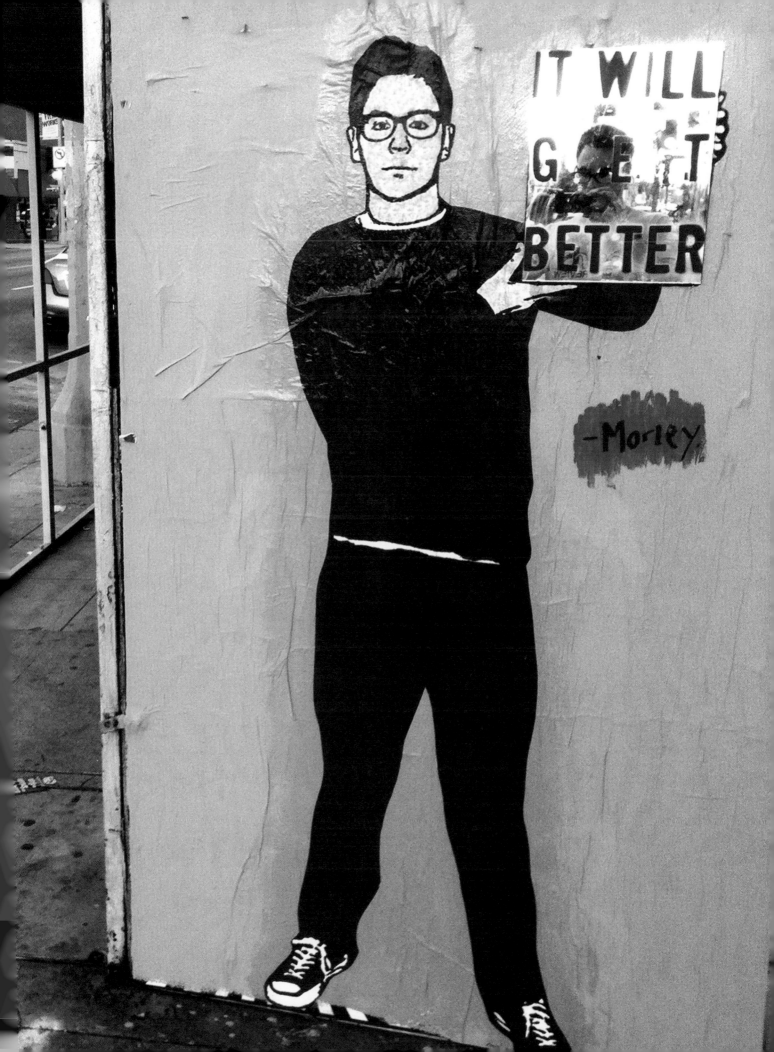

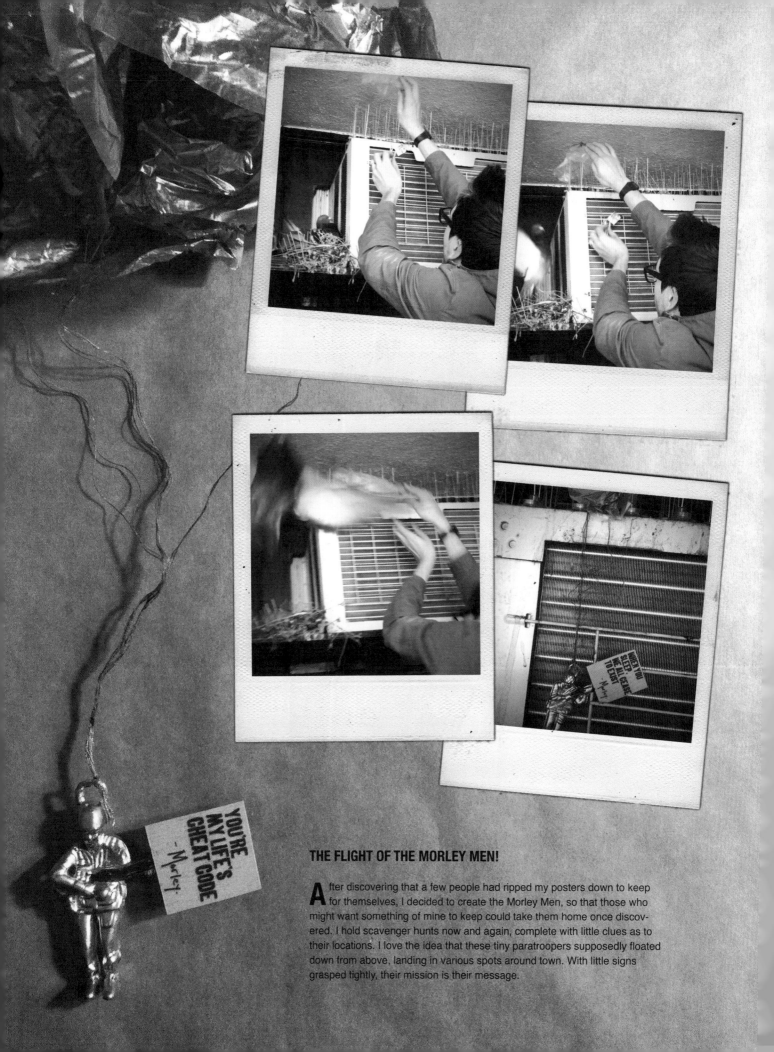

THE FLIGHT OF THE MORLEY MEN!

After discovering that a few people had ripped my posters down to keep for themselves, I decided to create the Morley Men, so that those who might want something of mine to keep could take them home once discovered. I hold scavenger hunts now and again, complete with little clues as to their locations. I love the idea that these tiny paratroopers supposedly floated down from above, landing in various spots around town. With little signs grasped tightly, their mission is their message.

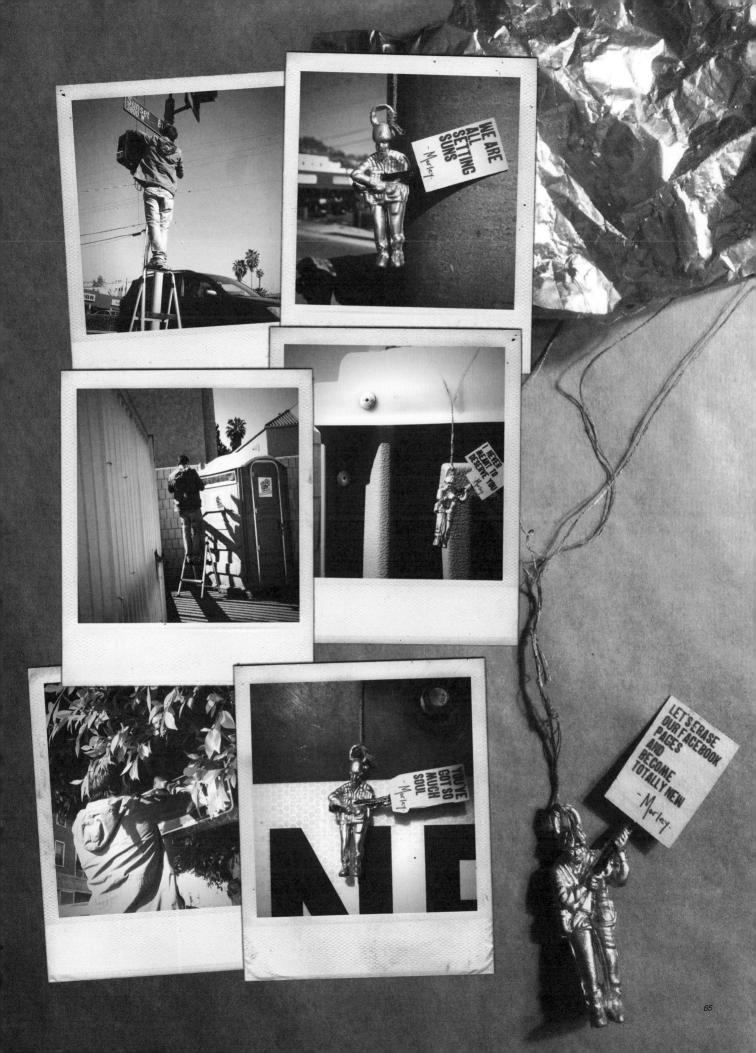

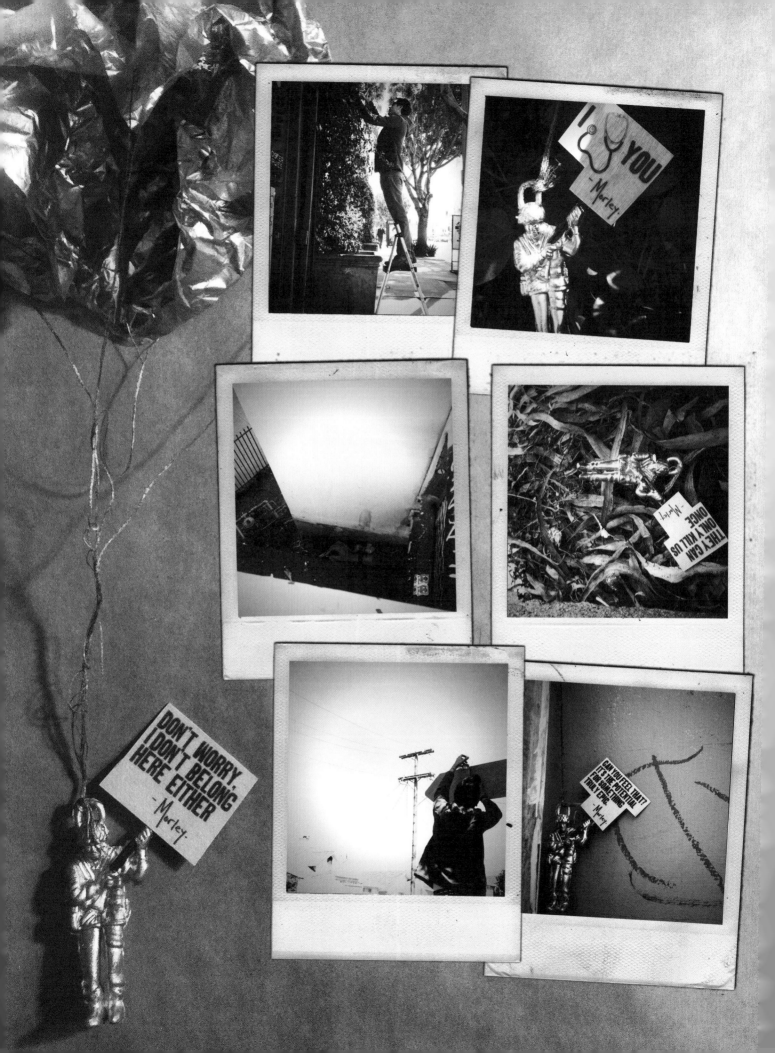

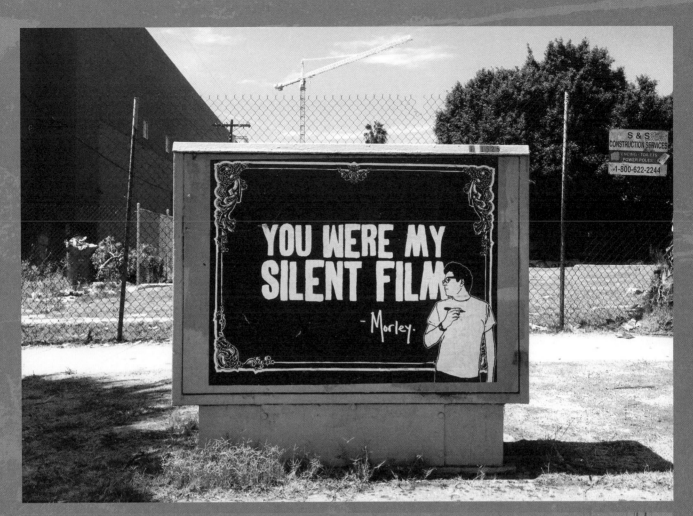

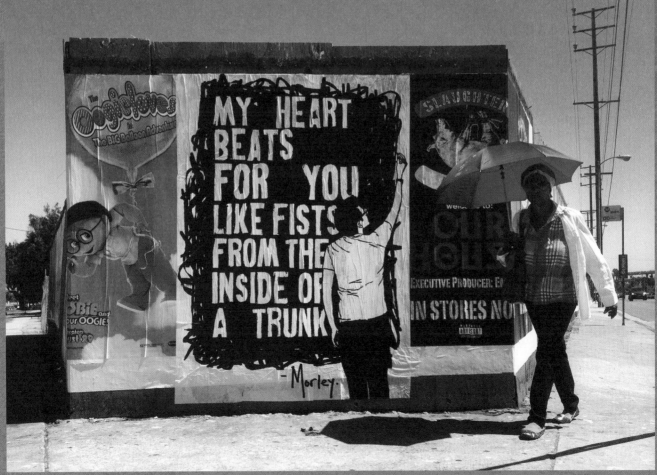

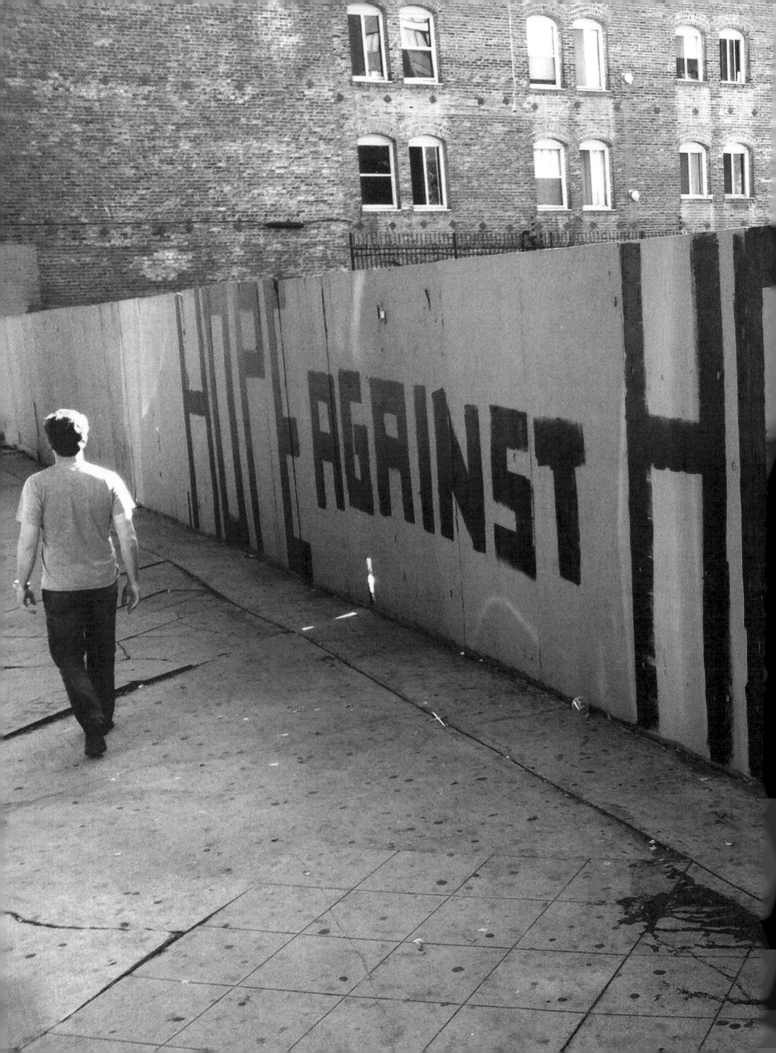

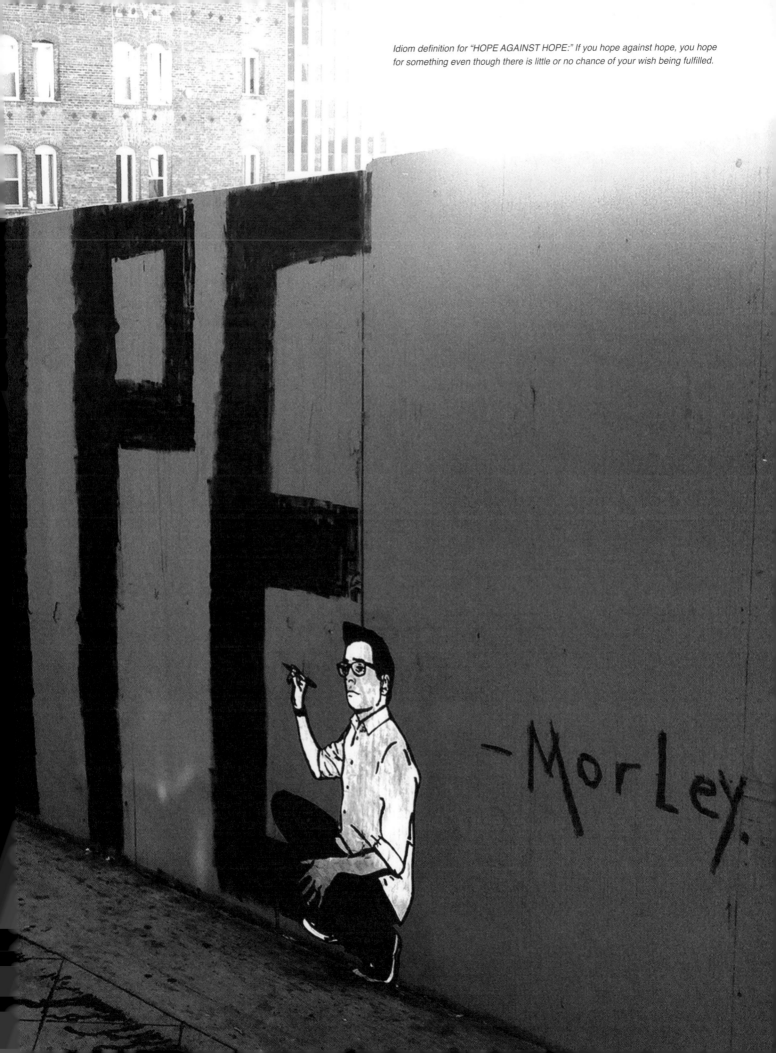

Idiom definition for "HOPE AGAINST HOPE:" If you hope against hope, you hope for something even though there is little or no chance of your wish being fulfilled.

−Morley.

WORKADAY

I put this piece up inside an out-of-business gas station. From age fifteen to nineteen, I worked in a series of gas stations and enjoyed all of an accumulative thirty seconds of it. Obviously, there are worse jobs in the world, but something about this job seemed to typify the future I would do anything to avoid. The mirror next to the poster was like that when I got there. At first, I was amused by a sentiment in such sharp contrast to the "It Will Get Better" mirror piece I had put up months prior. And then it dawned on me that maybe it's not dissimilar at all. As I looked at the poster I had just put up and the expression of tedium one feels wading through days that seem to last forever, the image of me working at a gas station, doing my best to whittle away each hour, appeared in my head. At the time, it never occurred to me to "just quit." It never occurred to me to do something proactive to change my situation, to play more of a role in my life's improvement. In that context, the notion is actually kind of challenging. Take a leap; it just might make all the difference.

THE DAYS OF THE WEEK ALL FIGHT TO THE DEATH, HOLDING ON TO THEIR DREAMS OF LASTING FOREVER.

- Morley.

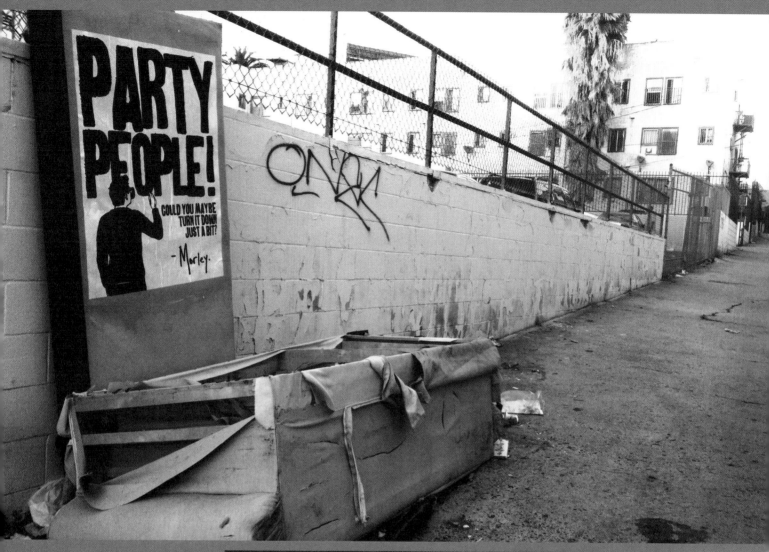

In case it wasn't obvious, the first line of this poster (*above*) was meant to be read in the style of the intro for the 1993 single "Whoomp! (There It Is)" by Tag Team.

The second line is to be read in the style of a thirty-one-year-old man who's annoyed by a ruckus in a neighboring apartment while trying to paint Warhammer figures.

It takes concentration, okay?!

(right) San Diego Comic-Con, 2013

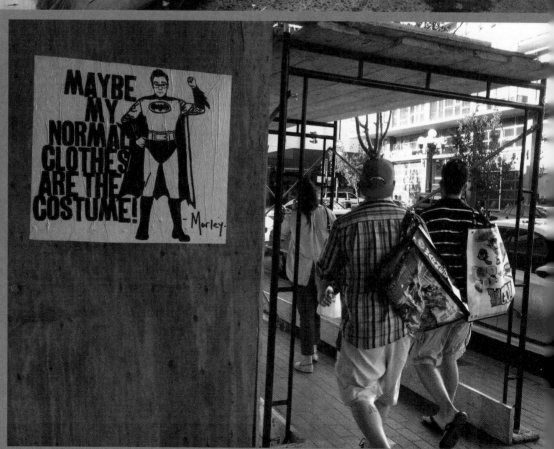

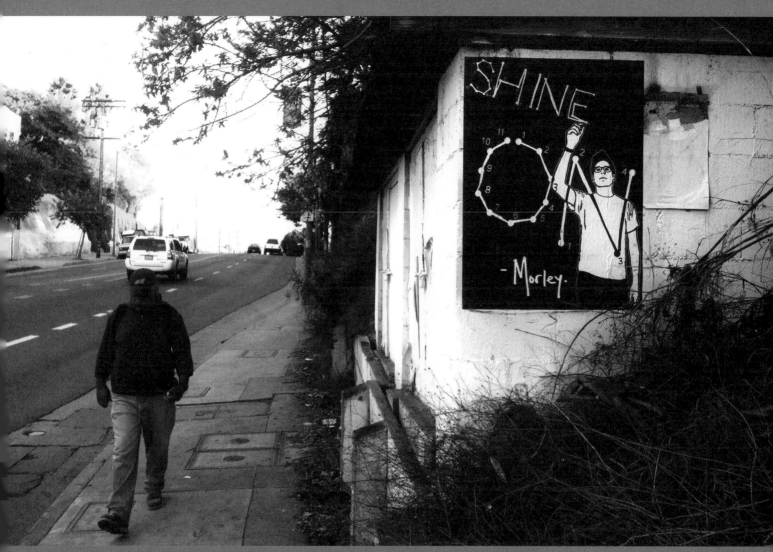

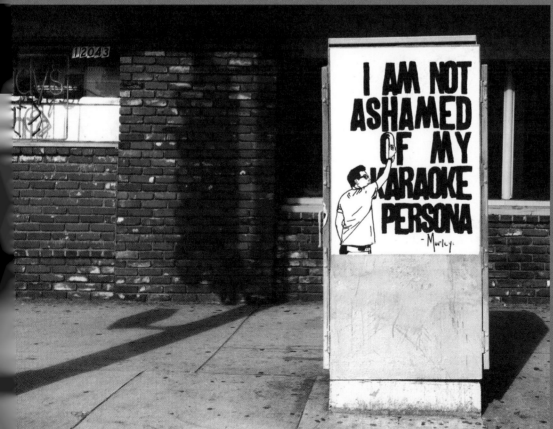

Look, if you didn't want me on stage imagining that I'm singing for hundreds of thousands of screaming fans, then you shouldn't have had "Lips of An Angel" by Hinder on your list of song choices!

What was the most dangerous and adrenaline-pumping night you have had putting up street art?
—Wesley Hostetter

My first night doing it. When you start, your adrenal gland assumes that your local police department is like the SS in an old World War II movie: always watching, waiting to close in on you and demand your papers. After a few missions, you start to realize that for the most part, you're a pretty small potato to them.

Now and again, I still get a rush if a spot seems challenging. But then, I don't really judge my spots on whether they will impress other street artists, so none of them are necessarily as ballsy as some of my contemporaries' greatest hits. When I'm actually putting the poster up, I'm kind of in the zone. It's usually not until I've just left a spot and notice a cop driving by that I appreciate the buzz of a close call.

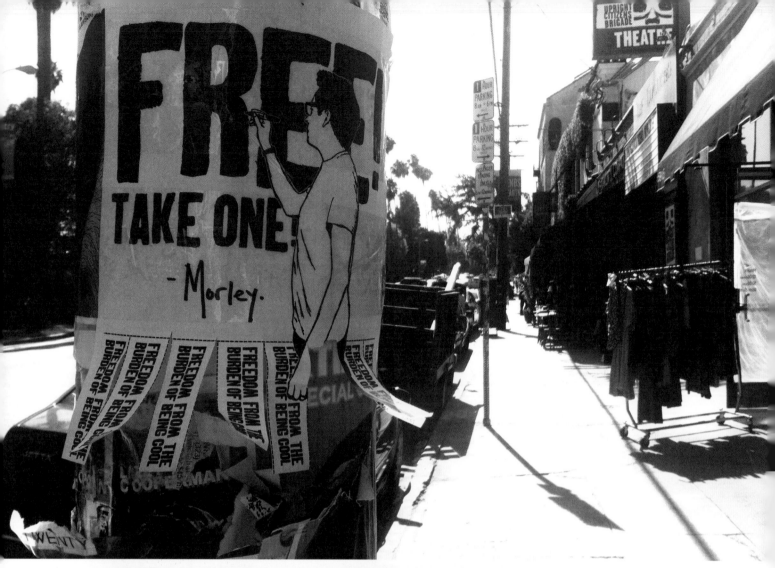

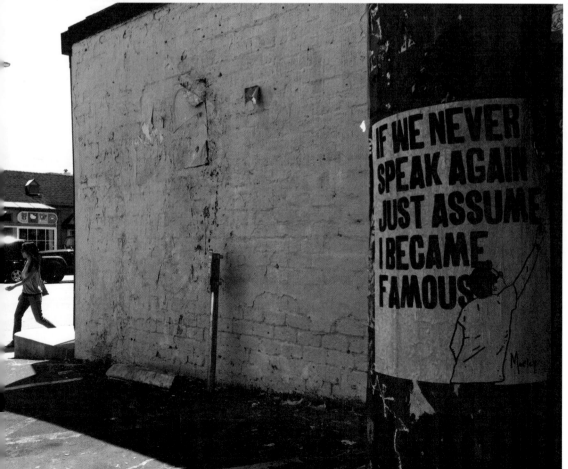

To me, the coolest person in the room is always the one who least needs validation from someone else's mercurial definition of "what's cool."

The kind of people I admire are the ones who don't wait for someone to tell them when it's okay to like themselves.

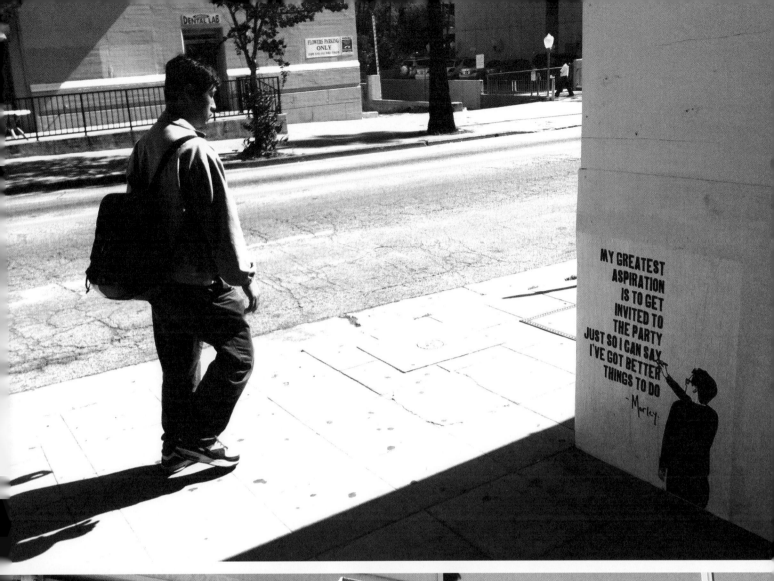

MY GREATEST
ASPIRATION
IS TO GET
INVITED TO
THE PARTY
JUST SO I CAN SAY
I'VE GOT BETTER
THINGS TO DO
-Morley.

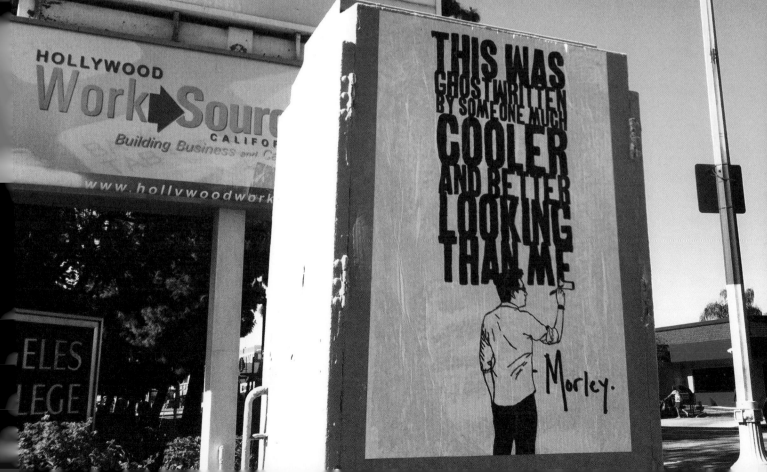

THIS WAS
GHOST WRITTEN
BY SOMEONE MUCH
COOLER
AND BETTER
LOOKING
THAN ME

Morley.

LONDON CALLING

In May of 2011 I was invited by The Outsiders to travel to London, where I would sign my first run of screen prints to be sold. This would give me the exciting chance to do some international posturing, which I jumped at with vigor. Once I had arrived I was told that Steve Lazarides was keen on me working in their studio to make a few one-of-a-kind, hand-finished prints. Perhaps this would be no big deal for anyone not already convinced that he had no business calling himself a contemporary of the other artists on The Outsiders' roster, but I immediately seized up with anxiety. When working from home, there is no pressure. No one expects me to create anything of value, so if I stumble upon something, it's a pleasant surprise. Now I was feeling like I'd just told someone I'd read a book that I hadn't just to impress them, only to have them ask what my favorite part was. Unsure of just what they were expecting, I spent hours second-guessing what exactly I should do to hand-finish the prints that might impress them.

As the night wore on, I was visited by visions of Stanley Donwood, Paul Insect and Blu. "Radiohead would have laughed at me if I gave them THAT for an album cover!" Stanley would say. "Oi! Let's see if Brad Pitt wants to buy that!! Not likely! HA!" Paul would chortle. "If I painted that on the side of a building, the city would tear the building down and they'd be RIGHT TO DO IT!" Blu would sneer in Italian that none of us would understand but whose tone would speak volumes. The following day Steve Beale, The Outsiders' new business director looked over what I had done.

"These look fab," he said casually, as though it was no big deal. "Oh, cool" was all I could muster as a heroin-like wave of relief washed over me. Back at The Outsiders' gallery, I took a seat as a family walked in to have a look around. Steve mentioned to the father that "this print was hand-finished by the artist," and pointed to a print on the wall. "He painted that orange part." I couldn't believe it.

What the hell had I been so worried about?! I wanted to scream at the visions of Donwood, Insect, and Blu "YOU JERKS GOT ME ALL FREAKED OUT FOR NOTHING!" to which they'd shrug and explain, "Uh, we're just figments of your own cruddy self-esteem, what the hell do we know?"

At this point I was happy to have some time to walk around London and check out the shops. This was to be the height of my good mood. I'd passed a test, would leave the following morning, and so the possibility of really embarrassing myself was getting slimmer and slimmer. I walked into a Starbucks for a little taste of home. I don't drink coffee, but I enjoy the Bucks' hot chocolate. I got myself a grande and stepped back out into the London streets. "Everything is going to be okay!" I thought as I began to come down from my relief high.

It was then that it hit me just how badly I needed to take a leak. With all the excitement, I'd neglected my bladder for about eight hours and now my body threatened to start crying urine if I didn't disencumber myself. I found a small café and ducked inside the restroom. Inside it was pretty gross. There were two urinals and a single stall with a man inside taking the loudest dump of his life.

I thought for a moment and decided that this was indeed the very last place I wanted to set down a grande cup of hot chocolate, as though the fecal grime would seep it's way through the cup and into the chocolaty goodness. Plus there was really no place to set the cup anyway. Still—I had to relieve myself. I decided that I would hold the cup with one hand while using the urinal with the other.

I unzipped and began to urinate. So far my plan had worked perfectly—until another man entered the small bathroom. He walked to the urinal beside me and began using it. I had finished peeing but was suddenly struck by the realization that I could not zip up and button my pants with one hand. Releasing the button and zipper was fine, but buttoning them back up might prove difficult, and now I had a man standing beside me to whom I would risk exposing myself. I decided to put the rim of the cup in my mouth and balance it on my chest. I only needed a couple seconds, after all. A couple seconds was all that fate needed, as almost immediately the cup slipped from my mouth and began falling to the ground.

I instinctively reached to catch the cup with my hand, but instead I accidentally just smacked it toward the wall. The cup hit the wall in front of me and exploded. Hot chocolate splattered the walls, my face, and all the way down to just below my crotch. I was stunned for a moment before realizing I should probably put myself away and zip up, so I did. The man at the urinal next to mine turned to me. "Ahh, I should have known that would happen," I said, my face, dripping. The man just turned and walked away. I looked around for paper towels, but alas all I could find was an electric hand dryer. The man in the stall who had been crapping his brains out came out and gagged. I realized that finding the walls of a bathroom dripping with brown liquid, he must have feared the worst—that someone's atomic diarrhea had some how hosed itself all over the walls and my face. "It's not what you think," I said. "What is it then, sick?" he asked. The image of me projectile vomiting all over the bathroom made me smirk. "Oh no, it's just hot chocolate," I said. "Did someone bump into you?" he asked. "Yes. Yes that is exactly what happened," I said, thinking that his explanation was a much better one than "I honestly thought I could hold a cup with my teeth while I put my junk away after peeing."

After cleaning up my mess, I ducked out of the café stealthily. I still needed to retrieve my poster tube and glue bucket from The Outsiders' gallery. With my jacket off, the only part of me still wet was my crotch.

Perfect.

I jogged into the gallery and waved to Scarlet, the curator who, of course, had to be attractive and hip and exactly the kind of girl who would have been too nice to outright reject me when I was single but would say: "Oh sorry, my phone's not working right now. How about instead of me giving you my number, you give me yours and I'll totally call you to go out sometime," only to never be heard from again. I quickly grabbed my stuff and ran out, looking, I'm sure, as if I'd stolen something, and all the while pulling the bottom of my t-shirt down to cover my stained crotch.

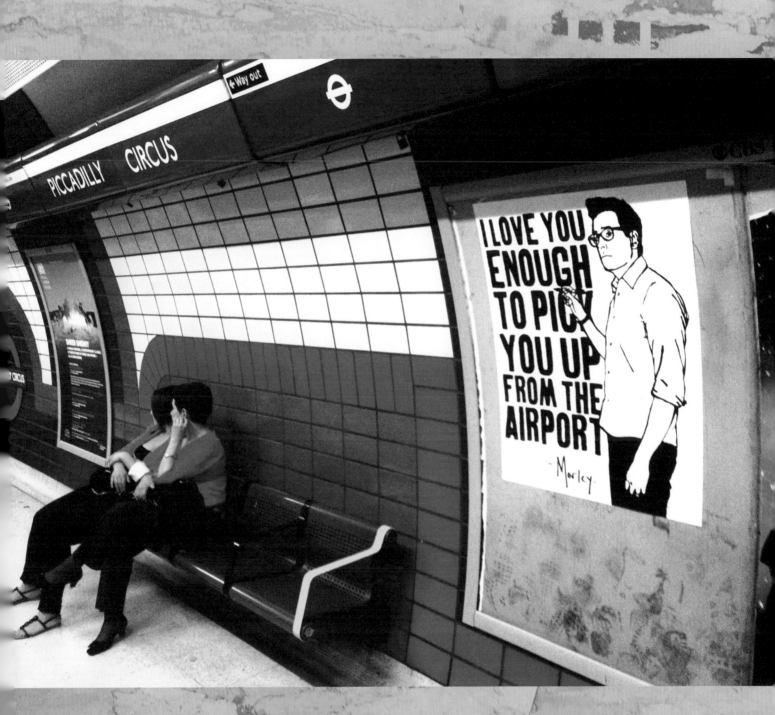

While I could see this only as another in a long line of mortifying experiences, I choose to take a more positive outlook and appreciate the fact that things like this keep me humble—and humility is what keeps an artist relevant. As I look at my favorite bands, directors, or visual artists, with very few exceptions, it was always the moment that they started buying into their own hype that their art suffered.

The moment that fame and money and success became their focus, they lost touch with what it was like to be a normal person.

What gives a person the right to speak about loss, rejection, heart-break, and struggle if they've forgotten what it was like to actually experience those things? Sure, I frequently wish I was the super cool, charming artist that could get someone like Scarlet's number, but the truth is, I am actually the kind of guy who spills hot chocolate all over himself in the bathroom of a café, and to be honest, if my work has any level of significance, it's because of that. So thank you, God, for making me such a clumsy oaf. If a slapstick-style humiliation keeps me more in touch with my own frail humanity, then so be it. I'll just learn to turn to the camera and wait for the tuba to echo "wah wah waaaaaaaah."

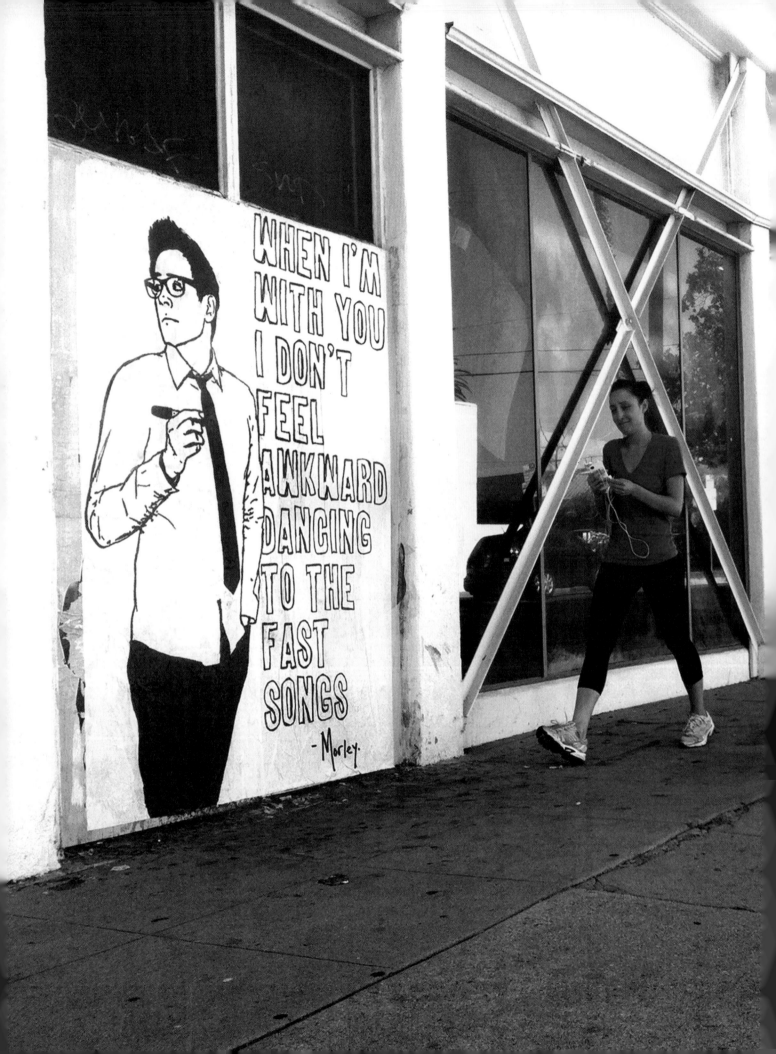

What's your least favorite question to answer about your work?
—Brenna Hitt

I don't really have a least favorite question. I'm usually just happy to be asked anything at all. That said, being asked who my favorite artists are can be nerve-racking.

Usually, I feel the same panic listing them as when someone looks through my iPod. I'm always worried that people are silently judging me. I always want to yell, "UHH—I ONLY LISTEN TO 'PARTY IN THE U.S.A.' BY MILEY CYRUS IRONICALLY!"

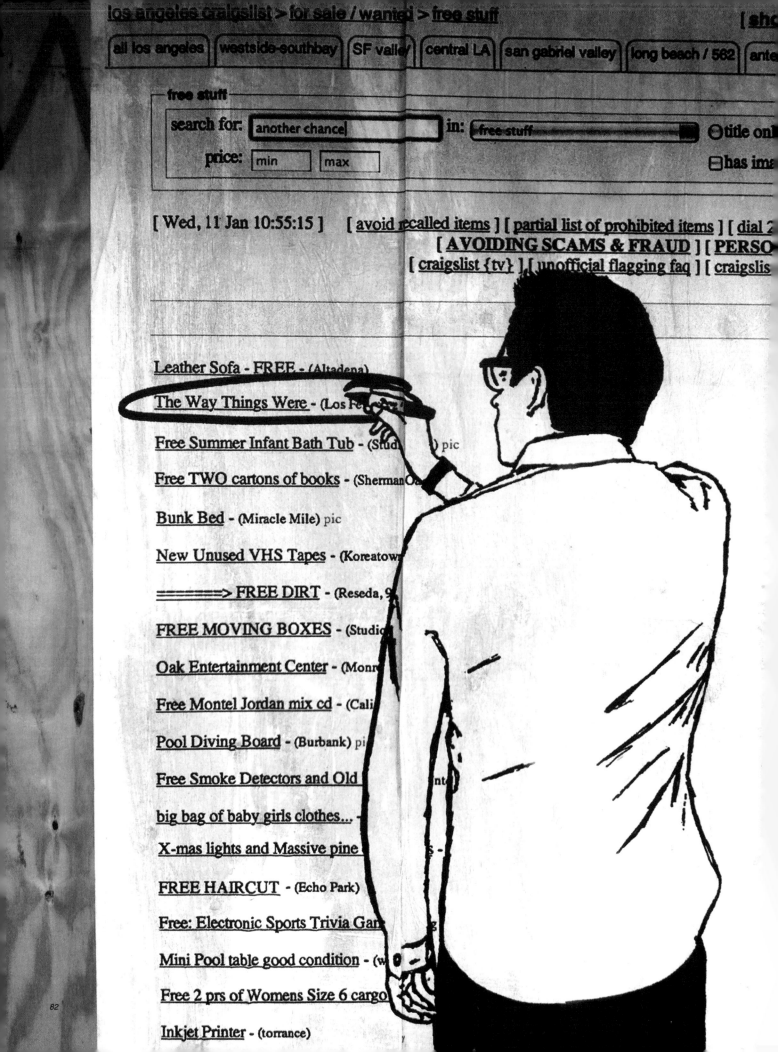

all los angeles | westside-southbay | SF valley | central LA | san gabriel valley | long beach / 562 | ante

free stuff

search for: another chance| in: free stuff ◯ title onl

price: min max ⊟ has ima

[Wed, 11 Jan 10:55:15] [avoid recalled items] [partial list of prohibited items] [dial 2

[AVOIDING SCAMS & FRAUD] [PERSO

[craigslist {tv}] [unofficial flagging faq] [craigslis

Leather Sofa - FREE - (Altadena)

The Way Things Were - (Los Fe

Free Summer Infant Bath Tub - (Stud) pic

Free TWO cartons of books - (Sherman Oa

Bunk Bed - (Miracle Mile) pic

New Unused VHS Tapes - (Koreatow

======> FREE DIRT - (Reseda, 9

FREE MOVING BOXES - (Studio

Oak Entertainment Center - (Monr

Free Montel Jordan mix cd - (Cali

Pool Diving Board - (Burbank) pi

Free Smoke Detectors and Old

big bag of baby girls clothes...

X-mas lights and Massive pine

FREE HAIRCUT - (Echo Park)

Free: Electronic Sports Trivia Gan

Mini Pool table good condition - (w

Free 2 prs of Womens Size 6 cargo

Inkjet Printer - (torrance)

please flag with care: [?]

miscategorized

prohibited

spam/overpost

best of craigslist

The Way Things Were (Los Feliz)

Date: 2012-02-20, 11:58AM PST
Reply to: sgpzs-2861504802@sale.craigslist.org [Errors when replying to ads?]

FREE:

The Way Things Were. Before it all got screwed up and confusing. Back when things made sense and people asked you what you wanted to be when you grew up. Back when the little pleasures made you happy and satisfied. Like hearing the song you dedicated to the girl you never had a chance with playing on the radio and looking at fake nude pictures of Julia Louis Dreyfus on America Online. Back when singing along with Pearl Jam in front of the mirror and imagining it was actually you at the 8th grade talent show could occupy you for hours. Back when you thought that the worst thing that could ever happen to you was summer school or discovering the girl you never had a chance with making out with your best friend at a party. Back when dreams weren't dreams but options to pick from. Back when listening to hip-hop music tricked you into thinking you were tough. Back when 2AM was a mysterious and magical time where anything could happen. Back when you knew- not hoped- KNEW that if you ever met Quentin Tarantino, he'd see something special in you and become a close friend and be really impressed by your short stories. Back before you thought trying stand-up comedy was a good idea. Before that terrible open mic night left you wondering if there was anything in you that could ever be loved or even liked. Back when taped up pages from Rolling Stone and NME was an appropriate way to decorate a bedroom. Back when you had to wait until you got home to see if anyone had called. Back when a 15 pack of blank cassettes was a great Christmas present. Back when you would spend half the night making a mix tape for the girl you never had a chance with, each song filled with not-so-subtle messages that you hoped would inspire her to fall madly in love with you. Before she said it made her uncomfortable and you played it off, saying that you just thought she'd like Mazzy Star's "Fade Into You" because it's a great song and that she shouldn't flatter herself. Back when teachers were all evil dictators who only took the job to lord their power over you and make you look stupid by calling on you to answer a problem on the board when you hadn't even raised your hand. Back when the cots in the nurse's office were the most comforting place of refuge from P.E. Back when you could consume almost nothing but Mt. Dew and Cool Ranch Doritos and not gain a pound. Back when you weren't sure they could ever make a game that was better than Super Mario Brothers 3. Back when you thought that tips from Maxim Magazine would actually help you seduce women someday. Back when you never bothered telling your mom that you loved her because she'd always be there and besides she probably knew anyhow. Back when you didn't understand why you should have to read old ass boring crap by Emily Bronte when there's so many better books written THIS century that you could be reading. Back when you could call the girl you never had a chance with and hang up after she said hello and wouldn't know it was you because you star 67'd yourself. Back when you wondered if they would really have flying cars in the future. Back when you never worried that you could die without ever having actually done anything with your life or made any kind of impact. Before even the concept of a legacy entered your mind. Before you ever had to seriously consider the idea of bringing a child into this world and putting him through all the same stuff. Back when things were what they were and nothing more and that was okay. Back then. Back then. Back then.

Pick up ASAP. Need it gone, it's taking up space.

- Location: Los Feliz
- it's NOT ok to contact this poster with services or other commercial interests

PostingID: 2861504802

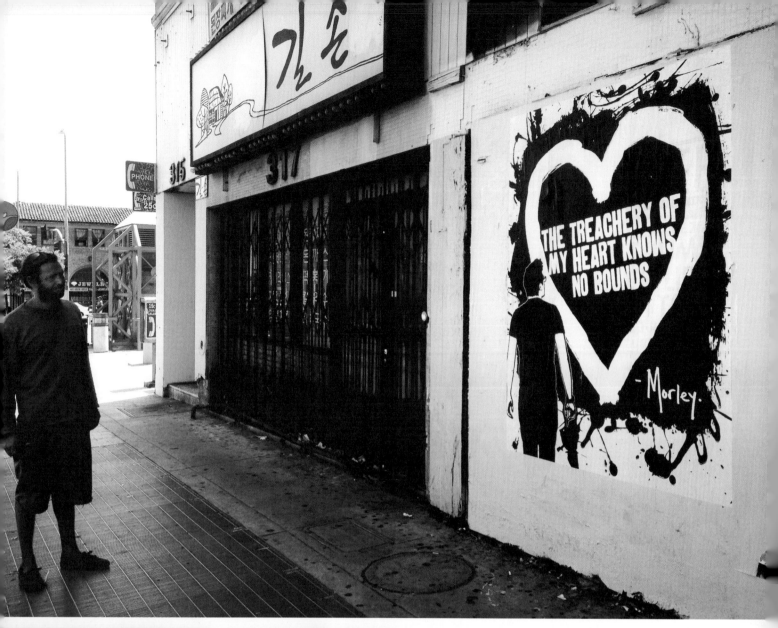

HINDSIGHT

I have a chronic problem with remembering events not by how they happened but by how they felt. Looking back, my recollection shifts dialogue and weather, adds a score and enhances sensory details like textures, sounds, and scents. It gives each scene epic scope and breadth. It adds slow motion and photoshops away acne or excess weight. All this to match the significance that a moment holds only in hindsight. My first kiss. The first time my heart was really and truly broken. Brief moments of pride and confidence scattered amongst an adolescence forever searching for a skin I might find comfort in. Each triumph and each tragedy plays like a scene from a movie, only edited and tweaked for optimal dramatic swelling and tension. Do the people who populate these moments with me share the same synaptic director? While I may have inserted a song by the band Explosions in the Sky over the memory of walking in a moonlit field with her hand held in mine, she may have decided that the theme from Benny Hill was more appropriate. Maybe to her, that moment held no significance outside of some innate hilarity that I failed to notice.

As I get older and the events that shaped me lag farther behind, I start to lose track of what I've embellished to what was factual. Like a dream upon waking, the details become fuzzier and the colors that painted me in broad strokes as a hero or a victim blur into the scenery. While this may simplify my past, it makes it less trustworthy when translating it into my art. But really, what is artistic expression if not a collection of feelings contorting facts? A love song may not be the most accurate historical account of a relationship, but in its own way it could still be the most honest.

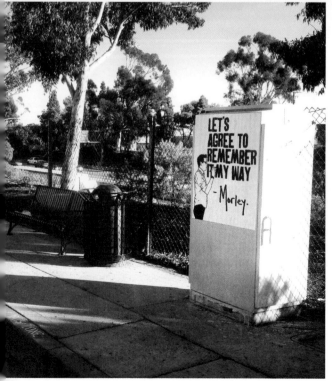

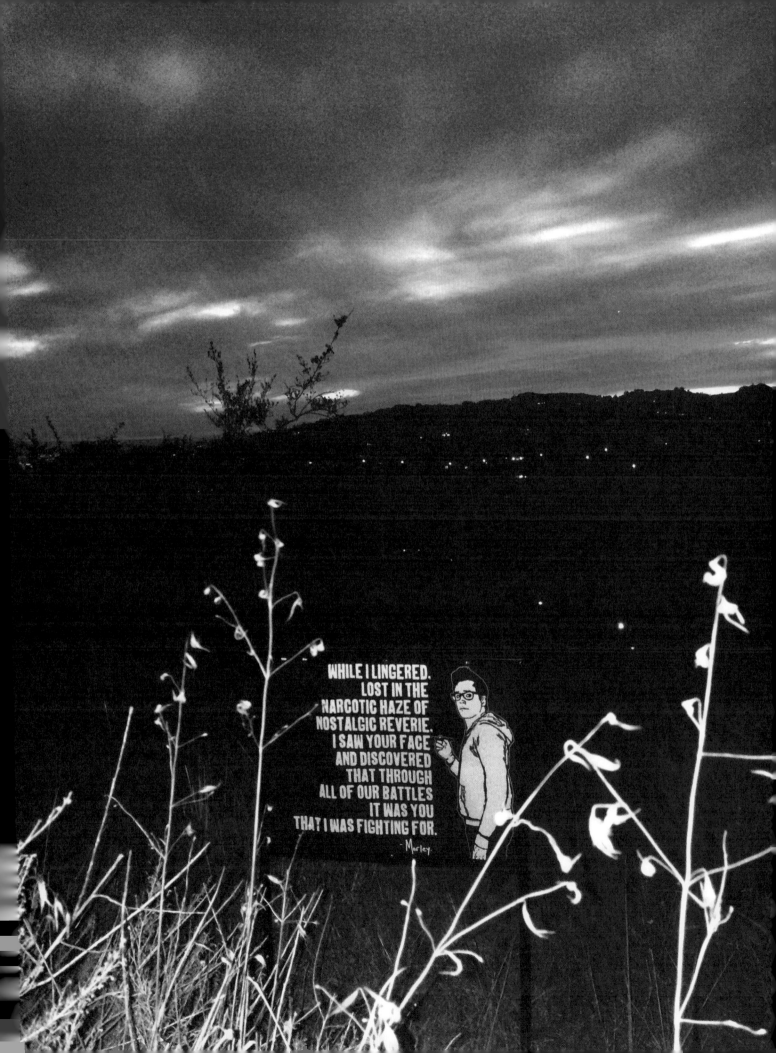

WHILE I LINGERED.
LOST IN THE
NARCOTIC HAZE OF
NOSTALGIC REVERIE.
I SAW YOUR FACE
AND DISCOVERED
THAT THROUGH
ALL OF OUR BATTLES
IT WAS YOU
THAT I WAS FIGHTING FOR.

- Marley

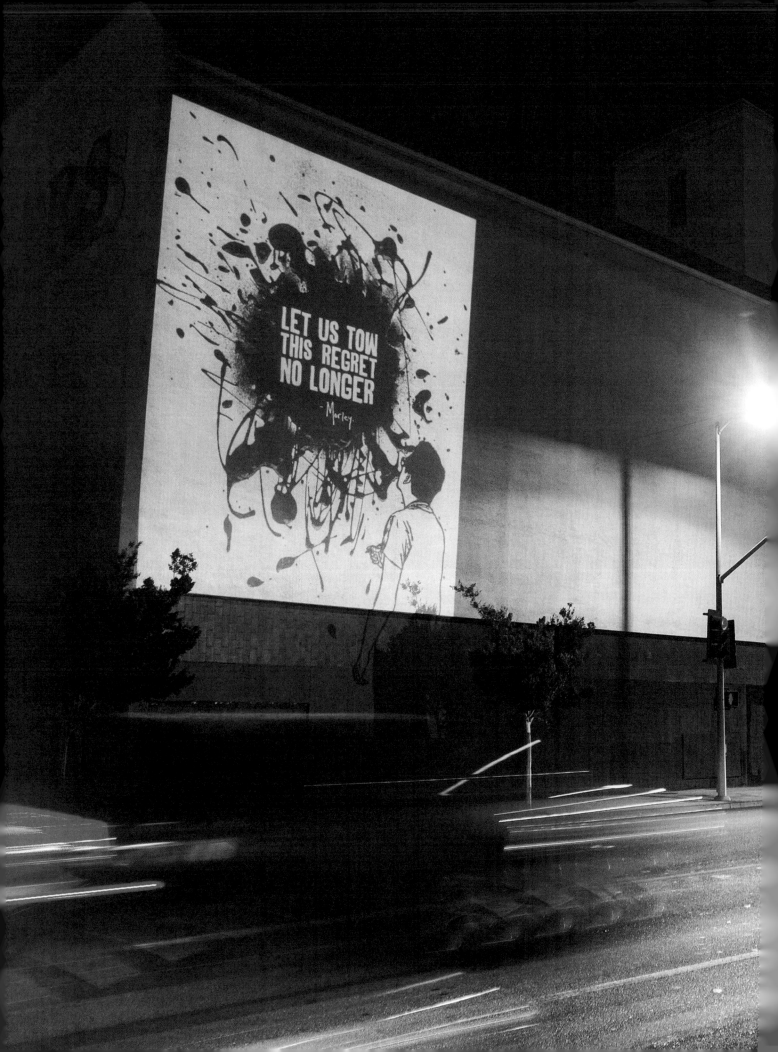

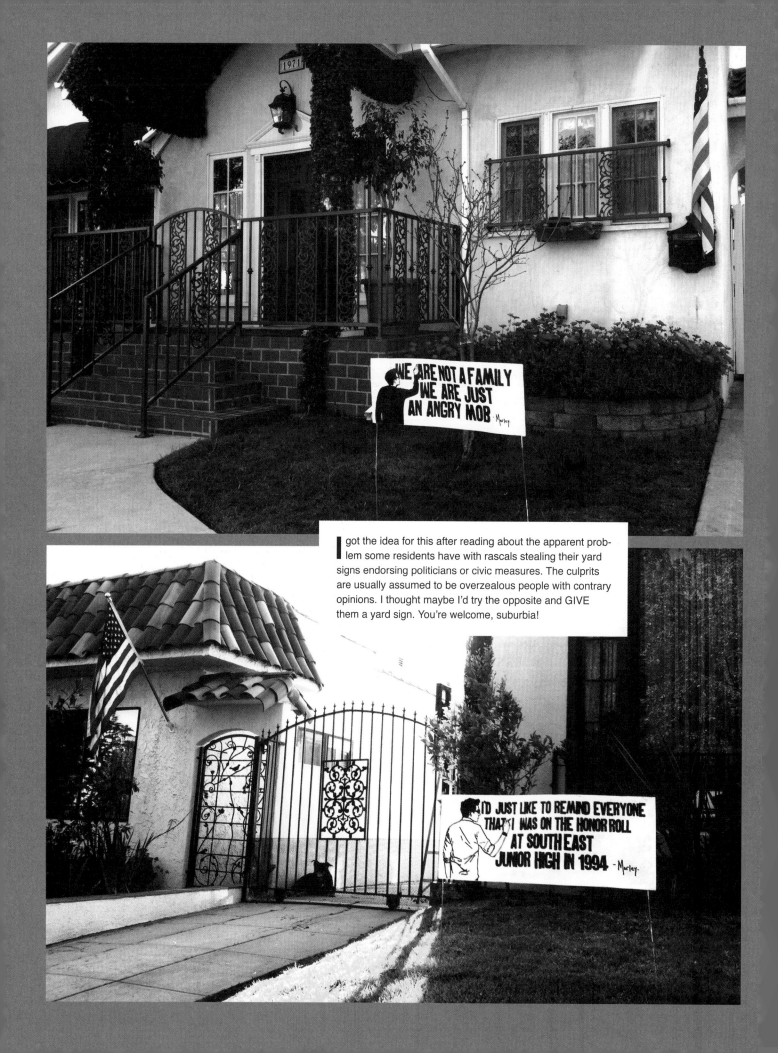

I got the idea for this after reading about the apparent problem some residents have with rascals stealing their yard signs endorsing politicians or civic measures. The culprits are usually assumed to be overzealous people with contrary opinions. I thought maybe I'd try the opposite and GIVE them a yard sign. You're welcome, suburbia!

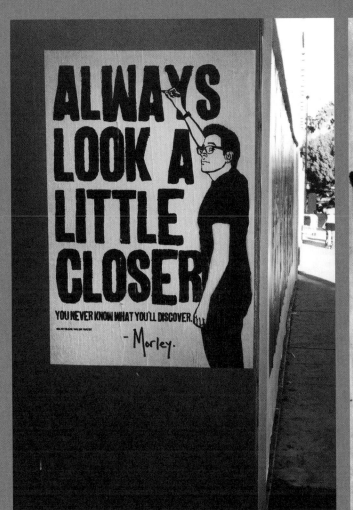

ALWAYS LOOK A LITTLE CLOSER

YOU NEVER KNOW WHAT YOU'LL DISCOVER.

— *Morley.*

YOU NEVER

WELL, NOT THIS CLOSE, YOU'LL HURT YOUR EYES!

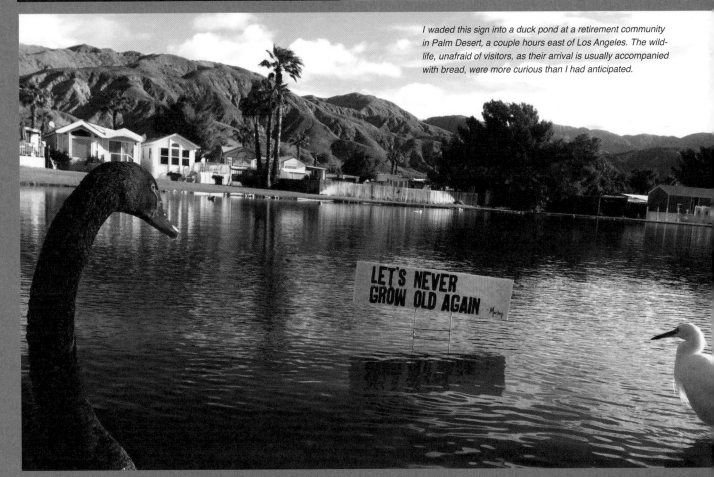

I waded this sign into a duck pond at a retirement community in Palm Desert, a couple hours east of Los Angeles. The wildlife, unafraid of visitors, as their arrival is usually accompanied with bread, were more curious than I had anticipated.

LET'S NEVER GROW OLD AGAIN — *Morley*

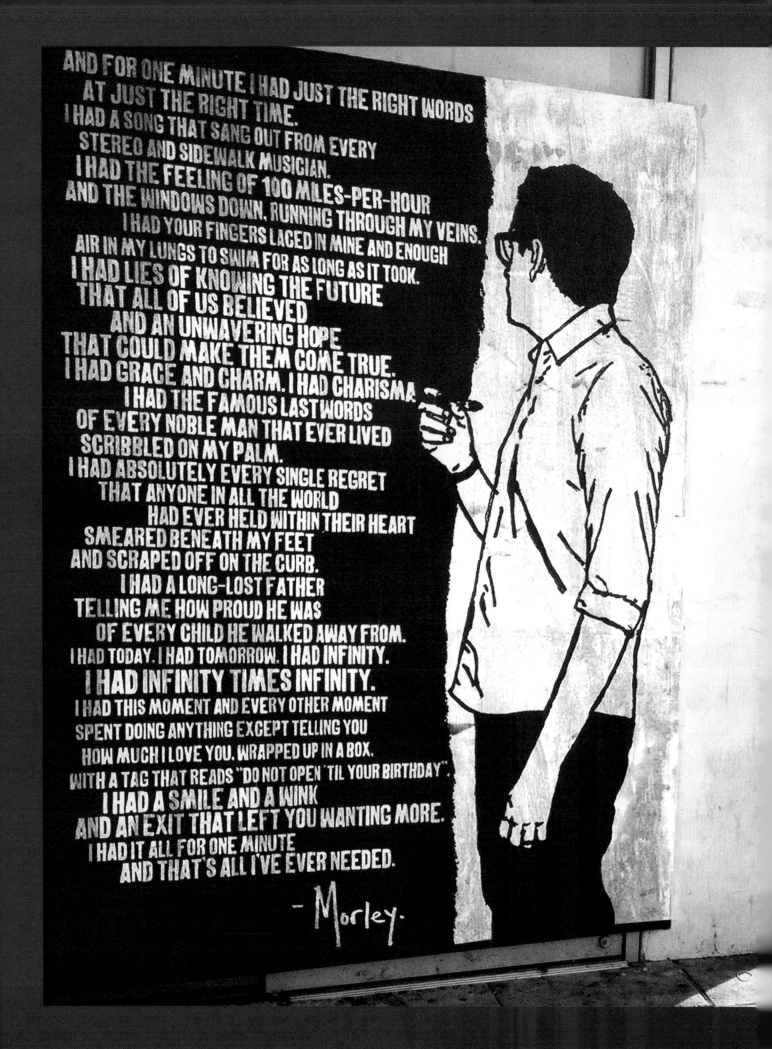

After putting this piece up, I left to stow my bucket and brush in the car. When I returned to take a photo, I noticed a woman standing in front of it. She quietly gazed at it for a moment before waving her hand dismissively, exclaiming, "Damn, I'll read that shit later!" walking away.

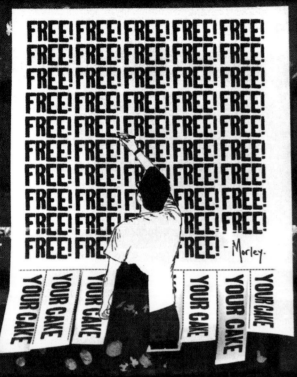

FREE! FREE! FREE! FREE! FREE!
FREE! FREE! FREE! FREE! FREE!
FREE! FREE! FREE! FREE! FREE!
FREE! FREE! FREE! FREE! FREE!
FREE! FREE! FREE! FREE! FREE!
FREE! FREE! FREE! FREE! FREE!
FREE! FREE! FREE! FREE! FREE!
FREE! FREE! FREE! FREE! FREE!
FREE! FREE! FREE! FREE! FREE!
FREE! FREE! FREE! FREE! - Morley.

YOUR CAKE · EAT IT TOO

HARP TUITION

RHODRI DAVIES
lus (Hons) MA PGcertTCM

on Concert and Clàrsach harps.
teen years of teaching experience

Tel: 0191 491 1459
Mobile: 07946 423 627
daviesrh@gmail.com

TREES FOR AFRICA
where trees mean life

BFI Mediatheque
Discovery Museum, Newcastle

Explore a wealth of free film and TV
from the BFI National Archive
bfi.org.uk/mediatheque

love architecture
festival 2012

15—24 June 2012

In Africa, the answers to
poverty grow on trees...

In Africa, the answers to
poverty grow on trees...

HEARTBREAK
productions
open air theatre at its best

CRAZY DEVIL
Little
Age Doesn't Matter

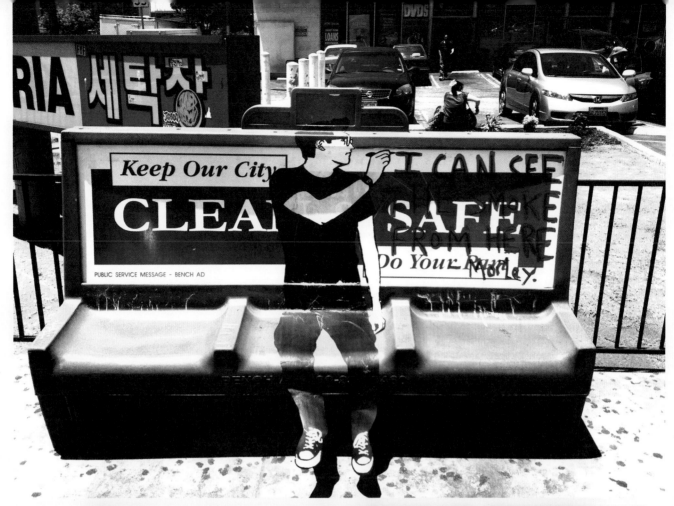

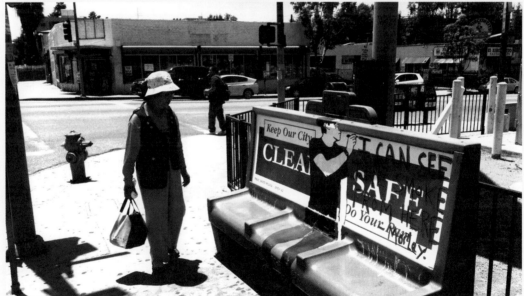

BURN

When the wildfires hit Los Angeles a few years back, it was unnerving to look up to the Hollywood sign, an iconic symbol of our home, and see flames and billowing clouds of black smoke just to the right of it. And yet, people kind of just went about their business. Few could be bothered to even stop and notice. I was in college on September 11th, 2001. My dorm was two miles from the Towers. That was my first real experience with black clouds of smoldering ash. Not that the two can be compared on any level other than an aesthetic one, but it seems to be a curious phenomenon, that moment when a society decides to move on and return to some form of functioning normality.

One might say that this practice is not strange at all, and in fact is done on a daily basis. The only difference is the distance of the clouds. Bombs explode in far-off lands, children starve to death, entire races and genders are marginalized and abused. We choose to proceed with life despite these things, as well as any number of travesties that are right in front of our faces because...well, because we have to. Reconciling this can be difficult for some and frighteningly easy for others. Life goes on, regardless of what's burning around us. This fact exemplifies both our resolve and our apathy in equal measures.

MAKE YOUR OWN
MORLEY
PAPER DOLL

DRESS HIM IN HIS FAVORITE OUTFITS!

INSTRUCTIONS:
CUT OUT MORLEY, THEN EACH OUTFIT.
PLACE THE OUTFIT OVER MORLEY AND
FOLD THE GREEN TABS BEHIND HIM!

NOTE: THESE DOLLS CONTAIN
ABSOLUTELY NO VOODOO POWER AND
CAN IN NO WAY BE USED TO FORCE
MORLEY TO DO A SILLY DANCE DURING
AN IMPORTANT JOB INTERVIEW!

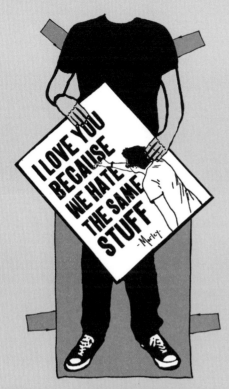

**WHEATPASTE
MORLEY**

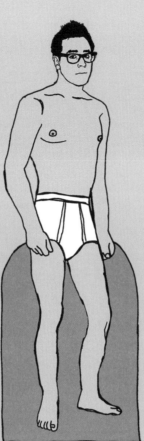

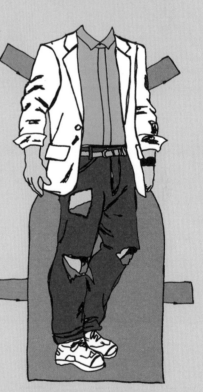

MASCOT MORLEY

**RELAXING AT HOME
MORLEY**

**PSYCHED-TO-FINALLY-
SEE-ACE-OF-BASE-IN-
CONCERT MORLEY**

FIRST-DATE MORLEY

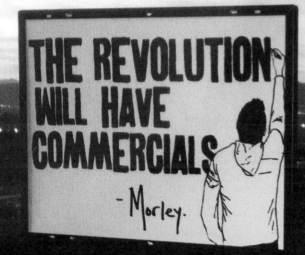

This revolution is brought to you by Pepsi, the choice of a new generation.

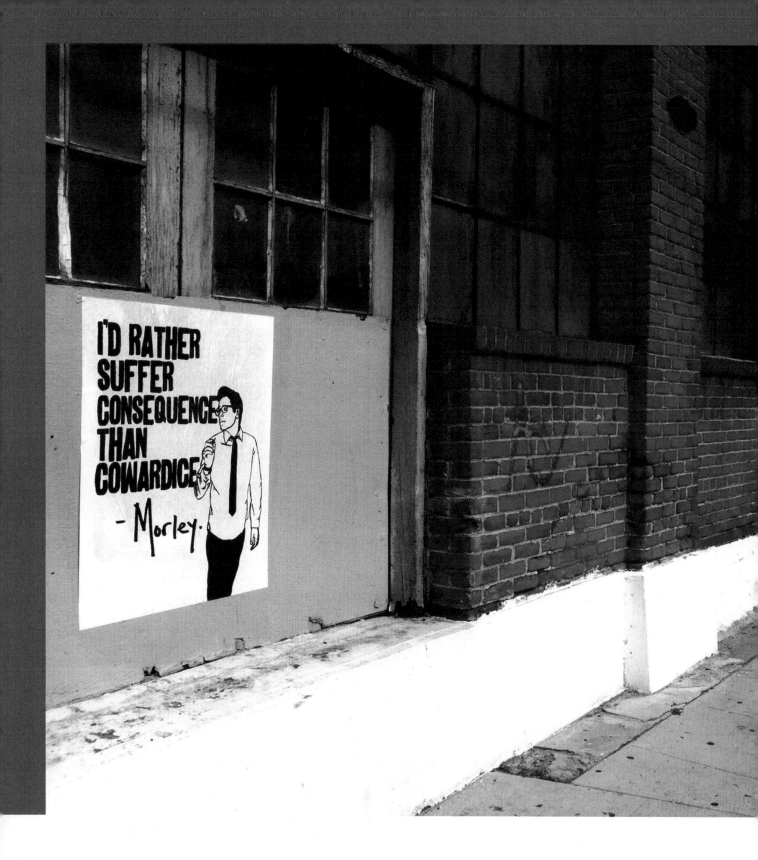

"All men dream, but not equally. Those who dream by night in the dusty recesses of their minds, wake in the day to find that it was vanity: but the dreamers of the day are dangerous men, for they may act on their dreams with open eyes, to make them possible."

—T. E. Lawrence

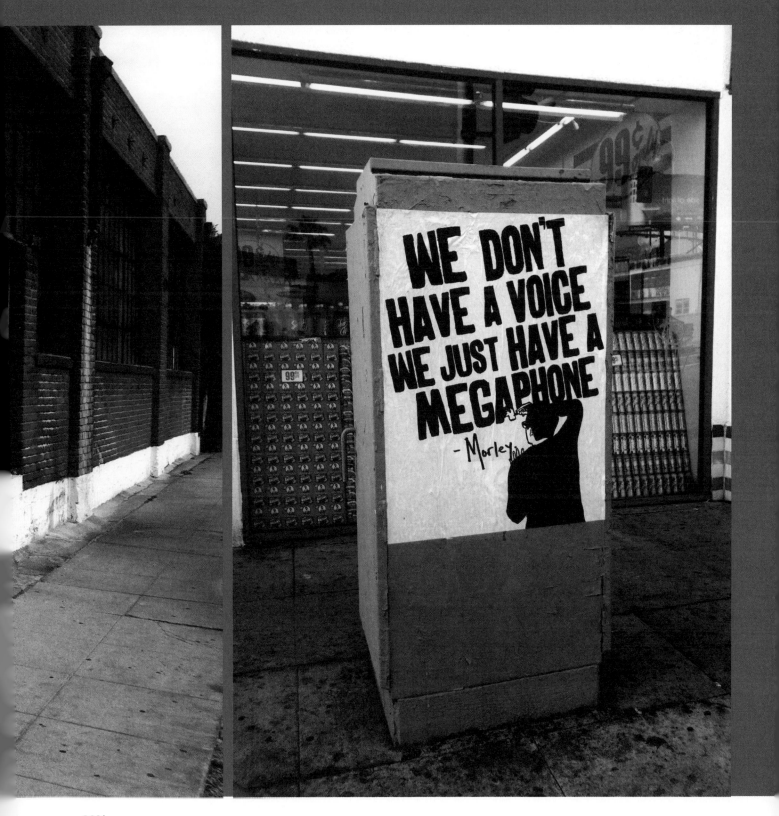

99%

As a rule, I stay away from politics in my work. It's not that I'm indifferent to the variety of important issues that face our world on a daily basis; I'm just turned off by the polarizing effect the current political climate has on people. These days, even wearing just one political belief on your sleeve dictates how people perceive who you are as a human being, how you feel on every other issue, and the level of disdain you hold for everyone else who has the opposing opinion. My goal has always been to speak to people in a way that won't divide or segregate based on who and what I vote for.

I adjusted this rule a bit when the Occupy movement captured the nation's attention. While I was hoping to show some sign of solidarity, I didn't want to become a stereotype. Having always admired the progressive intentions of the sixties, I wanted to encourage my peers to embrace what could possibly be their only moment in front of the mic—to speak and to make their words count; to be heard and to say something worth hearing. Looking back now, I wish I had encouraged this a little harder.

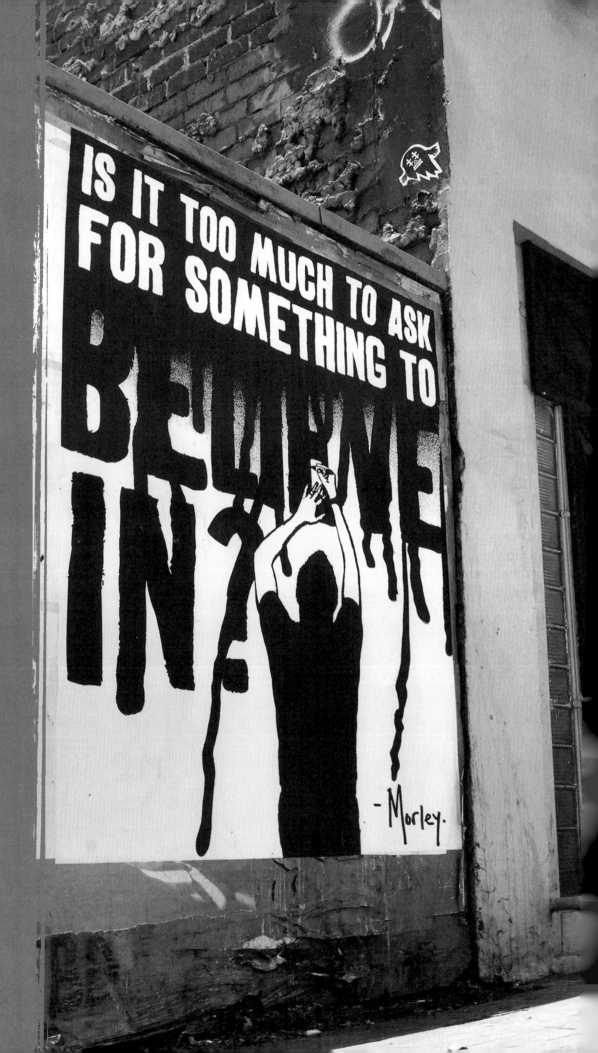

IS IT TOO MUCH TO ASK FOR SOMETHING TO BELIEVE IN?

—Morley.

Is it frustrating to see your work covered up or taken down? —David Serrano

It can be bittersweet, but I do my best to trust that my messages stay up only as long as they need to, and the people that needed to see them had the chance. There's something singular about the temporary nature of street art. The fact that someone might see something of mine that's gone the following day gives an immediacy to the moment that's kind of wonderful. If it helps them to see the world for all its fleeting beauty, that's all the consolation I need.

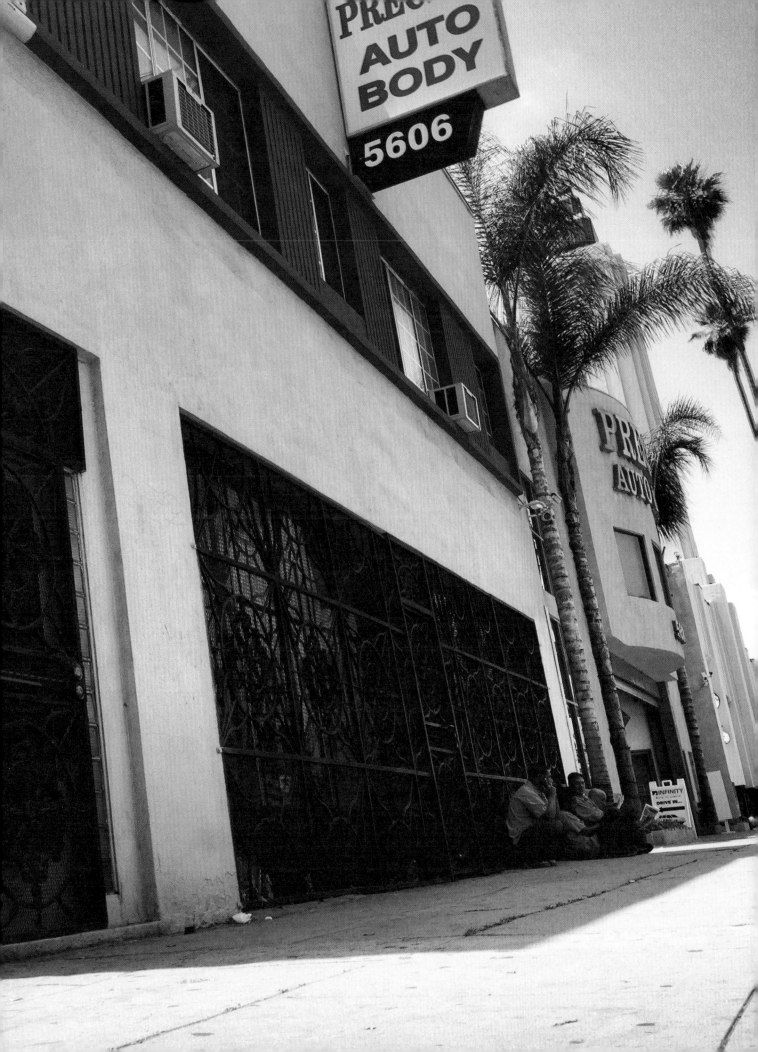

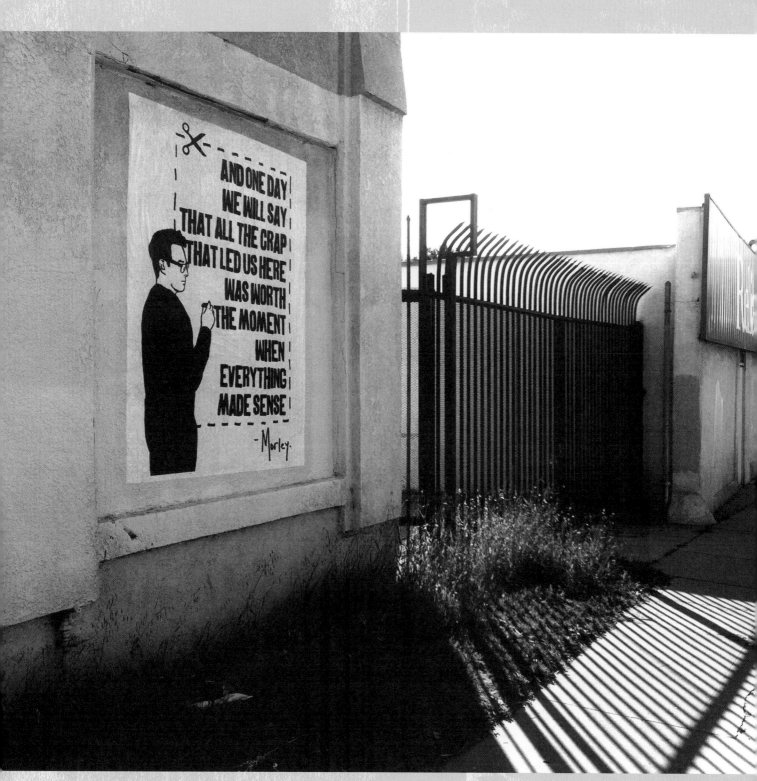

AND ONE DAY
WE WILL SAY
THAT ALL THE CRAP
THAT LED US HERE
WAS WORTH
THE MOMENT
WHEN
EVERYTHING
MADE SENSE

- Morley.

INSTRUCTIONS: *Cut promise here. Paste promise to your heart.*

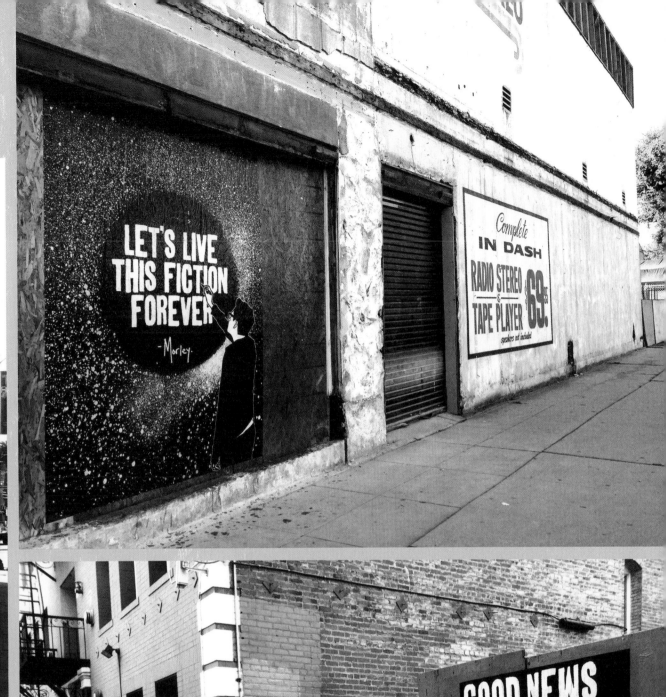

LET'S LIVE THIS FICTION FOREVER

-Morley.

Complete
IN DASH
RADIO STEREO & TAPE PLAYER 69.⁹⁵
speakers not included

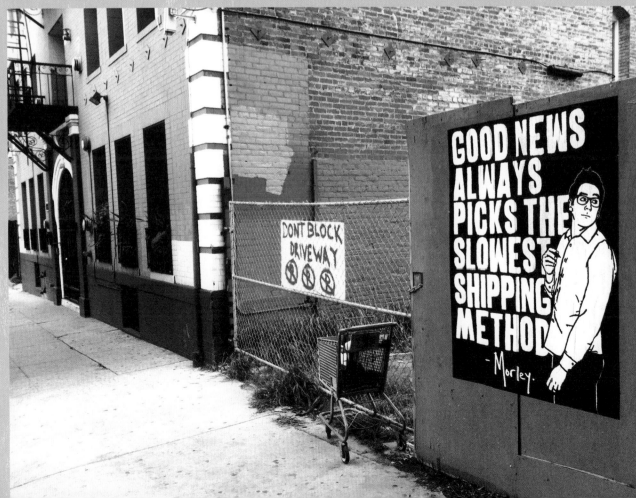

DONT BLOCK DRIVEWAY

GOOD NEWS ALWAYS PICKS THE SLOWEST SHIPPING METHOD

-Morley.

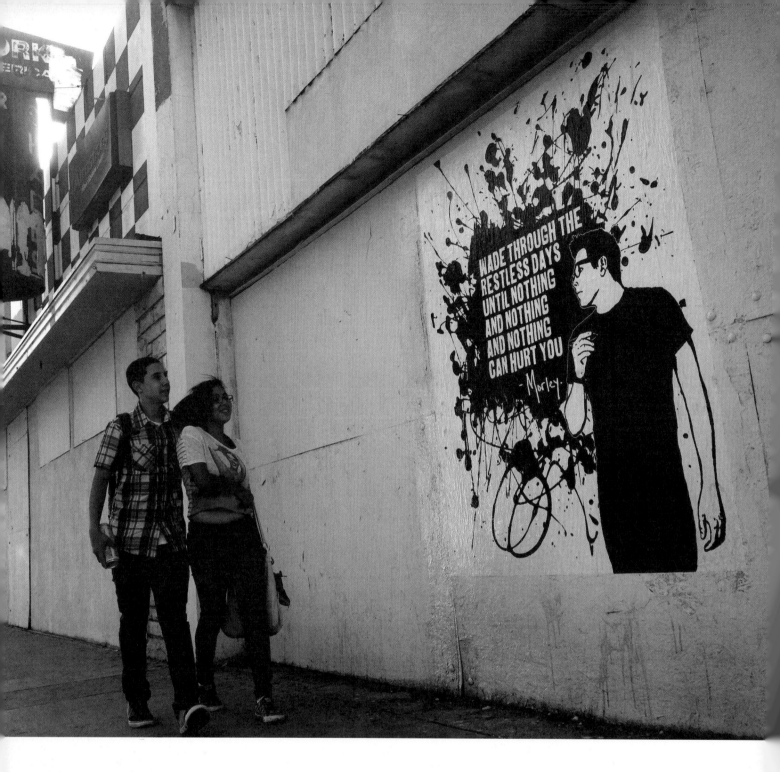

What types of reactions do you get from people passing when you're putting up new pieces? —Blake Woody

They vary. Some are nice, others get upset, most are indifferent. I may be guilty of ageism because I tend to clench up a bit when older people approch me. While the younger folk seem to have made peace with public art, it's generally the elder generations that think I'm worse than Hitler. They'll snap photos and tell me that they're going to send them to the police; they'll ask me why I think it's okay to break the law and stomp off; disgusted by my answer before I've even had the chance to give one. Once as I was working, an older woman approched and exclaimed, "It's you!"

Almost immediatly I began considering if I was the kind of person who could push an old lady over while trying to evade a citizen's arrest. Before I could decide, she continued, "It's really you! I've seen your work, it's wonderful!" I thanked the woman for the encouragment with a hug, probably hoping it would make up for the fact that only seconds earlier I had been debating just how much strength it would take to wrench my arm free without causing her to need a hip replacement.

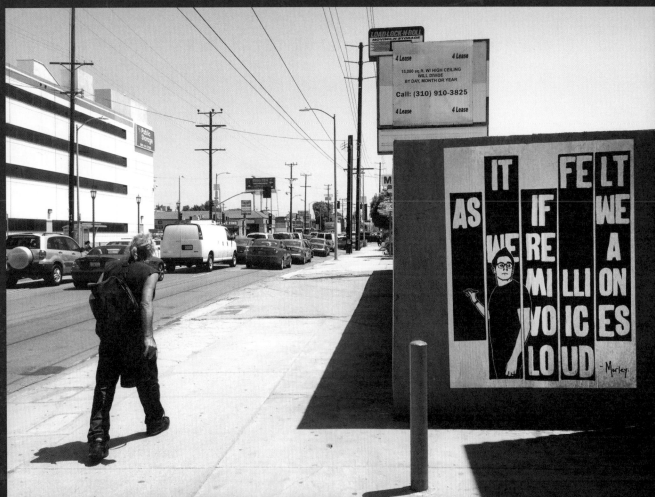

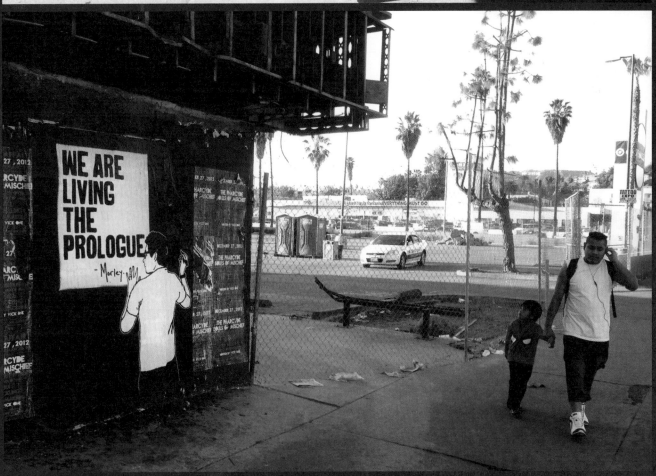

REACTION A:

AN E-MAIL I RECEIVED.

Subject: Thank you

Message:
I feel foolish typing this, but considering you're some Robin Hood type graffiti artist I'll never meet, I'll proceed.

For some reason I stumbled upon your art while in a poor place in my life. It was exactly three days after I was discharged from children's hospital psychiatric ward for suicide attempt. I was there for about a month, and other than the art we'd create in therapy, I wasn't exposed. So when I got home, all outstanding stimulates seemed foreign and strange to me. Friends, people, noises in general.

The first time I was allowed to get online after I got home, I went on Tumblr. My poor blog had suffered insufficient attention for some time. On my dash I saw one of your pieces. "let's fall in love like both our parents aren't divorced". It was brilliant. I saved the picture and found myself drawn back to it. Soon I searched you online and found your site. I ended up saving basically all of your photos to my phone.

I think I ran out of hope a long time ago, and resigned myself to be terrified of the world. Depression engulfed me, and nothing else really mattered. People didn't matter, love didn't matter. But for some reason, your art matters to me. Your art gives me hope, a feeling I'd forgotten. It inspires me I suppose.

I know I'm fragmenting my words and it isn't all really connecting. Basically, thank you. For being the type of amazing person I want to be. Thank you for sending messages that society can use. I can't explain why it helps me so much, but it does. I just thought you should know that.

You're brilliant. Thank you.

— A 15 year old struggling but getting better girl named Molly.

REACTION B:

After gluing up a poster on an electrical box in a suburban area, I walked back to my car, which was parked about two hundred feet away, to stow my bucket of glue. Closing my trunk, I heard in the distance "...kid in the red shirt!" I happened to be wearing a red shirt so I turned to see who was addressing me.

I saw two men, who looked to be in their mid-forties, decked out in pastel polo shirts, khaki shorts, and flip-flops (all of the "suburban dad" variety). Upon seeing that they had gotten my attention, one screamed, "HEY ASSHOLE! I'M TALKING TO YOU, YOU DUMB MOTHERFUCKER!"

I wasn't sure how to respond to this. From that distance, I could easily get in my car and drive away before they could reach me, even at a full sprint, so I just raised my hand and waved. This seemed to enrage the man further. He turned to the poster, still wet with glue, and began frantically clawing at it with his fingers, looking almost like someone swatting desperately at a hive of swarming killer bees.

At this point, I figured it would be best to leave. As I drove away I looked in the rearview mirror to see the man finally tear the remainder of the poster away from the box and throw it to the ground in a gluey heap, his chest heaving in and out, his face like that of some crazed Viking warrior, preparing to eat the heart of a vanquished foe to "gain his courage"...but, y'know, in flip-flops.

I know the story seems a bit farfetched, so I stopped by the box the following day and snapped a picture. As you can see, the marks of his Wolverine berserker attack are still visible.

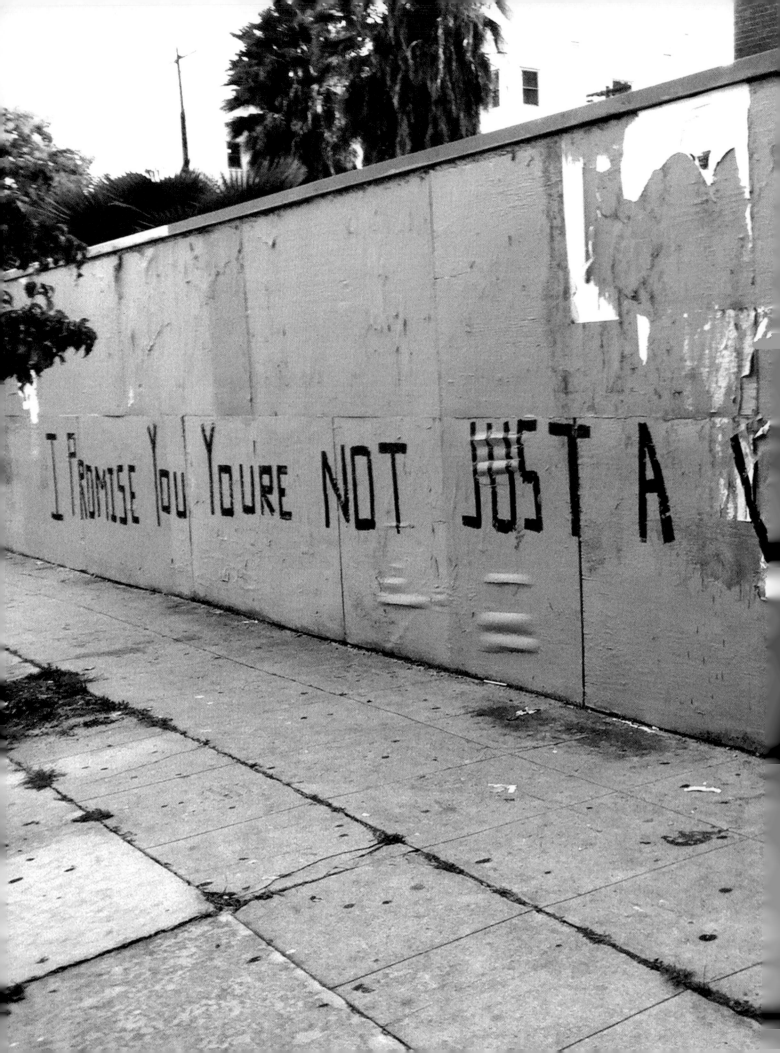

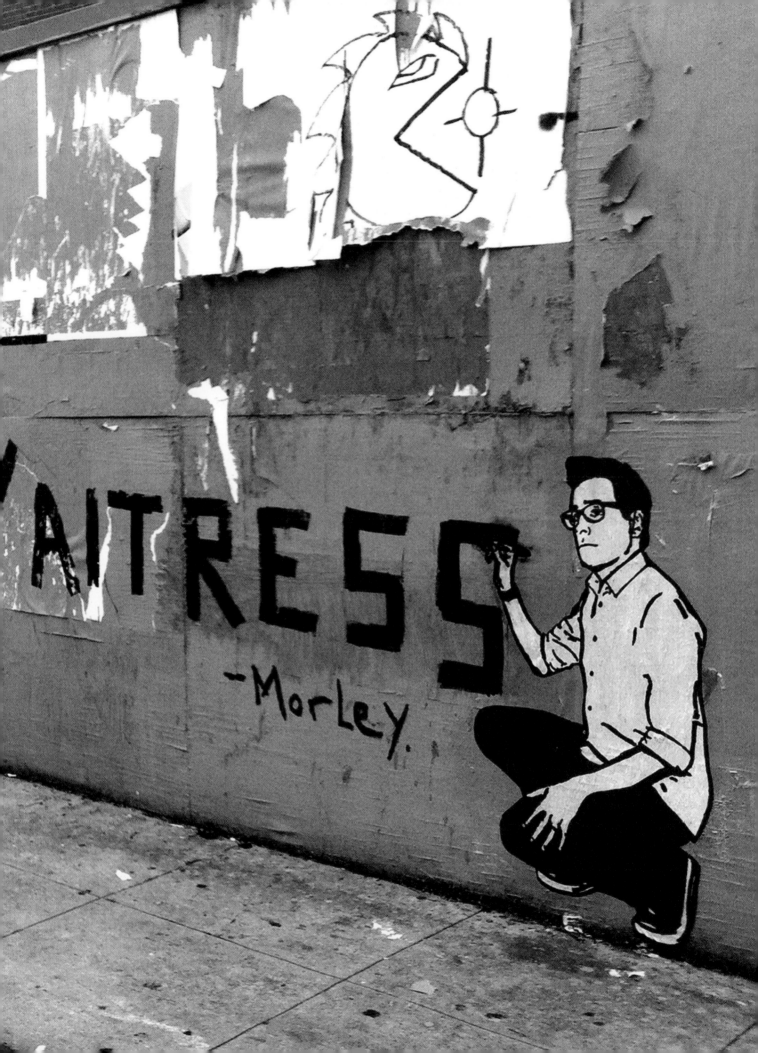

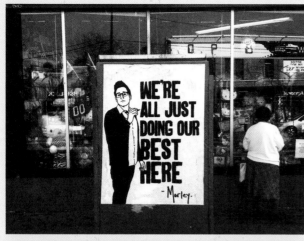
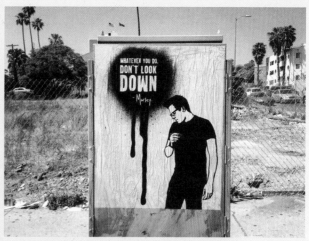
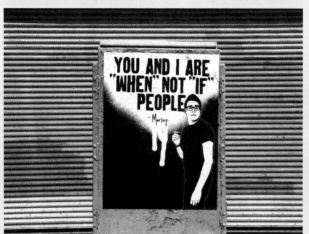
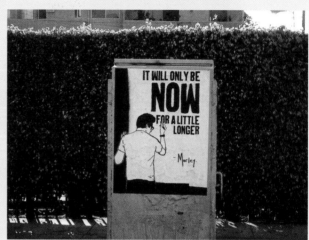
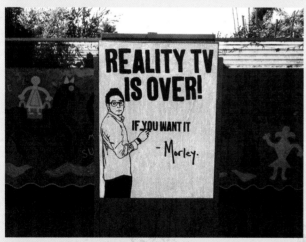
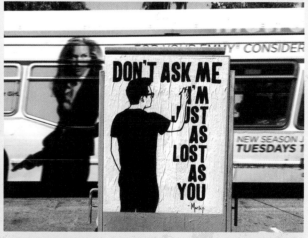
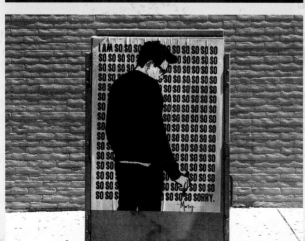
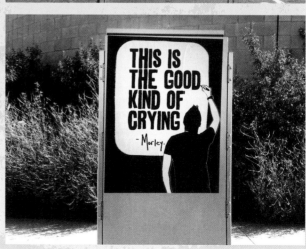

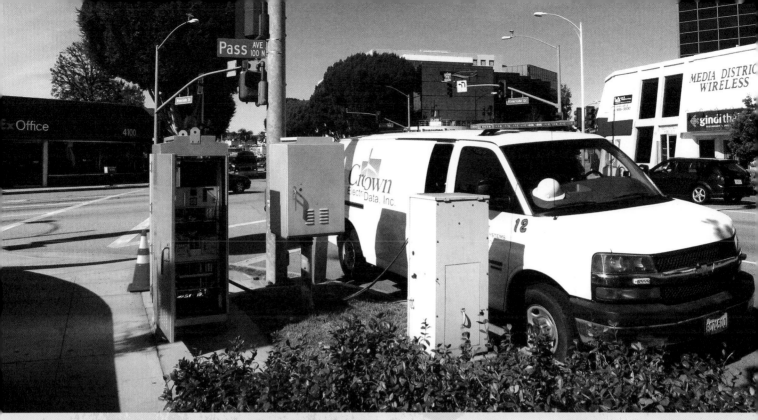

PLAYING WITH POWER

Throughout this book you've seen my posters pasted to many of these boxes. The ubiquitous cubes contain power panels to distribute electricity as well as monitors, detectors, and various components that control the traffic lights.

They are the most common canvas for street artists. The reason for this is because there is one at literally every intersection. Hundreds of people walk past them, cars stop right next to them, and since essentially they're just a weatherproof shell for the electronics inside, decorating them is more or less a victimless crime. Removing the offending art usually requires only a single coat of paint.

PLEASE TAKE ONE

— Morley.

A LOVE WORTH CHASING TO THE AIRPORT
A LOVE WORTH CHASING TO THE AIRPORT
A LOVE WORTH CHASING TO THE AIRPORT
A LOVE WORTH CHASING TO THE AIRPORT
A LOVE WORTH CHASING TO THE AIRPORT
A LOVE WORTH CHASING TO THE AIRPORT
A LOVE WORTH CHASING TO THE AIRPORT

You've seen it in a thousand movies—the guy chases the girl to the airport—before she gets on the plane that will take her out of his life forever. He gets there—just in time—to give her the speech she's been waiting the whole movie to hear. The speech about what he's learned and how she makes him a better man. She cries, they kiss and it's all very cliché.

And yet... I think we all deserve at least one person in our life worth becoming a cliché over.

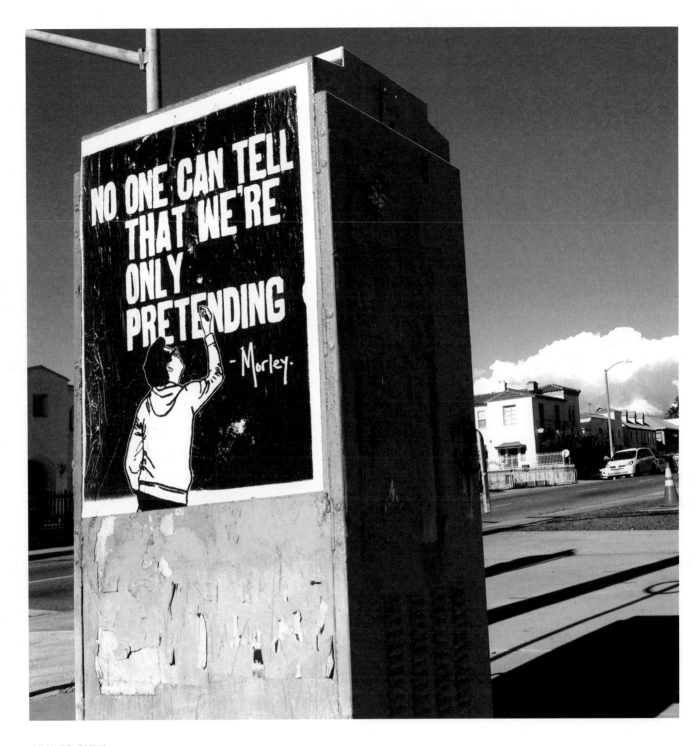

ADULTS ONLY

For most of my adult life I've wondered when I would start feeling like an actual adult. I held out hope leading up to each rite of passage that I would experience some measure of tangible change and maturity, but beyond growing hair where there once was no hair, the evolution of my mental development has been too slow and subtle to notice. Even after getting a driver's license, graduating high school and college, getting a job that pays all my bills, succsessfully taking care of a cat, and getting married, I still feel like a kid that simply managed to perform a few grown-up tasks. The only thing left is having a child of my own, I suppose, but if the trend continues, at some point someone (probably the doctor or midwife) is going to realize that I'm really just a twelve-year-old standing on the shoulders of another twelve-year-old, wearing a long jacket. And then what?!

The funny thing is that while I may feel like I'm just pretending to be an adult, I actually AM an adult. It's irrefutable. At thirty years old, I am officially of the age where it's weird to use the phrase: "When I grow up..."

But I guess it doesn't matter if you FEEL like a grown-up as long as you are willing to accept the responsibility that comes with being one. So as long as I step up to the challenges that life poses, maybe I can stop worrying the magic spell that the Zoltar machine cast, transforming me into a man overnight, won't suddenly wear off and change me back into a chubby pre-teen. Because I can't handle zits and my voice cracking again. Once is enough with that nonsense.

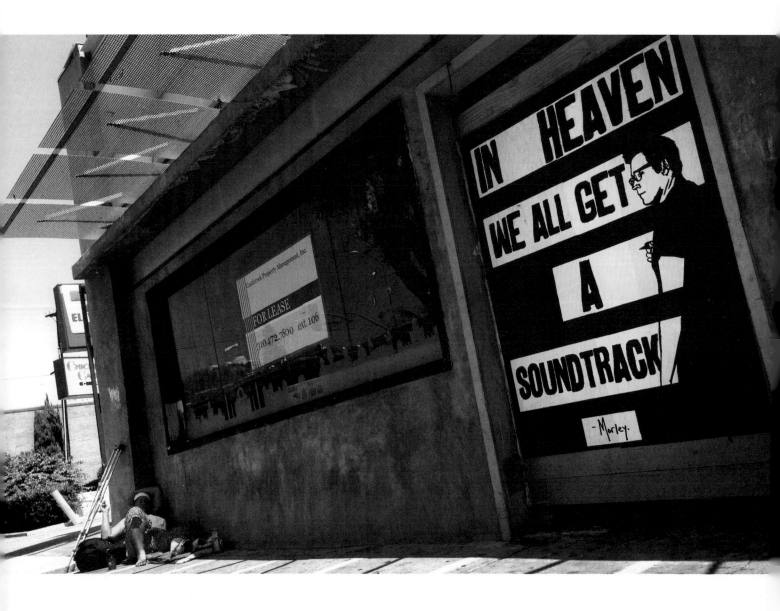

What would be the theme song for your life? —Ania Fijalkowska

*K*iss from a Rose by Seal. I will also accept *Smooth* by Santana
featuring Rob Thomas, that cover of U2's *One* where all the
lyrics are changed to be about Bank of America, and anything from
Bruce Willis' 1987 blues album *The Return of Bruno*.

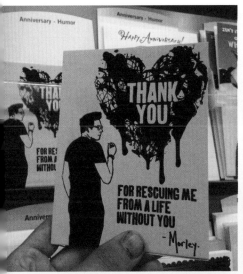

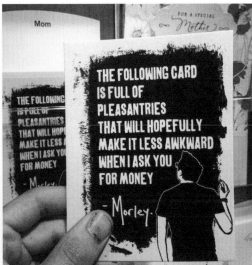

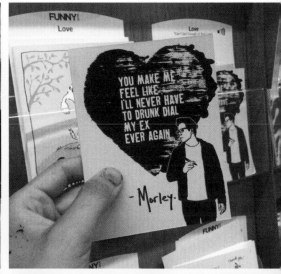

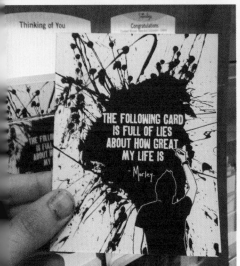

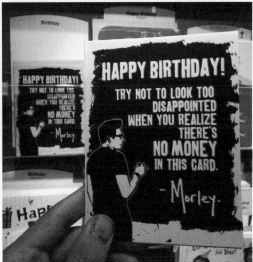

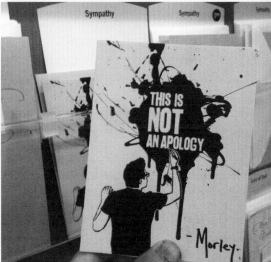

SALUTATIONS

I've been accused in the past of being sentimental and schmaltzy. Some guy even said my stuff belonged in Hallmark cards. I decided to embrace this idea, and I made a series of greeting cards which I took to various grocery and drugstores across Los Angeles and did a little reverse shoplifting.

I was a little worried that those who might find the cards would then be accused of stealing if they tried to take them home, so I tried to make it clear on the back that they were not actually for sale.

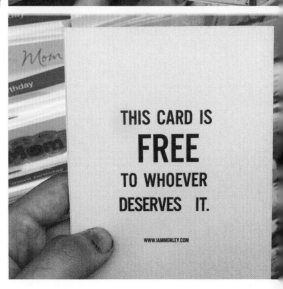

PICKING MY SPOT

The best spots for what I do have five things in common.

1) VISIBILITY.

A heavily trafficked area where it's easy to see. While putting a poster within arm's reach of the foot traffic compromises its safety, getting up close and personal is the only way it can define itself from the millions of images thrust upon us day to day.

2) LONGEVITY.

Generally, the more visible a piece is, the shorter it will ride. Obviously, the spots where a piece will last the longest are generally the ones where they aren't as visible to the casual observer. The sweetest of spots are the ones that can do both. This is usually a crapshoot. I'm often mystified by which spots last and which ones don't. Usually, I err on the side of visibility over longevity.

3) DIVERSITY.

I love the electrical boxes, because of their omnipresence. However, if I only ever posted on electrical boxes, it would get a little dull. Finding new and interesting places to put my posters is important.

4) COURTESY.

I don't like to post on anything that will do significant damage to private or public property. If I made a habit of doing so, it would create a lot more animosity, which would lead to a higher likelihood that police would want to arrest me. If the cops are somewhat ambivalent about what I do now, I'd like to keep it that way. A lot of artists have gotten arrested because they forgot one of the most important aspects of street art: courtesy. This might sound like I'm being cowardly or inconsistent with the cavalier street-art attitude that cooler artists than I can pull off, but if you want people to hear you out, you can't forget to at least consider the collateral damage of how you do what you do. To this end, I look for temporary surfaces and spots that won't necessarily leave a city trashier-looking than before I passed through (if I can help it).

5) ENVIRONMENT.

How does the environment you're putting a poster in alter and affect the message that you're trying to send? The more that the environment plays a part in giving the work context, the more punch the message will have. It also makes the environment part of the piece, and the whole point of street art is to make the street a living, breathing work of art.

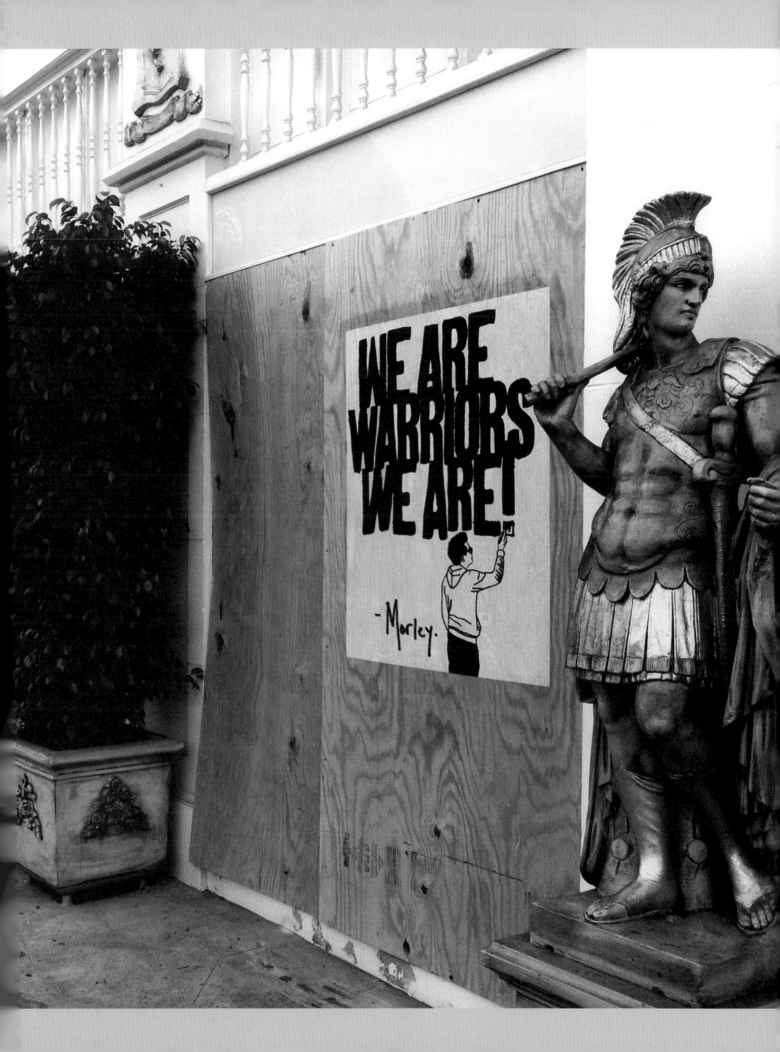

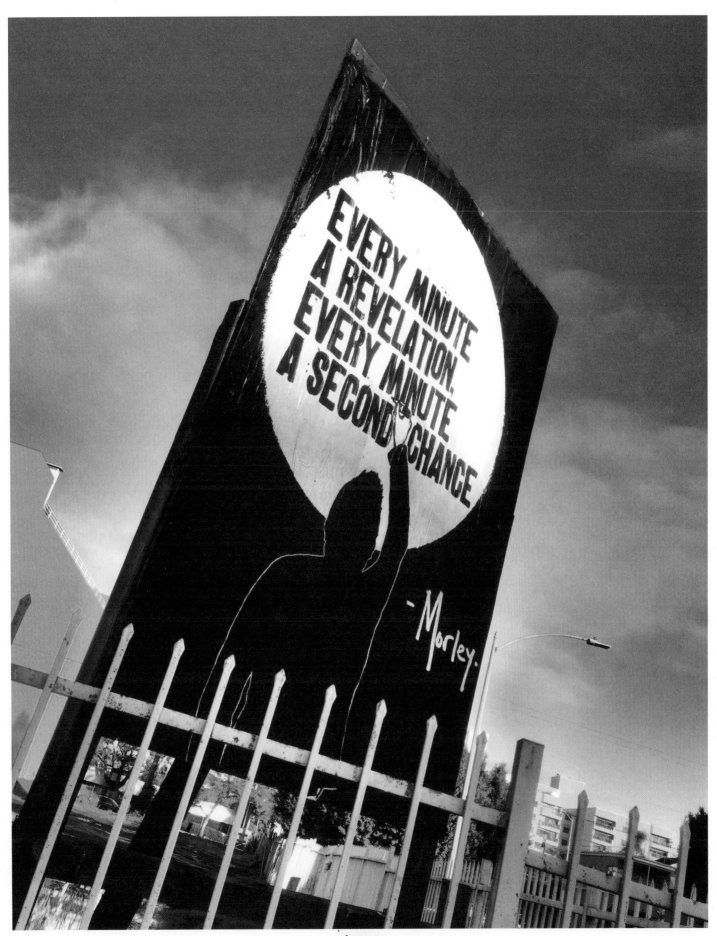

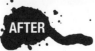

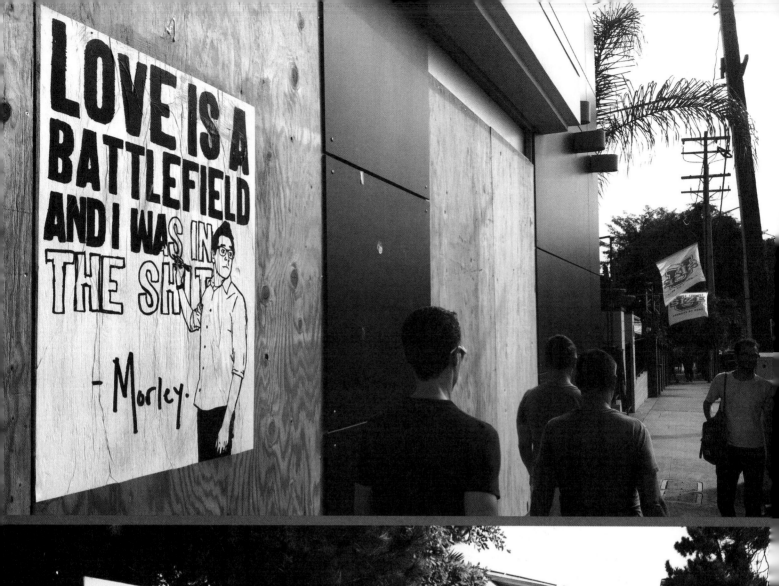

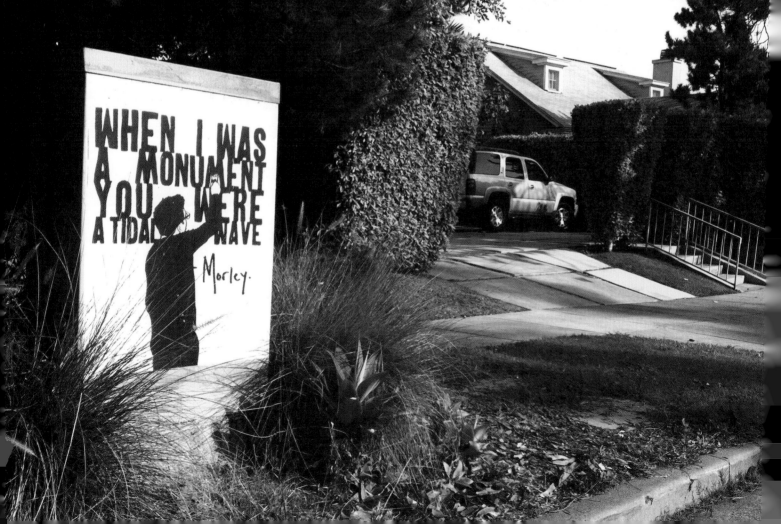

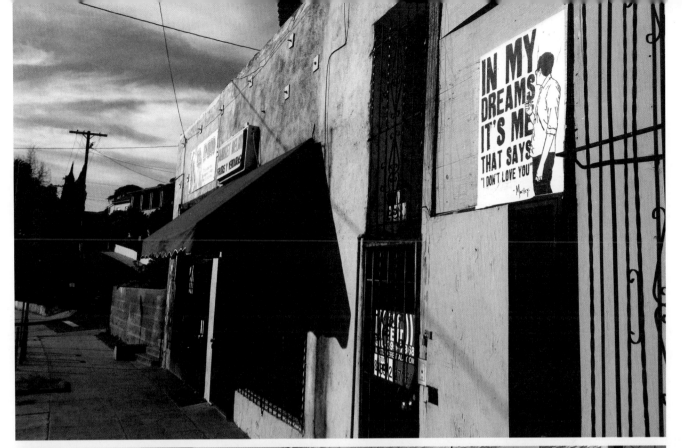

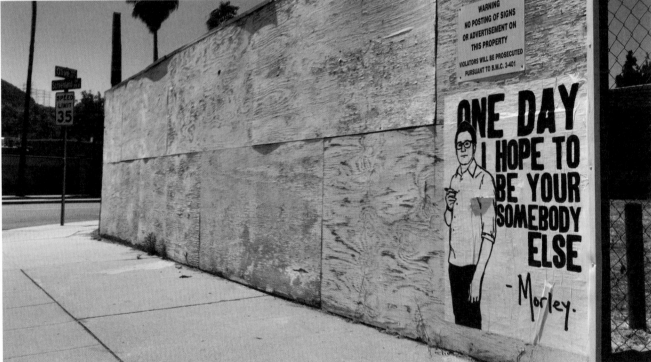

HEARTBREAKDANCING

Though I am happily married, I will, on occasion, make a poster relating to lost love. I do this because over the course of my life I've felt my fair share of heartbreak, and I know how important the various pieces of art that teased that wound were to me.

Like the strangely satisfying sting you get from flicking your tongue across a cut on the roof of your mouth, wallowing in lovelorn victimhood brings its own kind of masochistic pleasure. When an artist of any medium can accurately capture a familiar pain, it comes as almost a relief to us.

Often, I create these posters to speak to the past version of me that would have appreciated someone who knew how I felt. While I've since let go of those feelings of heartbreak, I can still draw on them. I think it's important for artists to be collectors of emotions that they can cycle through their brains and spit back out to the public. They create a mirror of the human experience that articulates what we thought existed in only our heads and hearts. If a monument from my past, long since dashed to the ground, can be useful to someone in such a way, I consider it an honor.

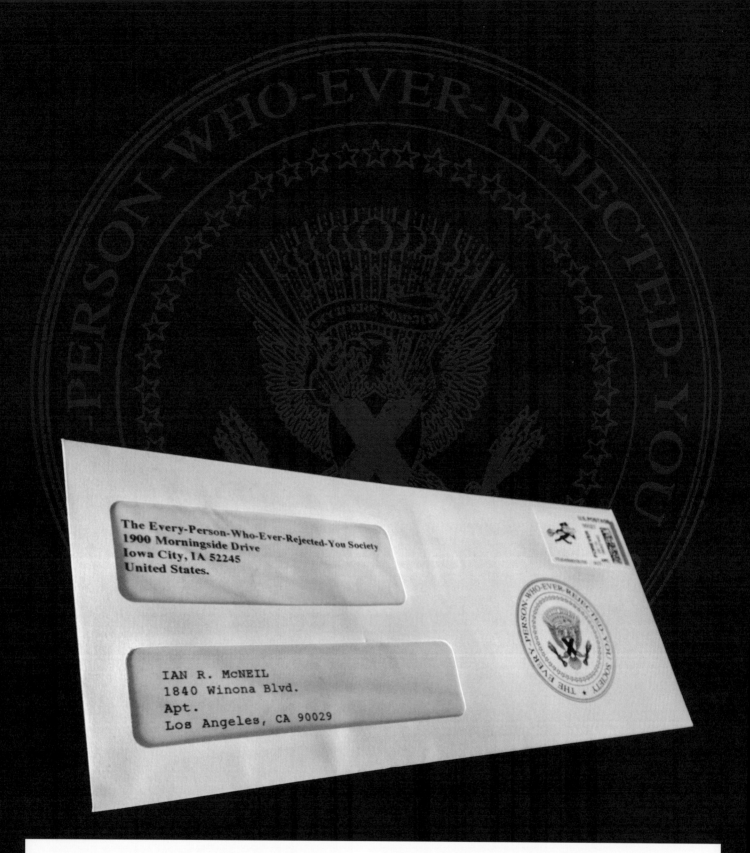

The gratification one derives from knowing that someone who rejected them in some way regrets it is one of the more potent sensations in life. This led me to fantasize about a formal organization made up of every person who ever rejected you, and their collective regret being communicated in something resembling a government correspondence.

I mailed fifty of these letters to addresses picked randomly from the phonebook. The Latin phrase written across the flag in the eagle's mouth is OCCIDERE SOMNIUM, which translates to "Killing the Dream," a phrase that felt apropos for an organization built on rejection. Also, the address of the society is actually the address of my old high school. This also seemed appropriate.

The Every-Person-Who-Ever-Rejected-You Society
1900 Morningside Drive
Iowa City, IA 52245
United States.

Dear Ian,

HOW COULD WE HAVE BEEN SO BLIND?!

 Sincerely,
 The Every-Person-Who-Ever-Rejected-You Society

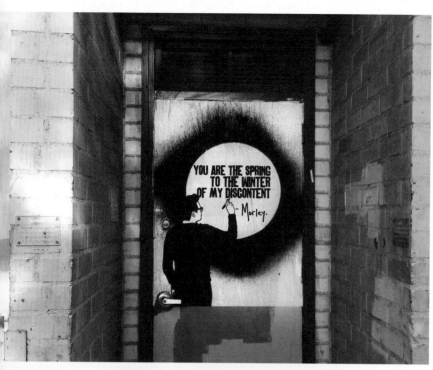

NUMBER-ONE FAN

It often takes someone else believeing in our potential before we can begin discovering it for ourselves. Those who love us and believe in us act as a reminder that maybe we're not as useless as the words echoing in our heads tell us we are. They help us up when we fall, dust us off, and tell us that next time it will be different. Even though we feel 100% certain that they are totally insane and are only pointing us towards more heartache, the knowledge that they will still be there to help us up again makes the possibility of additional woe that much less frightening. Often times, it seems as though it's ONLY their small and lonely voices that actually speak for us in a world of amplified rejection, our own voices long since silenced.

To all the people who stand by us and put their faith in a future we MIGHT be able to one day provide and love us through the days that we don't, thank you. From the bottoms of our hearts to the top of any greatness that may exist within us. You truly are the wind beneath our wings... even though most of the time we feel like penguins.

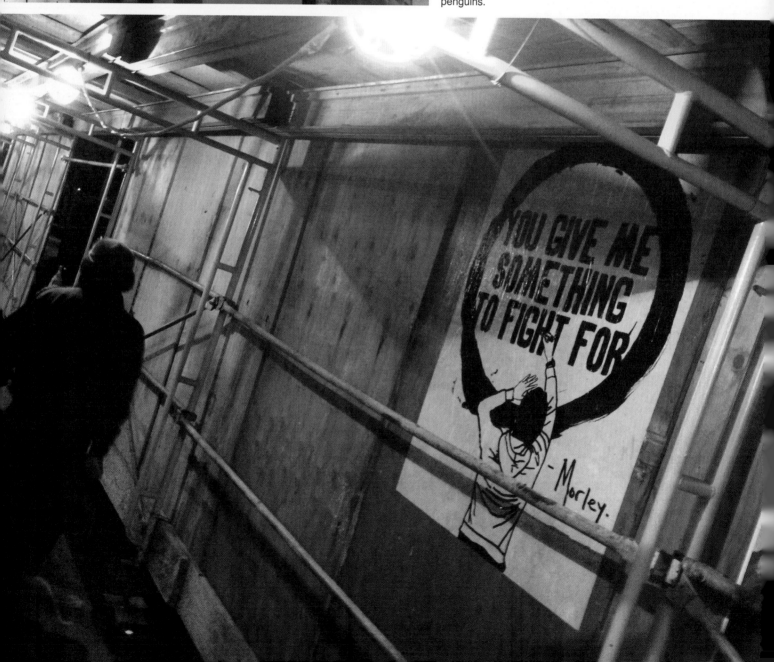

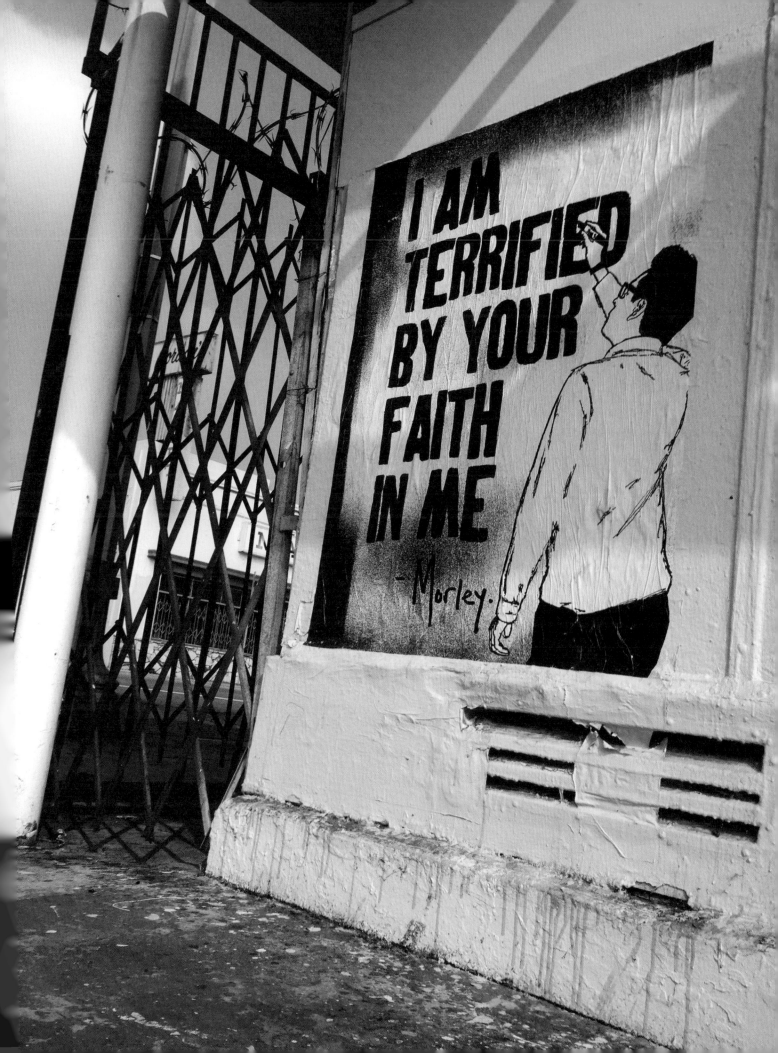

LIFELINE

Sometimes the perfect illustration of a statement I hope to make with my posters can find me. This poster came to me while listening to a call-in radio show I heard one night. The topic dealt with people who volunteer at suicide prevention hotlines. As the callers recounted some of their experiences, I was struck by the mixture of sadness and hope I was feeling—sadness at the sheer volume of desperate people calling these hotlines and hope that there were people to pick up those phones. As I listened, I became resolved to volunteer and help the cause, but almost immediately became terrified at the idea of failing. Did I have the kind of courage to speak to someone so close to ending it all, knowing that if I was unable to help, the level of guilt could be overwhelming? While I'm sure there are any number of wonderful people to train and prepare someone long before they ever pick up a phone, I pondered what I might say if someone called me on the spot. The words on this poster were the first thing that came to my mind.

About a week later I just happened to pass this graveyard and noticed the resemblance that the nearby electrical box had to a tombstone. It only seemed right to leave this message behind.

For information on how to volunteer with the suicide prevention hotline, visit: **www.suicidepreventionlifeline.org**

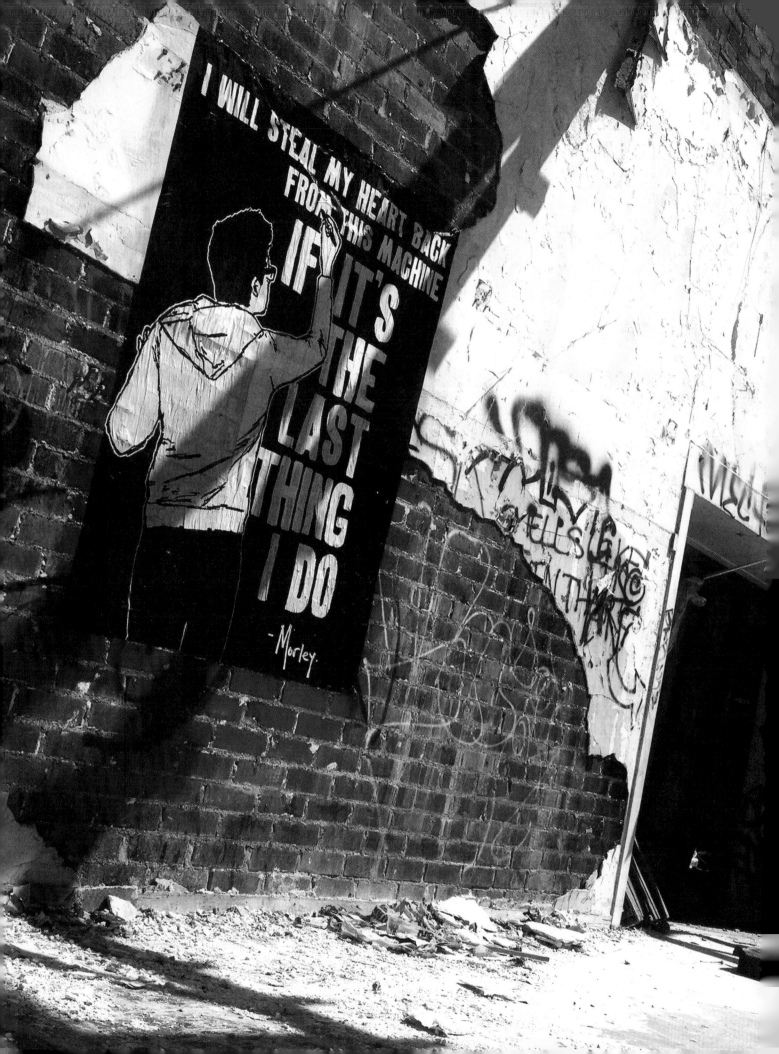

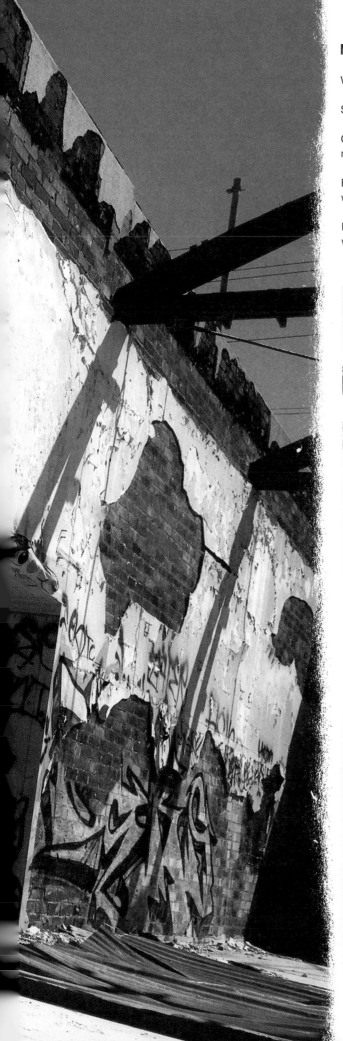

NOTE TO SELF:

Write a letter, not an e-mail.

Start a diary, not a blog.

Give someone a compliment, not a retweet.

Burn a memory in my mind forever, without taking a single photo.

Profess something to the world, without making a status update.

THEN MAYBE:

Read a book.

See a play.

Learn to play piano.

Learn a foreign language.

Go someplace I've never been before.

Swim.

Drink more water.

Hold my friend's baby without worrying about accidentally giving it brain damage.

Climb a tree.

Chase an ice cream truck.

Come to terms with the existence of traffic.

Laugh really, really hard at a joke.

Sing along loudly to a great song in my car at a stoplight with the windows down.

Kiss my wife in the rain.

Feel profoundly small in the epic scope of the universe...and revel in the freedom that humility gives you.

When I posted this photo on my blog, I had a lot of people asking me how I got the poster inside the case. One guy even asked if he could borrow my poster box key for his own mission. People seemed to think I was really badass for being able to break in.

I almost didn't want to admit that someone just forgot to lock this box and all I had to do was wriggle it open. Often you find the best spots from just being observent.

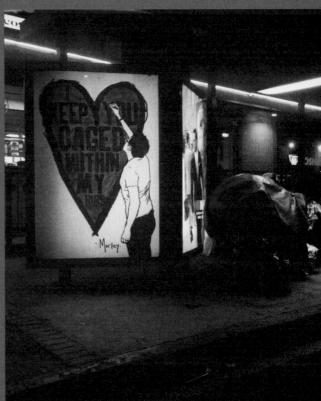

At night, this bus stop shelters a homeless man who said my poster was a big improvement to the ad for the Will Smith movie that it replaced. My guess is he's still holding a grudge for Wild Wild West.

WILDLIFE

How do you keep an elephant from running away? It's tragically simple, actually. When the elephant is a baby, its trainers lock a chain around its leg that's attached to a metal stake in the ground. This chain is strong enough to hold a young elephant, thus making an escape attempt a fruitless and often painful exercise in futility. The baby elephant learns this and over time gives up any hope of freedom. Once the elephant accepts this, the trainers can replace the stake with a wooden one that can easily be hammered into the ground as they travel. The average adult male elephant is between nine and thirteen feet tall and weighs up to 13,000 pounds. It could easily rip free of its leash...but does not. The reason for this is that it remembers the limitations it learned as a child and has allowed those limitations to define what it can and cannot do—even though, unbeknownst to him, he has far exceeded those limitations long ago. This is how the elephant became famous for its memory.

I believe that there are three lessons here.

1. Don't carry your limits with you so long that they define who you are or what you believe you are capable of accomplishing.

2. Never stop testing the boundries, especially the ones that you can only percieve.

and

3. Don't let anyone trick you into thinking that you're not a 13,000-pound wild animal.

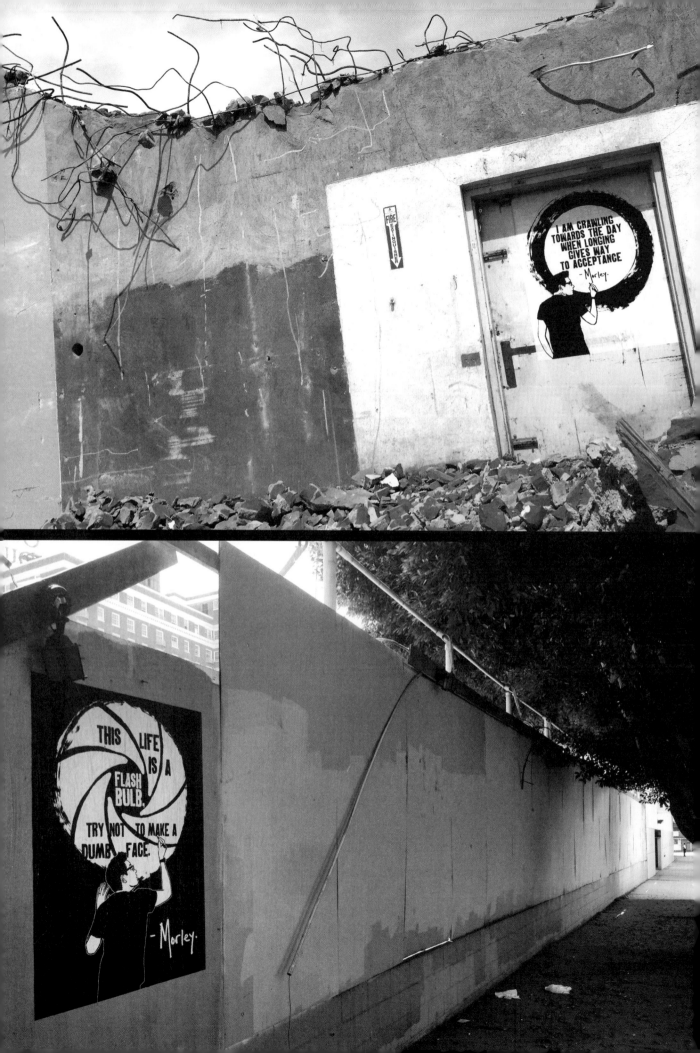

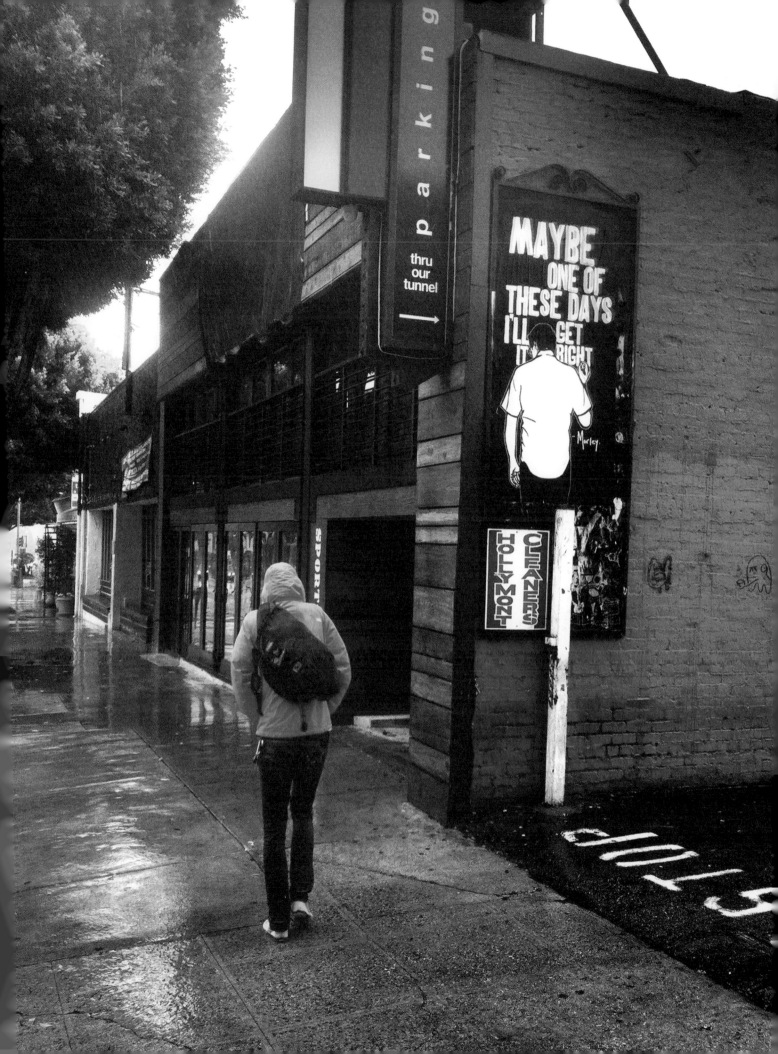

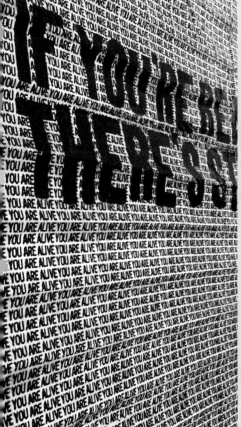
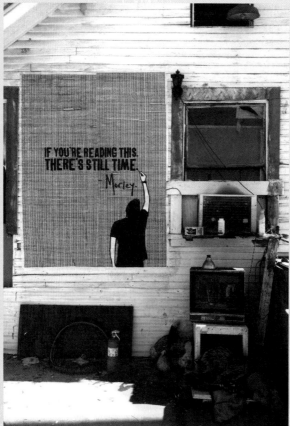

REQUIRED READING

So here I am, hopping the fence to what appears to be a condemned house that has fallen pretty deeply into ruin. The fence, part rusty metal, part wooden plank, is cheap and jagged, and it cuts my hand as I scale it. Nevertheless, once I'm in, I'm excited, because now I get to look around and pick my spot. I wipe the blood from my hand on my pants and survey the possibilities. I decide to go for the broad side of the house. The nice thing about spots like this is that the fence blocks most people from casually looking over and spotting me work, so I can take my time, which I do…liberally. After it's up, I take a bunch of pictures, even using a big ladder I find to get the best angle.

I also notice a big pile of damp, rained-on books…all sharing a common theme. See if you can spot it.

I still can't decide if my favorite title is *Mother's Hungry Boy* or *Hot-Mouthed Mother*.

After I finish taking pictures, I grab my bucket and brush and round the corner of the house to the front, deliberating if I should put up another poster while I'm here. Suddenly, I hear a sound. It's the sound of keys jangling as they open a padlock to the fence. With only ten seconds to think, I mull over my options.

If the guy has already seen me, running and hiding would lead only to the following embarrassing scenario:

HIM: Sir, please get out from under that tarp and come with me.
ME: (muffled) NO ONE'S HIDING UNDER THIS TARP!

I could just bolt and try to make it over another wall of the fence, but with my hand already wounded, I'm not sure if I could make it over fast enough, and that might lead to further bloodshed for me. The third option seems the craziest, but I figure I might as well give it a shot. I pick up my bucket and brush and stride confidently over to where the man is entering. As he unlocks the padlock and pulls the chain free, he looks up and I walk out the gate he's opened, saying, "Thanks; I was just leaving." Confused, he follows me to the street, sputtering monosyllabic "ums," "uhs," and "huhs," in quick succession. All of which I ignore. I get in my car and gingerly wave as I drive away.

Dumbfounded, he obliges a wave back.

It seemed as though he hadn't seen my poster or me putting it up. And luckily, the side of the gate he opened was not the side that I had been working on, so the fiction I invented in those ten seconds assumed he might mistake me for a city employee who stopped by for some official reason and thus, if I just acted authoritative, he might be confused long enough to let me get out of there.

Then again, maybe he was just glad I didn't mention all the books.

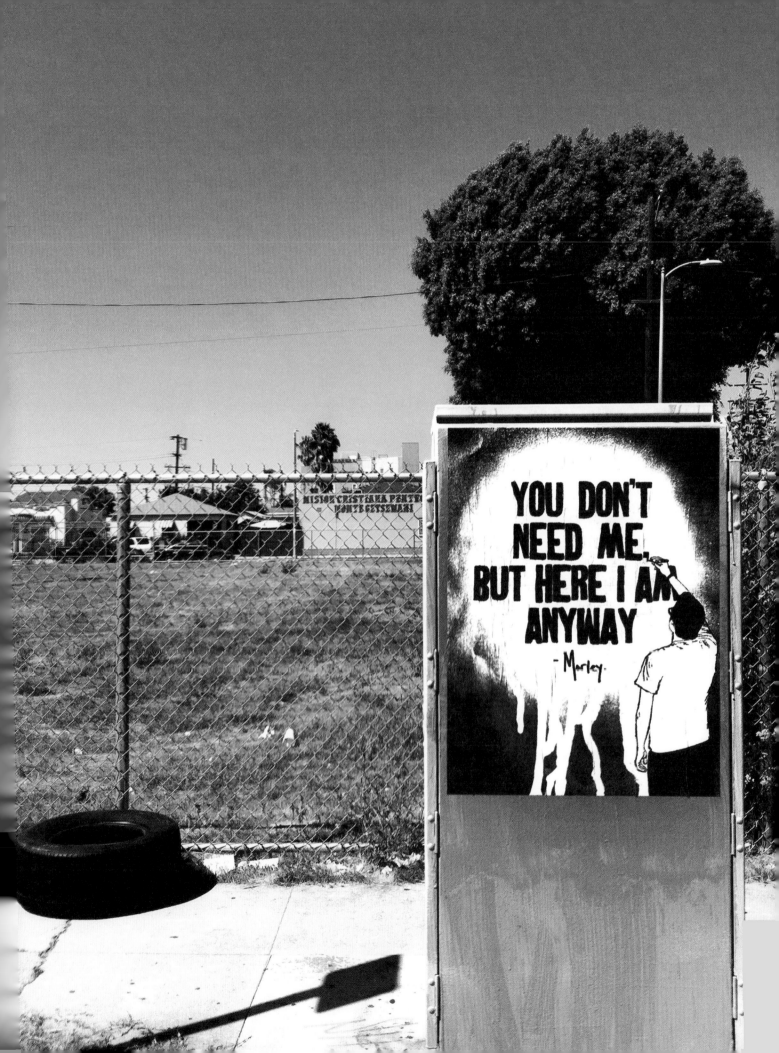

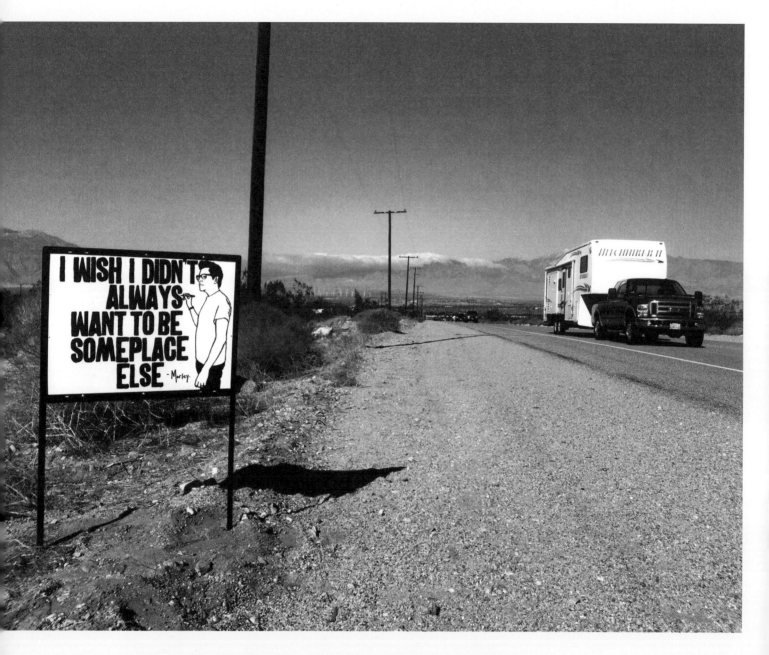

How would your art be different if you were creating it in Iowa? —Anna Boudinot

It's hard to say. Leaving Iowa was probably the biggest event in my coming-of-age. When I was in Iowa, I just assumed that once I was set free to chase my dreams, I would finally begin living the life I had always imagined for myself. I'd feel comfort and self-confidence in my own skin. I'd find the grace to glide through the days that would lead to the mapped-out future I'd drawn as a child. But once I was out, none of that happened. I stayed awkward, and the future stayed distant and blurry.

In truth, that disappointment shaped who I am more than success ever could. If I hadn't left Iowa, I might have gone on assuming that its boundaries were the enemy. I might have continued to give the outside world more credit than it deserved, and my work might have been less about encouragement and more about my own unrest and discontentment and there's plenty of that kind of art already as it is.

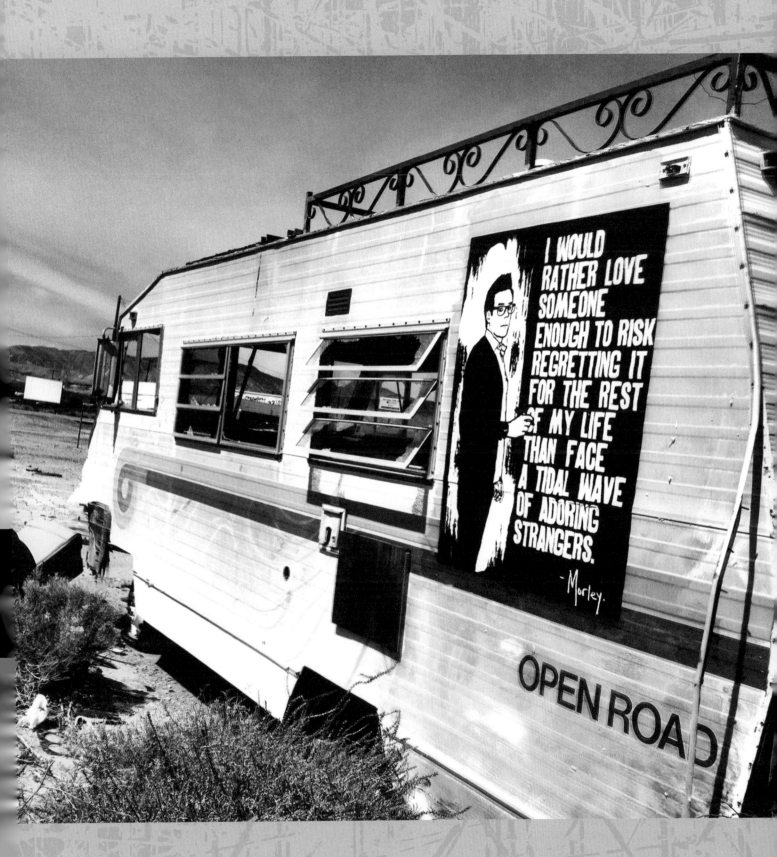

M-DAY

JULY 21ST, 2012:
A DATE WHICH WILL LIVE IN INFAMY,
WHEN THE BRAVE MEN OF MORLEY
COMPANY INVADED LONDON.

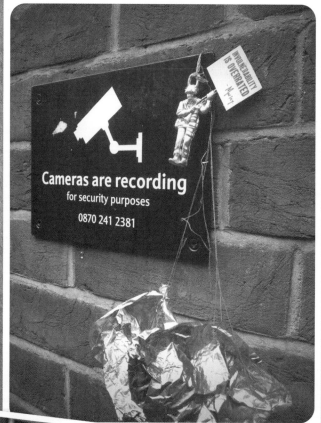

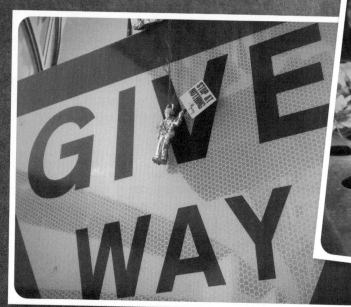

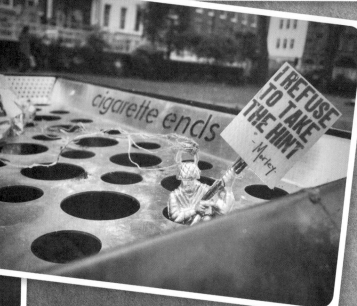

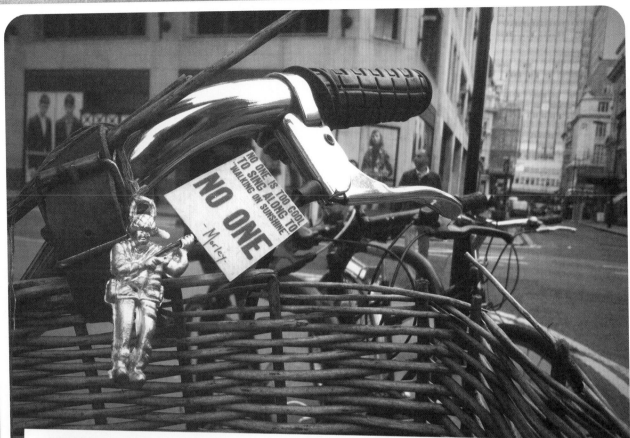

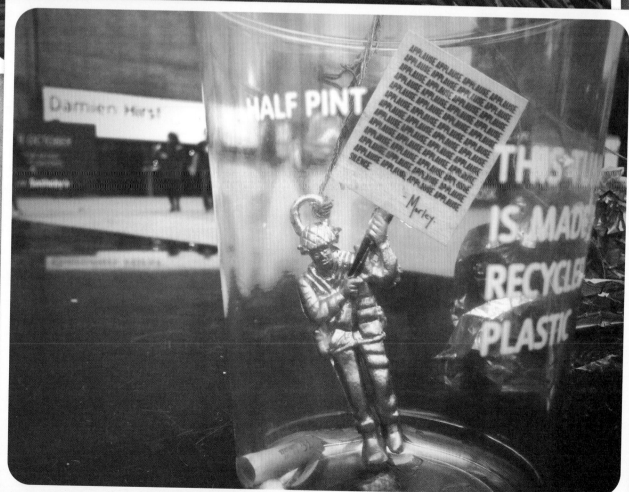

I often use the term "slogan" when describing what I do.
In the dictionary, a slogan is defined as:

*"A distinctive cry, phrase, or motto of any party, group,
manufacturer, or person"…*Or *"a war cry."*

I think that sounds about right.

THE TALE OF THE TAOIST FARMER

There is an old Taoist story of a farmer who tirelessly worked his crops. One day, his horse ran away. After hearing the news, his neighbors offered their sympathy at his misfortune, saying, "What terrible luck!"

"We'll see," said the farmer.

The next day, the horse returned with a pair of wild stallions behind him. "What good luck!" the neighbors exclaimed.

"We'll see," replied the man.

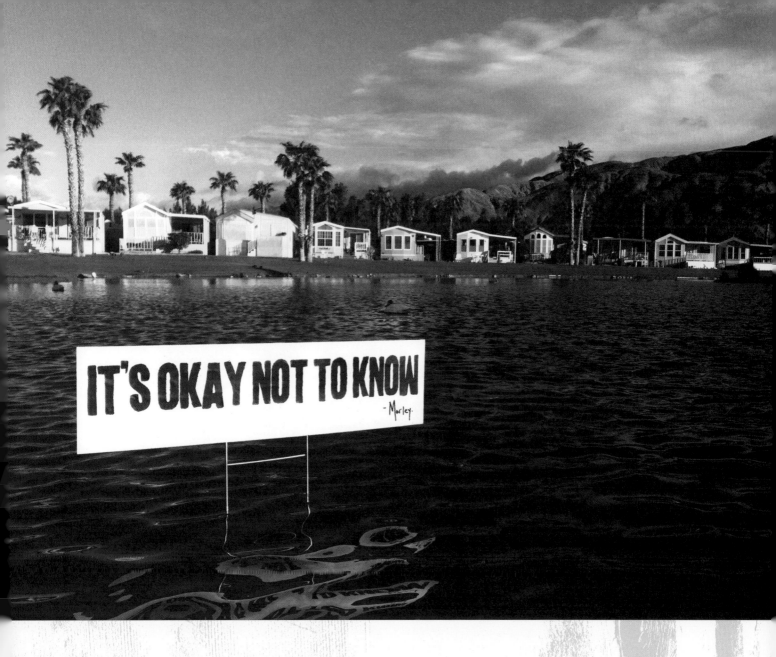

The following day, when the farmer's son tried to tame one of the stallions, he was thrown and broke his leg. The neighbors again came to offer their condolences.

"We'll see," answered the farmer.

The day after, military officials came to the village to draft every able-bodied young man into the army. Seeing that the son's leg was broken, they passed him by. The neighbors congratulated the farmer on how well things had turned out.

"We'll see," said the farmer. "We'll see."

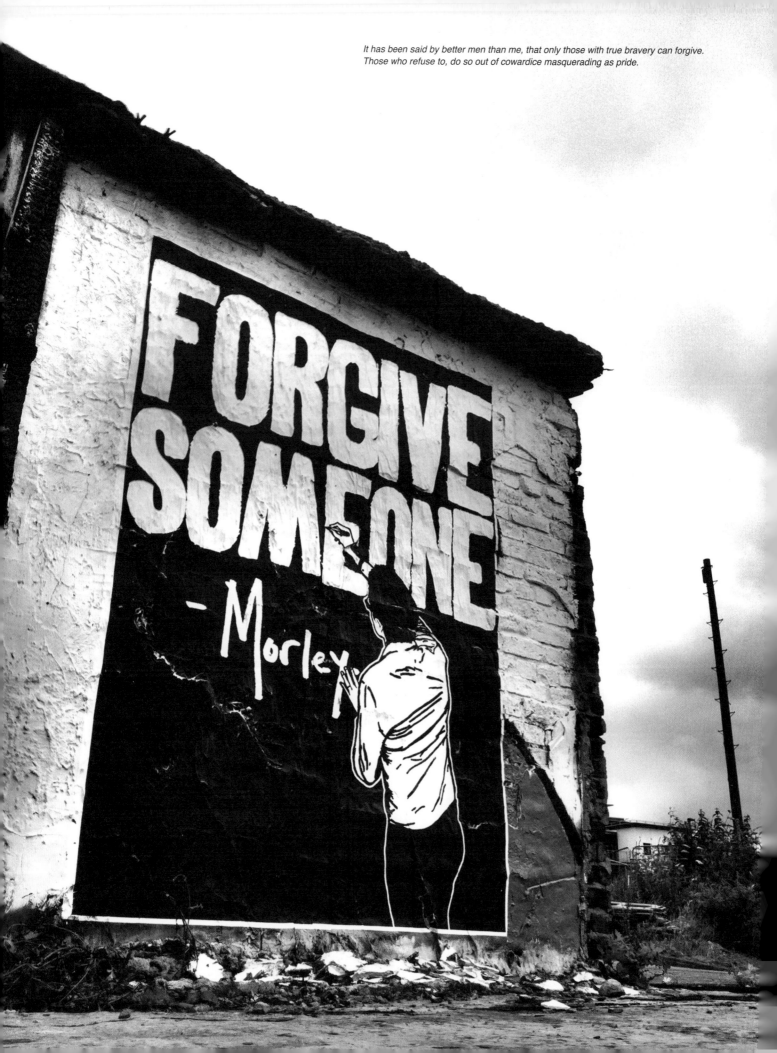

It has been said by better men than me, that only those with true bravery can forgive.
Those who refuse to, do so out of cowardice masquerading as pride.

AND JILL CAME TUMBLING AFTER

When I make a piece I try to have a few different ways one can interpret the sentiment. This allows for a variety of people at various points in their life to define how it relates to them. With this piece specifically I wanted to create a visual with the text: the visual of a seemingly endless chasm—a precipice. We reach these deep chasms from time to time in our life. For me, the most terrifying of them all is the fear of failure; to make a leap of faith in myself and instead of finding wings to sail across the precipice I simply tumble downward and crash to the bottom of the ravine. But then I realize that I am not alone. That I can find solace in those who leapt with me, hand in hand, suffering similar bruises and broken bones.

Or perhaps they are simply there to help me up.

Another way to picture this is from the perspective of someone looking up from the bottom of a vast hole, deep enough to appear impossible to climb out of. The treacherous goal of ascending up from the consequences of a past mistake or the exhausting task of daily self-improvement. In that moment before you first mount the chasm wall the question will arise if an attempt is even worth the possibility of falling back down again. Oftentimes that question is answered upon discovery that someone stands with you, at the bottom of the pit. Perhaps someone who has fallen into similar patterns and faces similar needs of personal repair, or maybe it's someone who just supports you and encourages you to take the first step.

There are other ways that one could decipher this statement; those are just a few, and I leave it to the reader to pick which one applies to their present circumstance, but rest assured that there will always be another precipice to face in life. The question is, who jumps with you, falls with you, crashes to the ground with you, helps you to your feet, and climbs out alongside you?

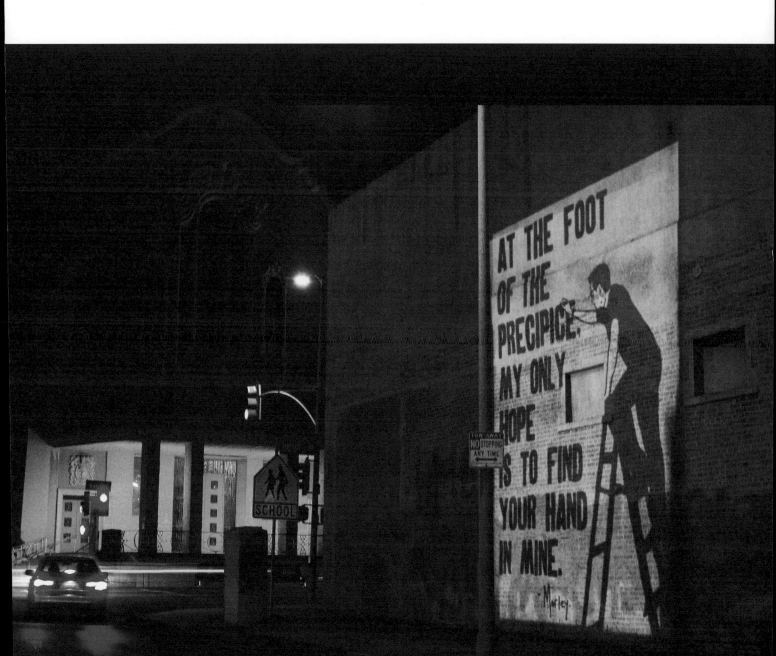

MORLEY VOUCHERS

CUT THEM OUT!
Give them away!

I got the idea for these one very broke Christmas season. As a child, long before I had a job or any money to speak of, I would give my mother cards like this, which boasted, "GOOD FOR ONE HUG!" or "ONE CLEAN ROOM." They were endearing at the time, but as I grew up, promising a hug to my girlfriend instead of actual gifts became decidedly less cute, so I thought it might be interesting to update the promises to reflect metaphysical things that grown-ups would actually appreciate.

The goal was not just to make the cards applicable for my friends and family, but that they could then give the cards to others, who could give the cards to others, and so on.

The following year, I was able to afford real gifts but came back to the idea for a project. Driving around Los Angeles, I left them in the pockets of clothes at stores ranging from Goodwill to Armani, from Walmart to Urban Outfitters. I like to think that my vouchers came as a pleasant surprise to the people who bought the clothes, and maybe even came in handy as gifts that season.

Now you, too, can share the love!

THIS CARD IS GOOD FOR ONE SMALL VICTORY
THAT KEEPS YOU GOING.

THIS CARD IS GOOD FOR ONE NIGHT
WHERE I WON'T GET BORED LISTENING TO YOU TALK
TO YOUR FRIENDS ABOUT SOMETHING
I KNOW NOTHING ABOUT.

THIS CARD IS GOOD FOR AN ENTIRE DAY
SPENT READING CELEBRITY GOSSIP BLOGS
RETURNED BACK TO YOU.

THIS CARD IS GOOD FOR ONE ENTIRE DAY
WHERE I SHUT UP AND LET YOU DRIVE
FOR ONCE IN MY FREAKING LIFE.

THIS CARD IS GOOD FOR ONE LAST CHANCE
TO GIVE ME YOUR PHONE NUMBER.

THIS CARD IS GOOD FOR ONE PERFECT MINUTE,
FROZEN IN TIME LONG ENOUGH
TO BE ADEQUATELY APPRECIATED.

THIS CARD IS GOOD FOR ONE LIFE
THAT'S TOTALLY IN ORDER AND ON THE RIGHT PATH
AND NOT AT ALL AN EMBARRASSMENT
TO ITS PARENTS.

THIS CARD IS GOOD FOR ONE CHANCE TO
HEROICALLY JUMP THROUGH A WINDOW IN SLOW MOTION
WHILE FIRING TWO HAND GUNS AND SCREAMING.

THIS CARD IS GOOD FOR ONE PERSON
WHO WOULD BE LOST WITHOUT YOU.

THIS CARD IS GOOD FOR ONE AIR-TIGHT EXCUSE
TO NOT HAVE TO GO TO SOME LAME:
PARTY/CONCERT/BARBECUE/ONE MAN SHOW/
REUNION/WEDDING/BABY SHOWER/BRIS/
RE-COMMITMENT CEREMONY/INTERVENTION/FUNERAL.

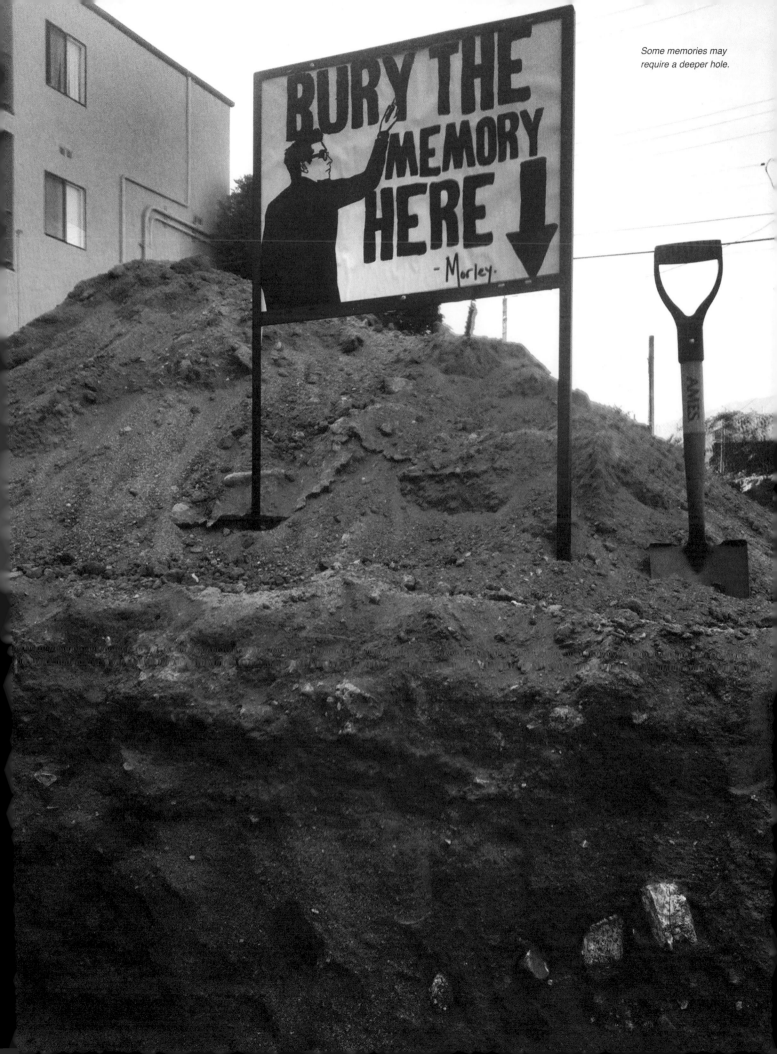

Some memories may require a deeper hole.

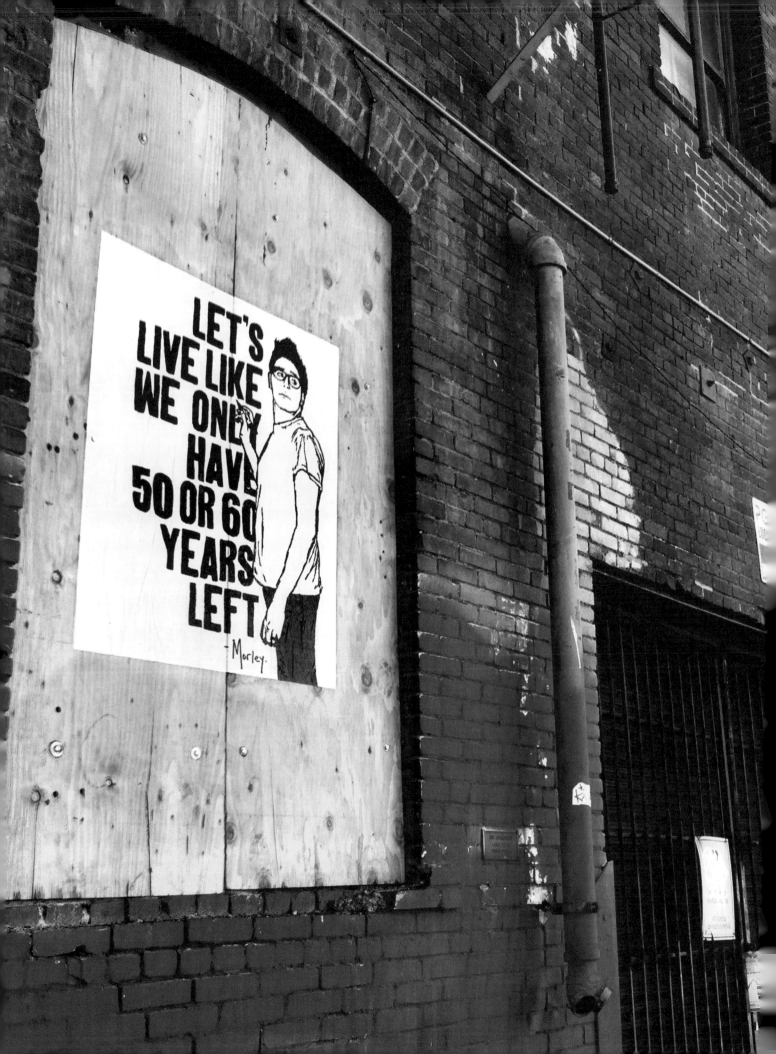

TIME LIMIT

I think some people may look at this poster and read it as me saying that we shouldn't live in the moment or to not bother treasuring things with immediacy. Actually, I think it's the exact opposite. Life can never be too long, and fifty or sixty years seems terrifyingly brief to me. I often feel like a kid at Disneyland, paralyzed by the knowledge that he only has enough time for a few more rides and that the line for Space Mountain means he might not get to go on Pirates of the Caribbean. While I'm not particularly *afraid* of death, no matter when it comes, I can't imagine I won't be bummed that I couldn't fit in one more ride.

153

HEAVY LIFTING

Legend has it that in the 1920s, a friend of Ernest Hemingway made a bet with the writer that he could not tell a story in only six words. Ernest took the challenge and produced the following: "For sale: baby shoes, never worn."

Leave it to Ernest Hemingway to school us all in six words.

For me, the challenge to evoke something that can stir up real emotion from the reader in such a concise manner is one I routinely place upon myself (with varied success). The fact is, with so few words, you're encouraging the reader to do all the heavy lifting. To take what you've given them and fill in the rest with what naturally jumps to their minds.

It's my hope that each of my posters means something different to every person who sees them. That they fill in the blanks with the details and create a narrative that applies to their struggles, their relationships, their quests more specifically. We're always more curious to see how *those* stories end anyhow.

WITH THE SEA TO OUR BACKS
AND TOMORROW AT THE BREACH OF OUR LIPS,
WE RIDE AT THE HIGHEST SPEED,
LAUGH LIKE OUR SOULS HAVE NEVER KNOWN HUNGER
AND LIVE OUR LIVES
AWAKE.

—Morley.

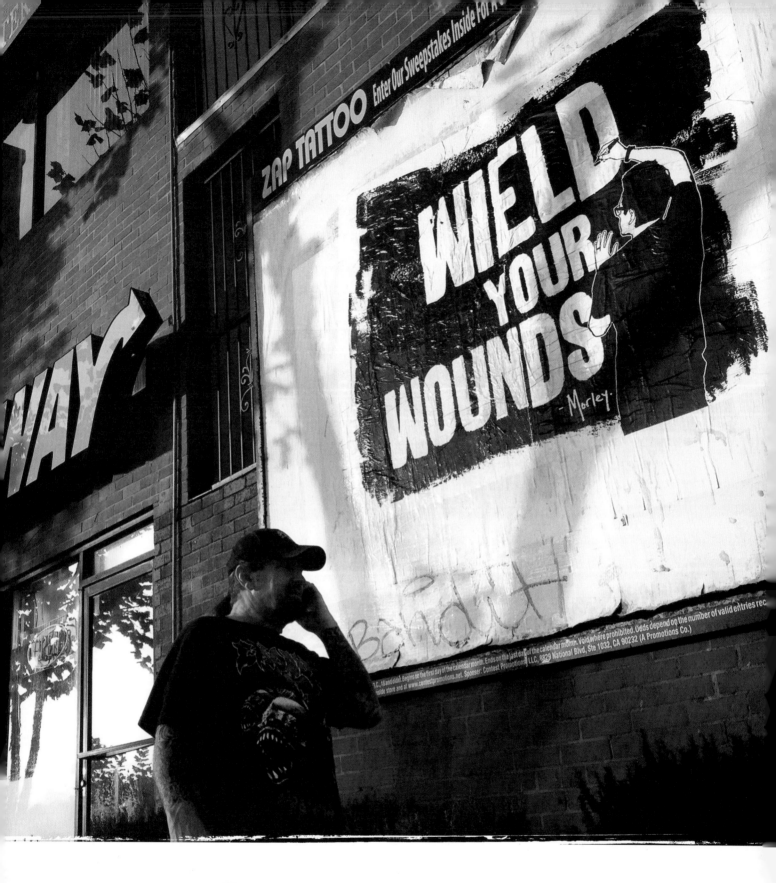

THE WIELD SERIES

I wanted to try doing a series of posters with a common theme in the text. This became what I called "The Wield Series." The idea is obviously about personal empowerment, taking control and using for one's own purposes the difficult or otherwise unwieldy aspects of life.

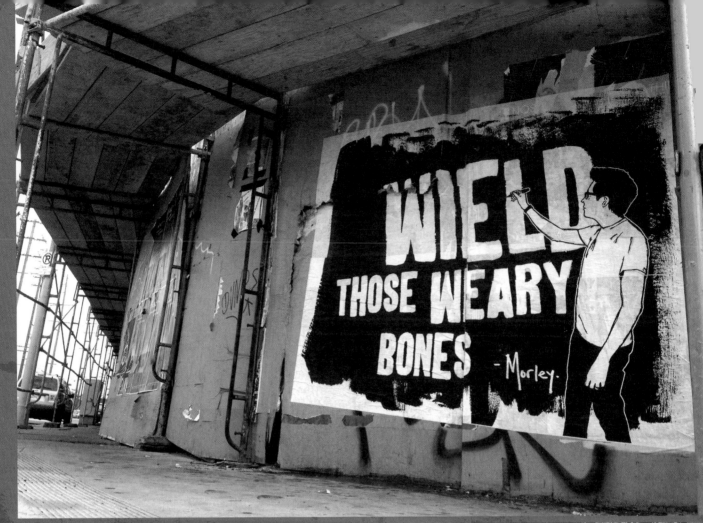

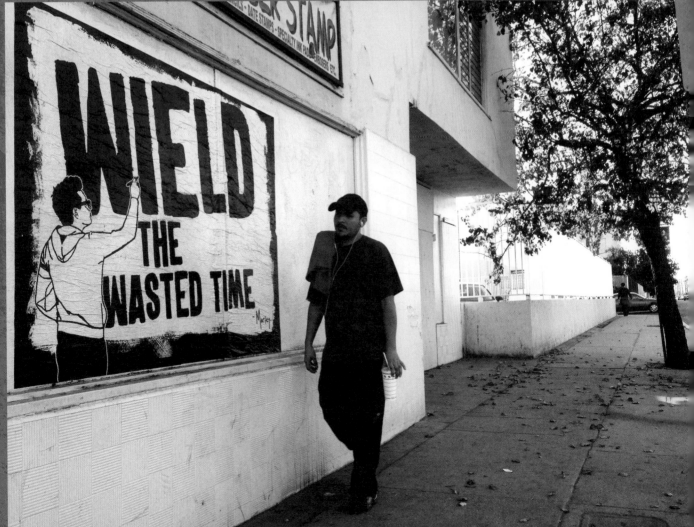

"The most absurd and reckless aspirations have sometimes led to extraordinary success."

—Luc de Clapiers

158

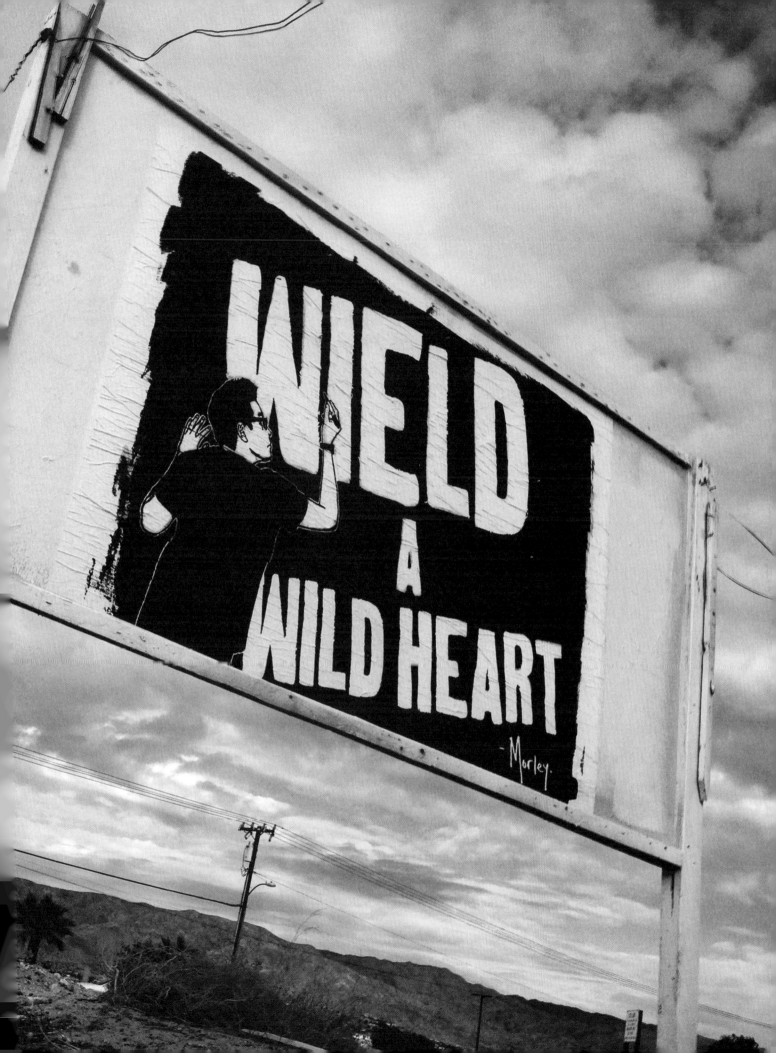

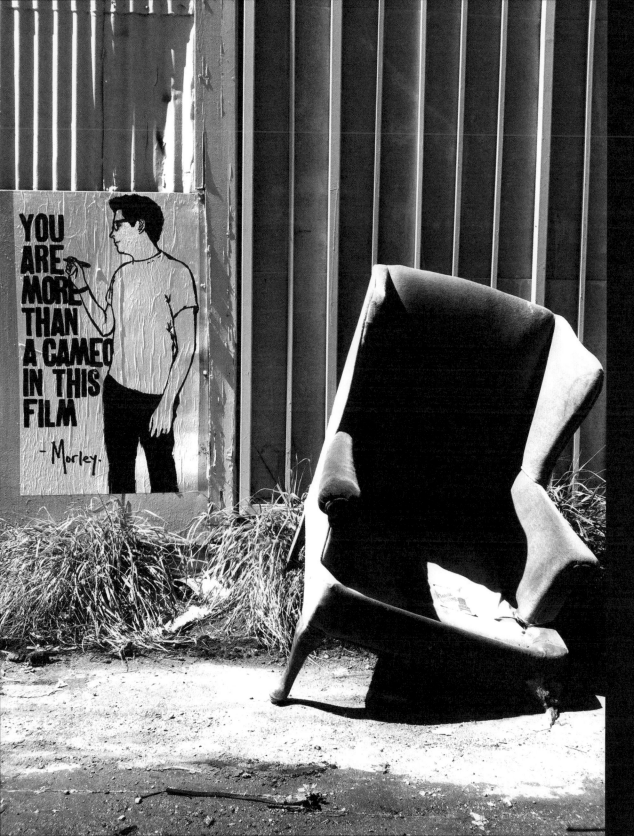

HYPEROPIA

There's a lot to admire about the true visionaries of our world, and yet, something to pity as well. To be forced to spend your life waiting for the world to catch up to your ideas must feel like a punishment. Of course, there are numerous men and women who've been able to translate their vision to monumental levels of success and progress, but I trust that even they feel the frustrating burden of imagining a world that can never truly be, left only to make the best of the broken pieces they're offered from this one.

Becoming the person you want to be can prove a more challenging objective if someone else already got there first.

"Tip the world over on its side and everything loose will land in Los Angeles."
—Frank Lloyd Wright

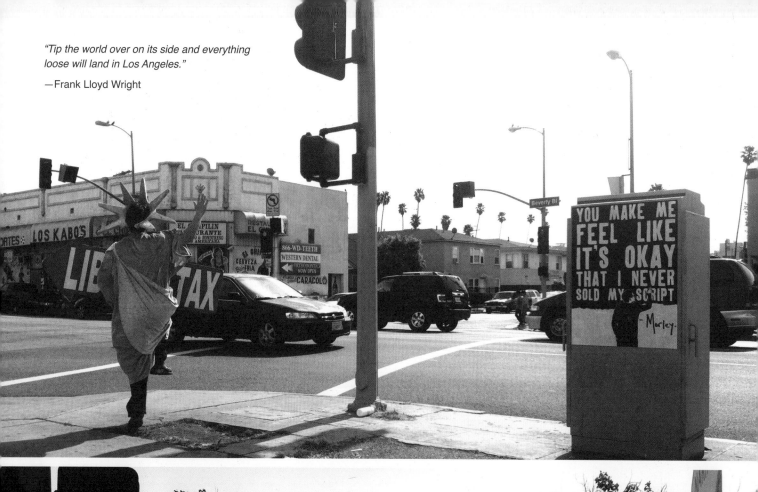

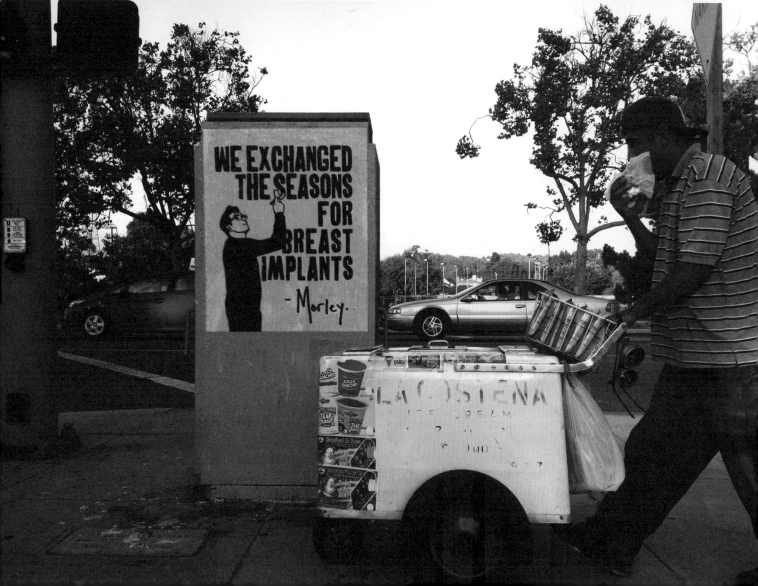

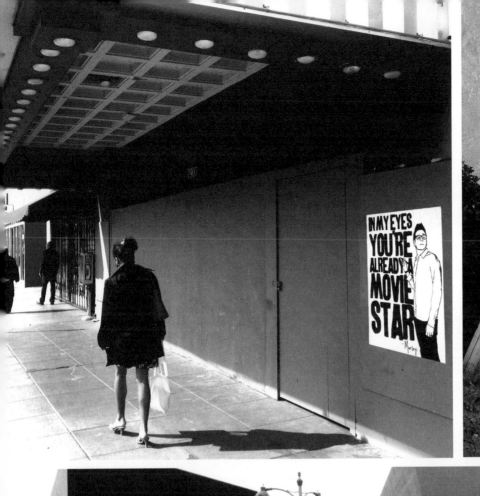

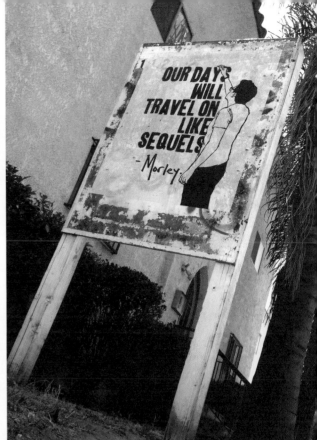

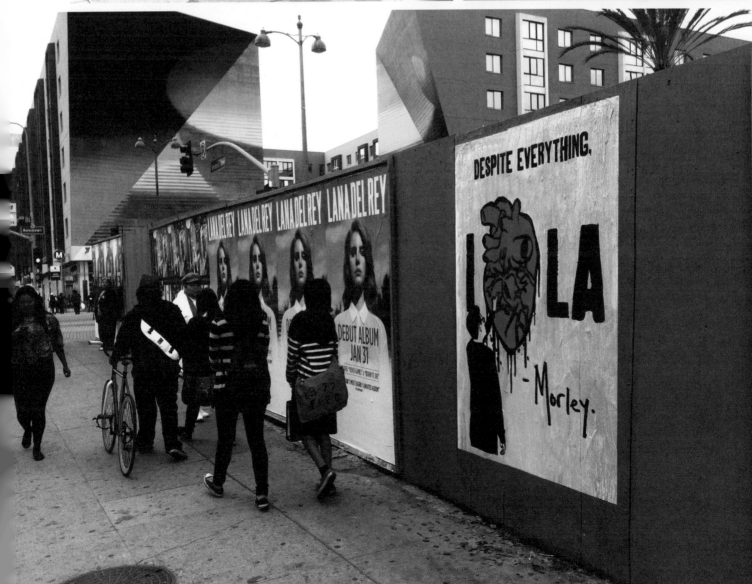

LATITUDE

This poster was born in part after a discussion I had with my friend Tim. A fellow transplant from Iowa, he's been in Los Angeles for the last eight years working as an actor. Every few months he confesses to flirting with the idea of leaving, wondering if living in Los Angeles is really what he wants or if more exciting prospects could be found somewhere else.

Selfishly, I'd like to rattle off a dozen reasons he should stay, but I always do my best to be supportive. I encourage him to consider the pros and cons as thoughtfully as possible, but let him know that I'd support whatever decision he arrived at, and I'm sincere. Luckily for me, he hasn't left yet.

There are times when all of us question the direction our lives are heading and wonder if it's not too late to veer off. The other night, lying in bed, I fantasized about running an ice cream truck. How gratifying would it be to spend your days making children smile, selling Flintstones Push-Ups and Rocket Pops?

Oh, for a job where the validity of the product isn't constantly being called into question. You could spend your entire life creating a painting, only to be told that it's worthless or that it "doesn't quite fit the demo we're aiming for this year." A guy selling ice cream isn't told to do something else with his life just because a few people don't like the flavors he's selling. I can't blame Tim for wanting to leave, and I refuse to accept that someone shifting his or her priorities is the same thing as being a quitter. But the most important thing to remember is that wherever we are, there is value in why and how we got there. This is not to say that there doesn't come a time to move on, but in the moments when you're convinced that the years you've spent somewhere have proven fruitless: they haven't.

The wisdom that comes from embracing the person your environment has made you is more valuable than booking any national commercial. The future might not keep you here, Tim, but right now, you're exactly where you need to be.

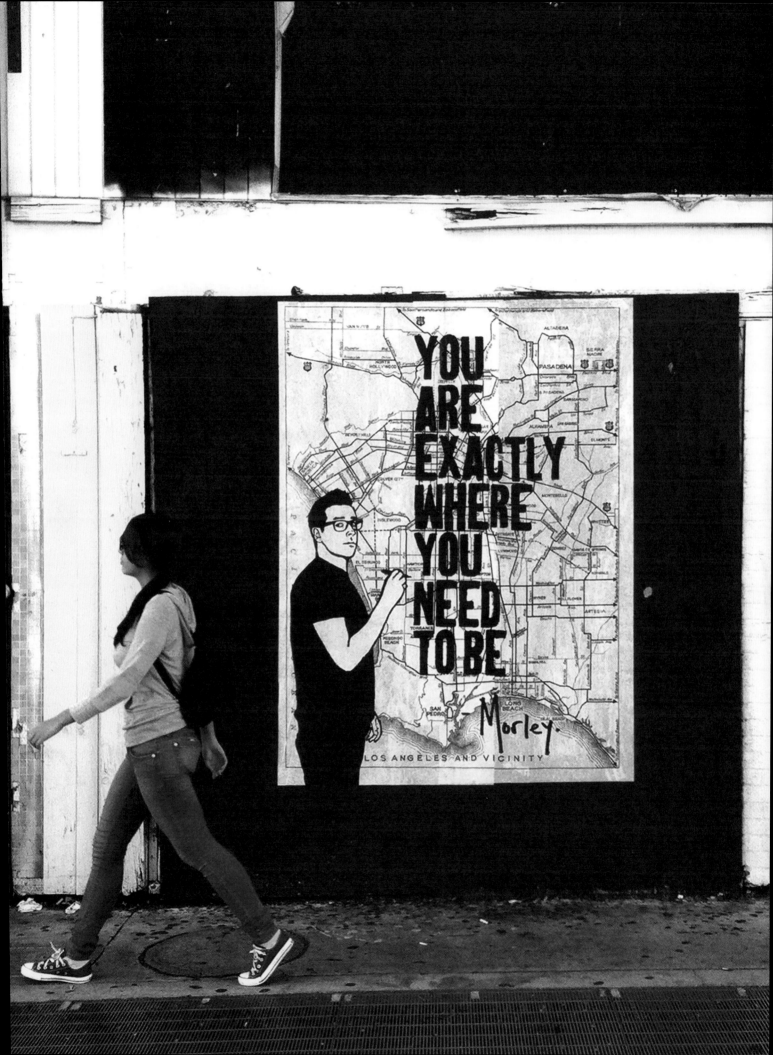

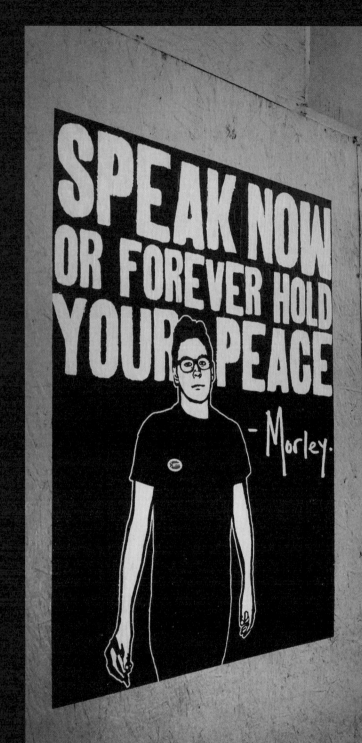

NOVEMBER 6TH, 2012

Having only lived through seven presidential elections in my life, the political season leading up to 2012 seemed even more endless than those that preceded it, and thanks to the deafening bicker of pundits and political double-talk from both candidates, it's easy to understand why someone would get disillusioned with the system that appears increasingly pointless in the scheme of things.

Nevertheless, I feel it's an important part of being an American citizen to do one's best to make as informed a choice as the media allows. After casting my vote, I decided to make good use of my "I Voted" sticker. I didn't want to push any specific agenda or tell people who they should vote for, just to encourage people to let their voices be heard by exercising their democratic right.

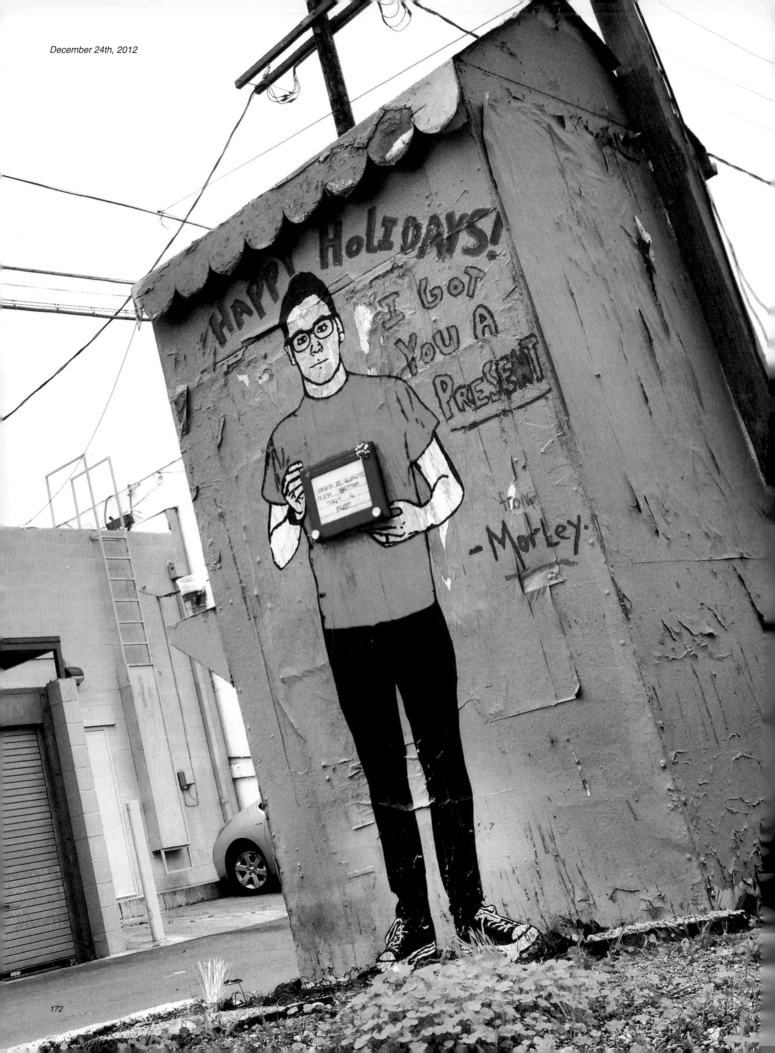

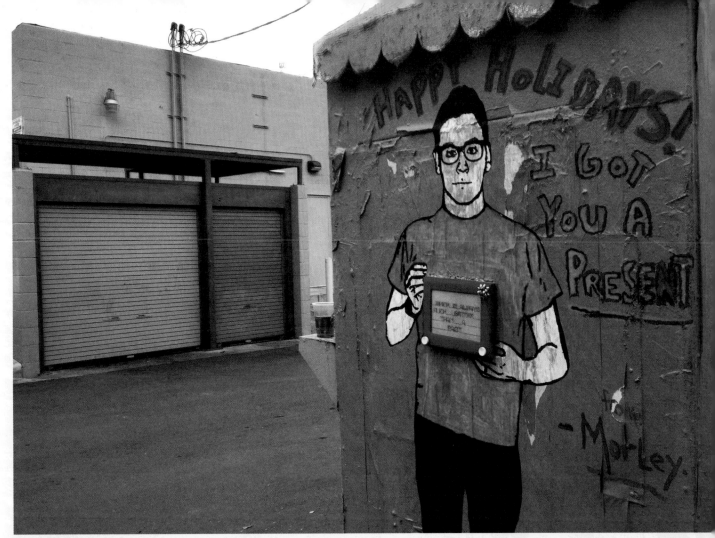

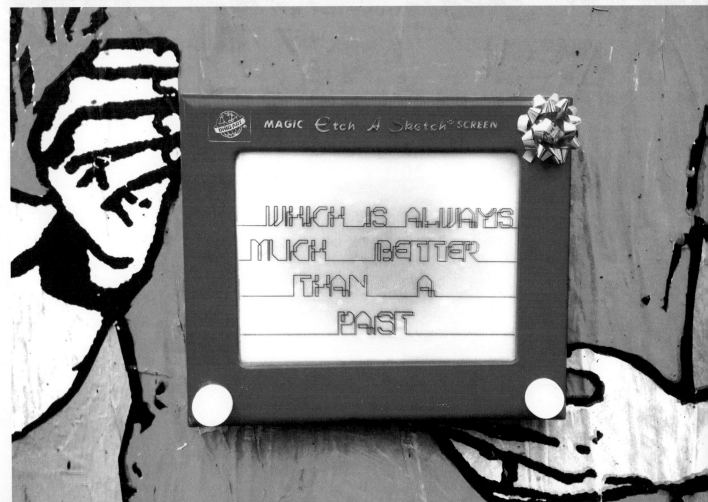

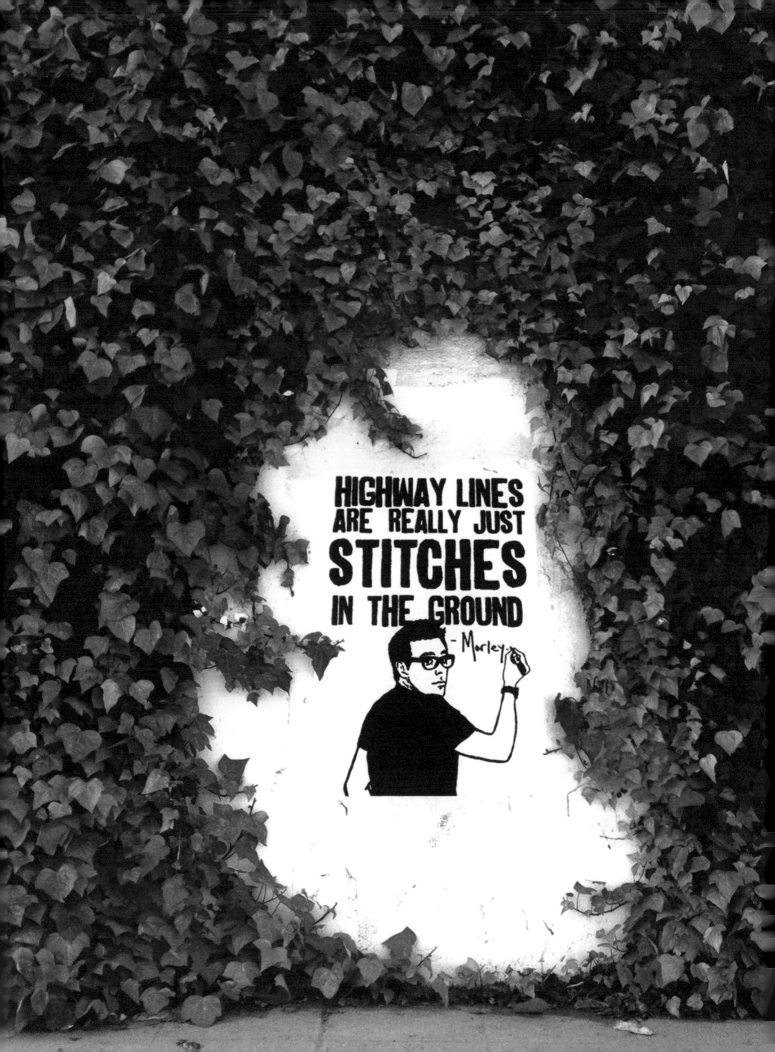

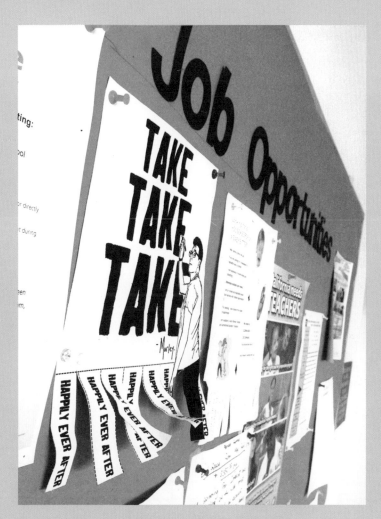

If you could put your artwork on any structure in the world, where would you put it? —Sasha Makayla Fuentes

The Great Wall of China. It would take a lot of time, but I can't imagine you can get much better than hitting a spot that's visible from low orbit.

"We must learn to reawaken and keep ourselves awake, not by mechanical aid, but by an infinite expectation of the dawn."

—Henry David Thoreau

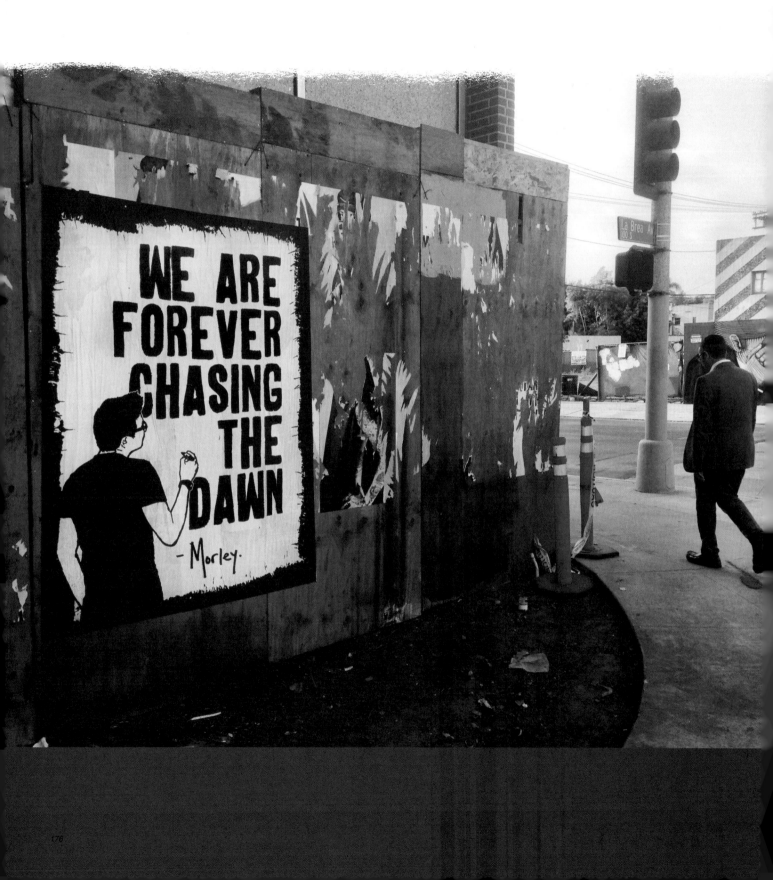

How good are you with a can of spray paint? —Moses Keshishian

Not very. Incidentally, I'm also pretty bad with hair spray, bug repellent, air freshener, and I can ruin any party with a can of Silly String.

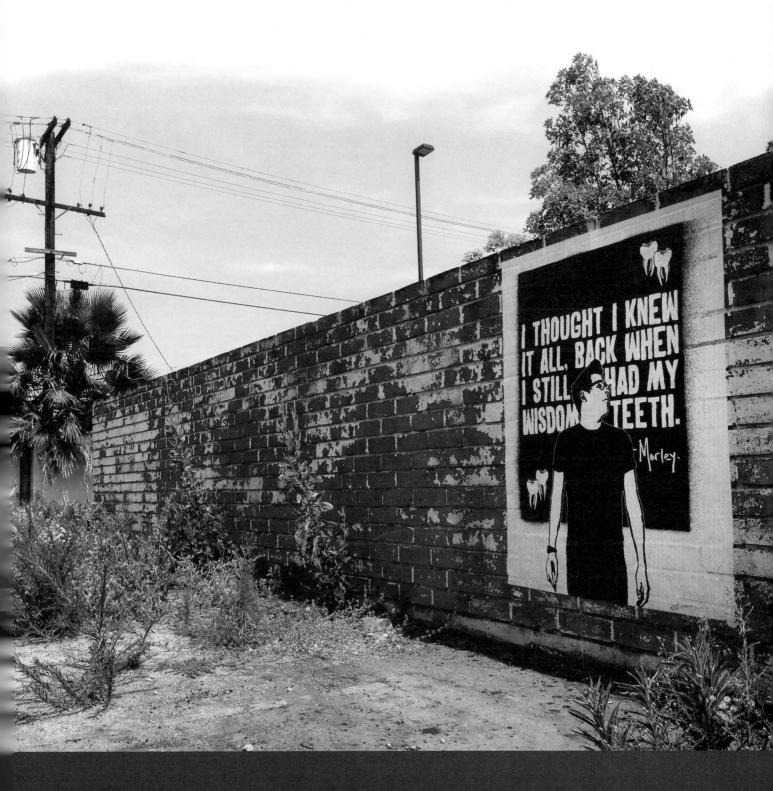

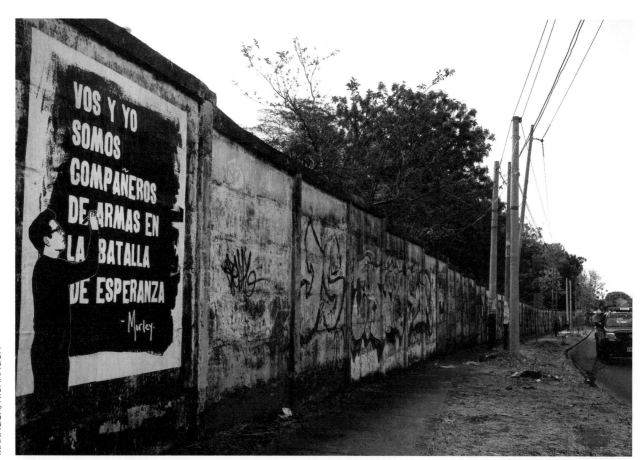

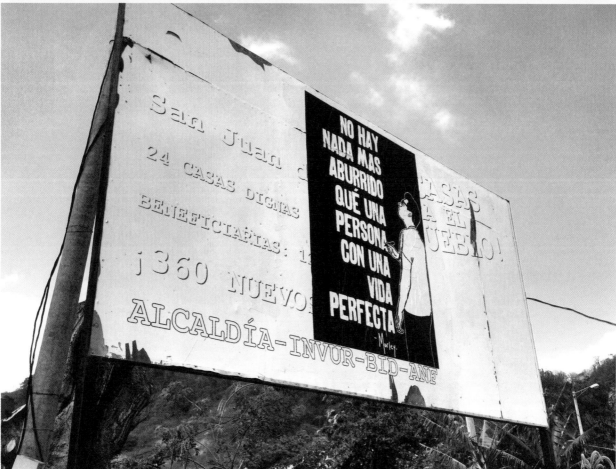

YO NO SOY DE AQUI

Nicaragua. It's the largest country in the Central American isthmus, bordering Honduras to the north and Costa Rica to the south. The country is situated between 11 and 14 degrees north of the equator in the Northern Hemisphere, which places it entirely within the tropics. The Pacific Ocean lies to the west, and the Caribbean Sea to the east. It's population is roughly 6,071,000 people.

That was about all I knew before I accepted a trip down, sponsored by the Volverá Project, which asked me to put up some of my art and help with a class on public expression with some local San Juan Del Sur kids. I briefly skimmed Wikipedia to see just how they punish vandals—I can take a little Singapore-style caning, but my courage falls short of anything involving electrodes or public execution. Wikipedia didn't mention anything like that, so I accepted. I asked my brother-in-law to translate a few of my slogans—I'd been told that often the language and proper translation can depend on region—and as he'd grown up speaking that dialect, I figured I was safe.

Upon arrival, as I left in the shuttle arranged to get me from the airport to my first city, San Juan Del Sur, the driver started laughing and explained in Spanish—which I only understood a few words of—"small, child, no mother or father"—I looked out the window and saw what seemed to be a fifteen-year-old boy flailing about as two police held him by his arms and legs and carried him, like one would a wounded man or someone having a seizure. I thought that perhaps the boy was having an epileptic fit, but after carrying him into a small security booth, before the door to the booth slowly closed, I saw the police holding the kid on the ground, punching and kicking him. The driver groaned in what I thought was sympathy but then

laughed again and said in English, "Bye baby". At this point, all that was missing in my first impression of the country was a soundtrack of "Welcome to the Jungle" by Guns N' Roses reminding me that "you're gonna DIIIIIIIEEEEEEE". Thankfully that was not a theme that reoccurred, and this turned out to be the most worrisome part of my journey.

SIDE NOTE: I discovered that no matter how hard I tried to recall my high school Spanish classes, literally the ONLY thing that I could remember was a song that taught you to "Rock the Capitals" of South America, which is great if someone were to put a gun to my head and demand that I tell them where Bogota is. It's a little less helpful when you're just trying to find a bathroom.

As far as how safe the country was, I seemed to get contradictory advice from the various expats I came in contact with. "Nicaragua is totally safe, you're just being a paranoid white American! The only people who get robbed here are the stupid, thoughtless ones who let their guard down for even a second! You're gonna be just fine. But if you see any kind of obstruction in the road ahead, we're just gonna ram through it because sometimes bandits build fires in the road and come from the sides with knives if you stop. But that probably won't happen so just sit back and enjoy some chilled-out reggae music." After all was said and done, I can honestly say that Nicaragua is a wonderful place where the people are warm and generous and I would happily return. For all my concerns, what I actually discovered was a vibrant culture, which has a long history with street art and embraces it along with anyone visiting to put it up.

I dropped a few of these Morley Men from a very tall church bell tower that was open to the public for the price of two American dollars.

"I BUILT YOU AN ARMY TO PROTECT YOUR HEART"
GRANADA, NICARAGUA

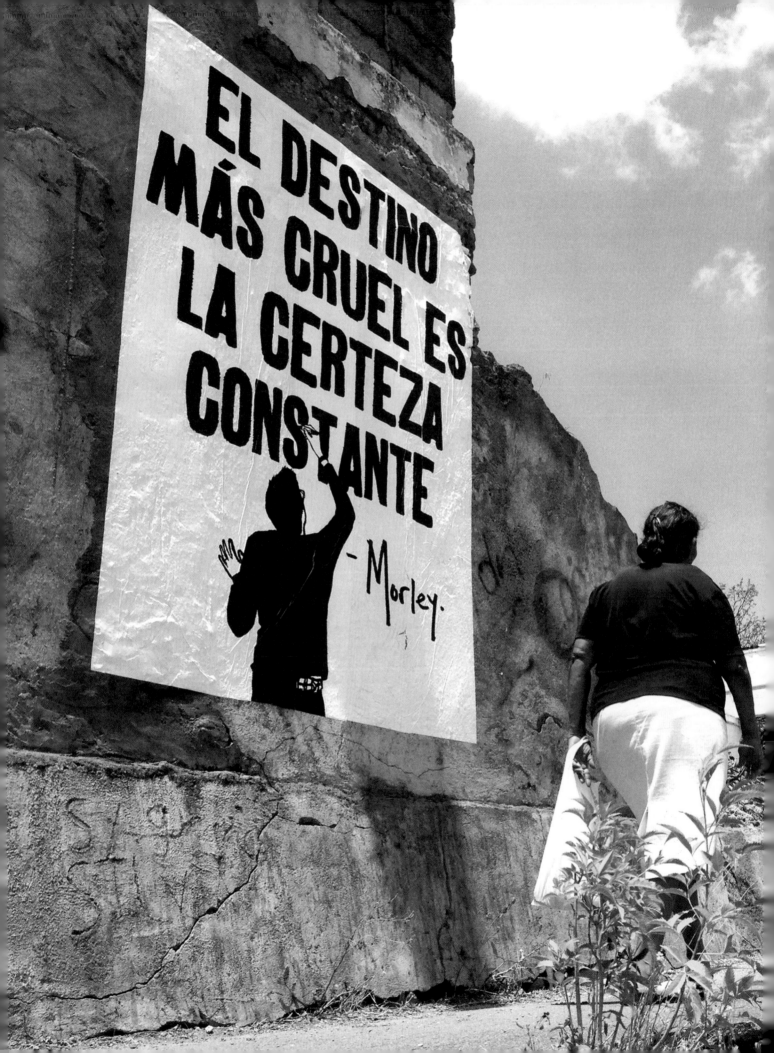

My friend David, acting as guide through my travels in Nicaragua, found this spot. It was an old abandoned hospital that had fallen into deep disrepair. I was so in love with what was left of this structure that I wanted to put up a second piece within its walls. As I, David, and David's friend Sean, our driver and helper for the night, scouted in the ruins for a good spot, David suddenly came up to Sean and I and told us to leave, that security was coming and he'd handle it.

We dutifully exited and waited. Later David would explain that when the security guards reached him, guns drawn and cocked, he claimed that he was a photographer and simply wanted to take photos. They ushered him off the site and watched us as we drove away, totally unaware that they had been watching from a hole in the building only inches away from the seven-foot poster we'd just posted.

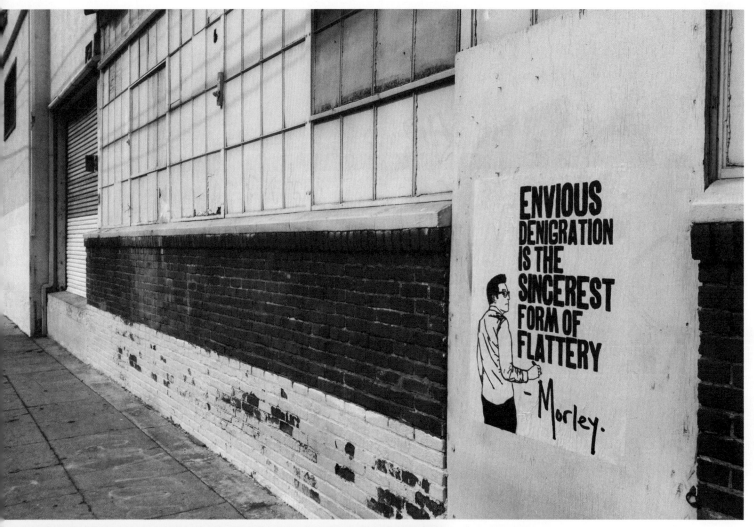

THE CRAB EFFECT

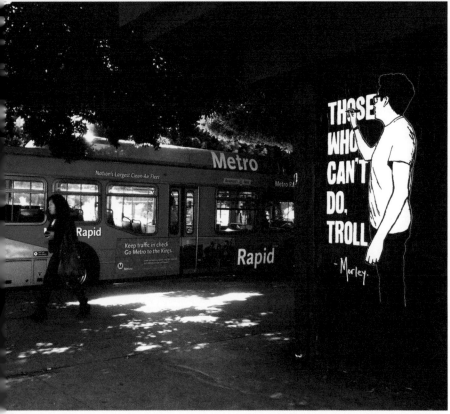

A pot of live crabs requires no lid. If the pot contains only one crab, it will almost certainly crawl out, but in a group of crabs, a curious phenomenon occurs. If one of the crabs attempts to escape, the other crabs will actually pull it back in. It's even been noted that often the other crabs will actually wait until an escaping crab is almost free before yanking it back down. They snap and grab at each other, sabotaging their peers' escape in a useless king-of-the-hill competition which ultimately only serves to prevent any of them from escaping.

Human behavior seems to mimic this from time to time. An envious mindset that leads to tearing down others we perceive to be achieving or receiving something we feel we deserve—or at least, that they don't. What's fascinating is that if we spent less time focusing on the success of others, and more time on our own ambitions, achieving them might be that much more attainable. The result of the Crab Effect is not: "Isn't it great? A crab who didn't deserve to escape got boiled because who the hell was he to think he's special, Sebastian from *The Little Mermaid*?!" This kind of satisfaction evaporates quickly when the water starts to heat up.

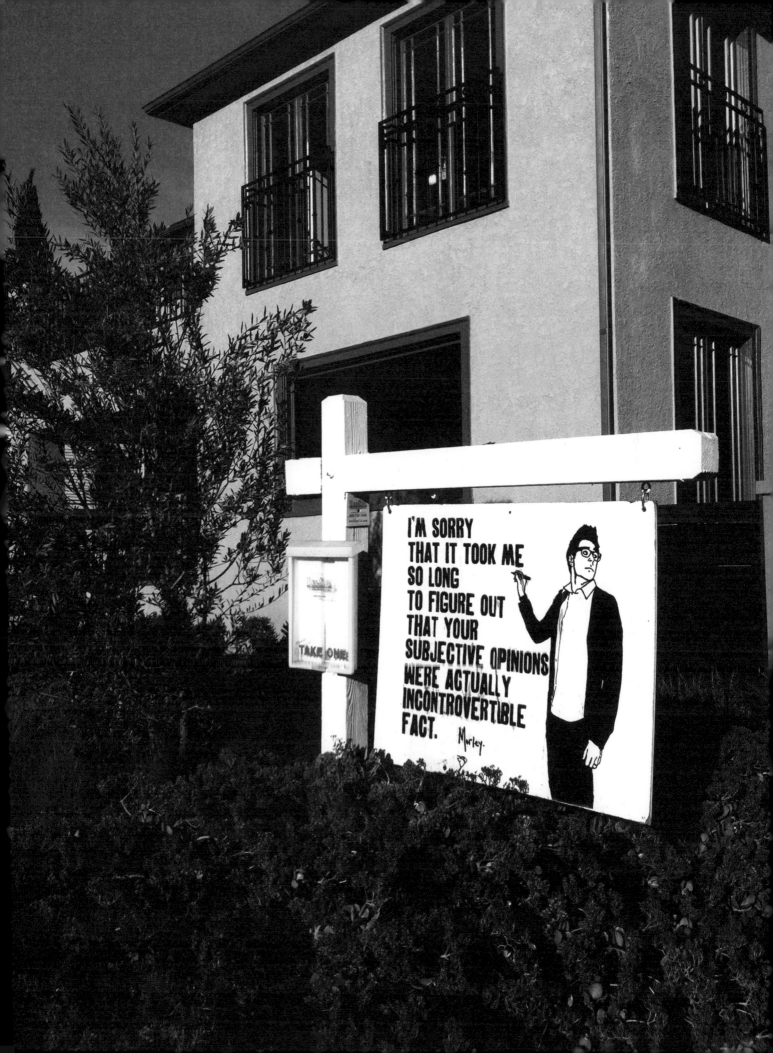

I HOPE WE SURVIVE ALL OF OUR DREAMS COMING TRUE.

They say that success doesn't turn you into an asshole as much as it reveals your true character. I just hope my true character doesn't like to wear silk shirts, constantly chant "SHOTS! SHOTS! SHOTS!" in public places, or use the phrase "I *crushed* it, bro!" in conversation.

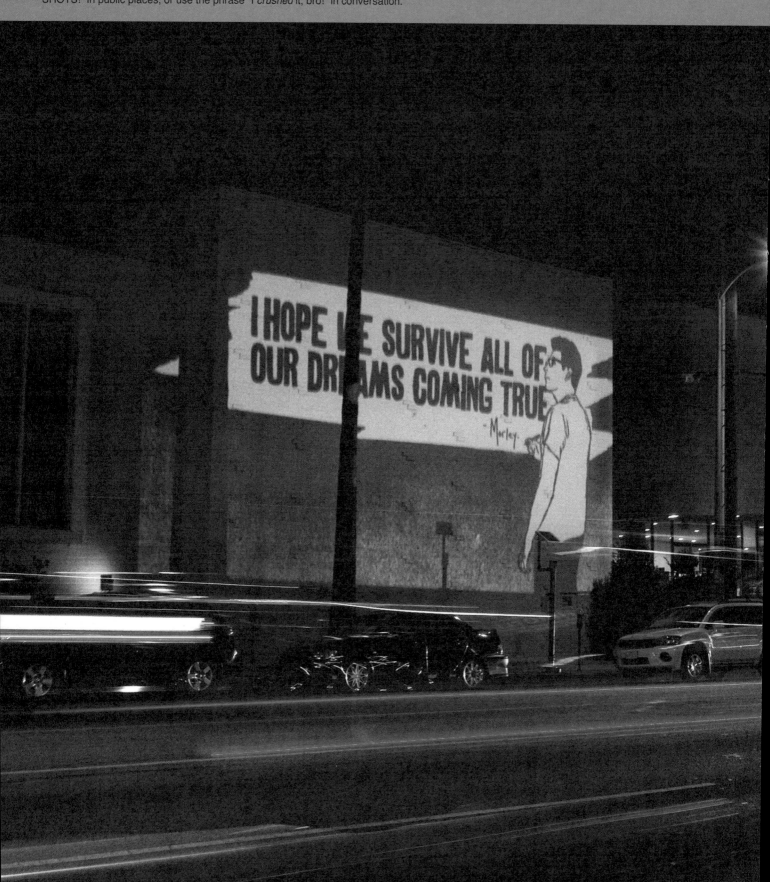

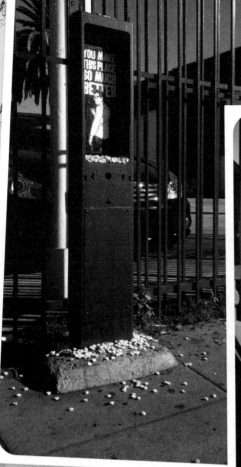

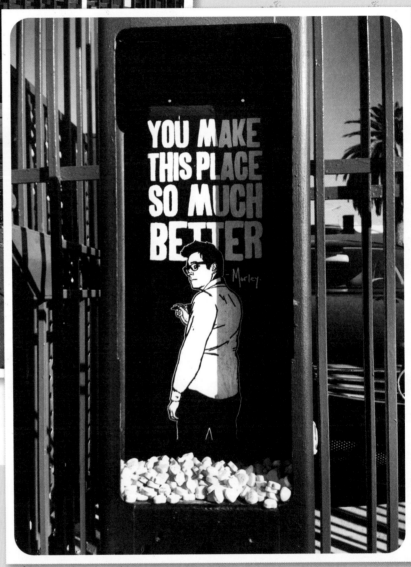

Once upon a time this was a payphone. But just because the PHONE part is gone doesn't mean it can't be used to tell someone you love them on Valentine's Day.

MORLEY VALENTINES
CUT THEM OUT! Give them away!

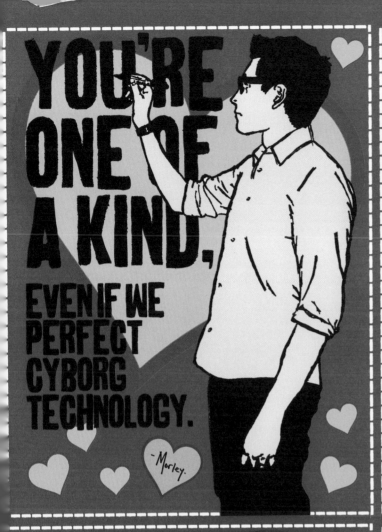

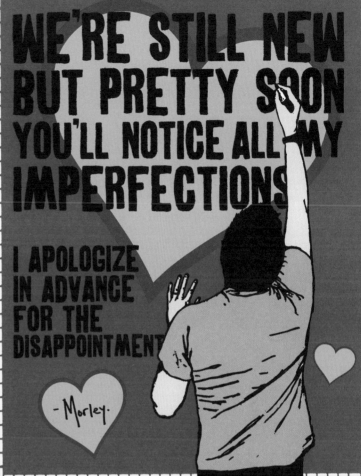

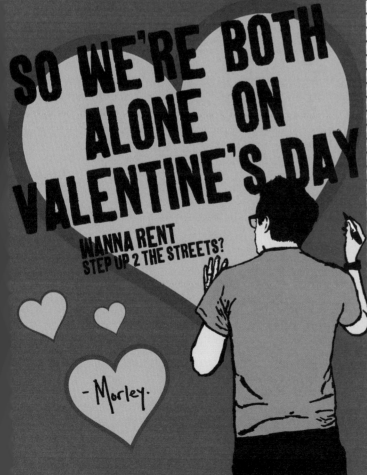

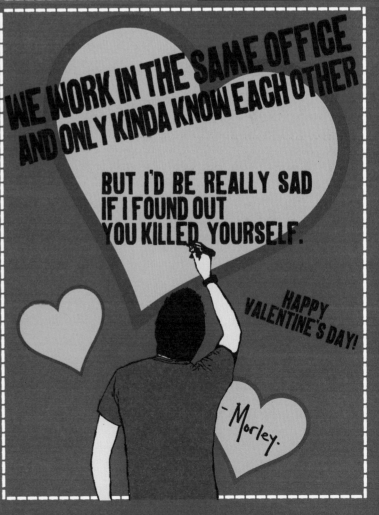

TO:

FROM:

MESSAGE:

TO:

FROM:

MESSAGE:

TO:

FROM:

MESSAGE:

TO:

FROM:

MESSAGE:

50 WONDERFUL THINGS...

1. WHEN YOUR TURN SIGNAL RHYTHM MATCHES WITH THE BEAT OF THE SONG ON YOUR STEREO
2. PUSHING IN THE BUBBLES ON THE LID OF A FAST FOOD SODA CUP
3. HELICOPTER LEAVES
4. JARS OF CHANGE
5. THE CLEAN TRAIL IN THE CARPET THAT THE VACUUM MAKES
6. SEEING WITH GOGGLES UNDERWATER
7. OIL PASTELS
8. THE SATISFYING FEELING OF MAILING A LETTER
9. THE THEME SONG FROM "READING RAINBOW"
10. A SINGLE CUT FROM ONE END OF THE WRAPPING PAPER TO THE OTHER
11. BROWNIES
12. REDISCOVERING THE BOXED UP TREASURES OF YOUR YOUTH
13. BREAST COAT POCKETS
14. THE SKY, FIVE MINUTES BEFORE A STORM
15. SNOW DAYS
16. SEALING A ZIPLOCK BAG
17. RABBITS THAT DON'T FREAK OUT WHEN YOU TRY TO PET THEM
18. COMIC BOOK THOUGHT BUBBLES
19. THE RARE OCCASION WHEN TOM & JERRY SET ASIDE THEIR DIFFERENCES
 AND TEAM UP AGAINST A COMMON FOE.
20. TILT-SHIFT PHOTOGRAPHY
21. SLEEPING CATS
22. THE SMELL OF OLD LIBRARIES
23. THE SMELL OF DAMP CONCRETE
24. THE SMELL OF BURNING LEAVES
25. THE SMELL OUTSIDE A LAUNDROMAT
26. THE SMELL OF A BIG BOX OF OLD, BROKEN CRAYONS
27. THE SYMPHONY "PETER & THE WOLF"
28. THOSE AWFUL TIGER ELECTRONIC HANDHELD VIDEO GAMES.
29. MYSTERY SCIENCE THEATER 3000
30. THE SIMPSONS, SEASONS 1-8
31. JACK LEMON MOVIES
32. JOHN CANDY MOVIES
33. G.I. JOE ACTION FIGURE FILECARDS
34. THE VOICE OF GARRISON KEILLOR
35. THE CRANBERRY DESSERT FROM TV DINNERS
36. CALVIN & HOBBES
37. HALL & OATES
38. BEN & JERRY'S
39. THE RUN AFTER LIGHTING THE FUSE OF A FIRECRACKER
40. SCRATCH AND SNIFF STICKERS
41. THE SONG "FREE FALLIN'" BY TOM PETTY
42. SINGLE SERVING VARIETY PACKS OF BREAKFAST CEREALS
43. WATCHING ANTS WORK
44. FRUIT ROLL-UPS
45. THE SOFT HANDS OF A GRANDMOTHER
46. WARMING UP WITH SOMEONE UNDER BLANKETS
47. LUDEN'S COUGH DROPS
48. PICKING OUT A DOZEN DONUTS
49. THE SOUND OF RAIN FROM INSIDE A PARKED CAR
50. THINGS YELLED IN THE MOMENT BETWEEN JUMPING FROM A HIGH DIVE AND HITTING THE WATER

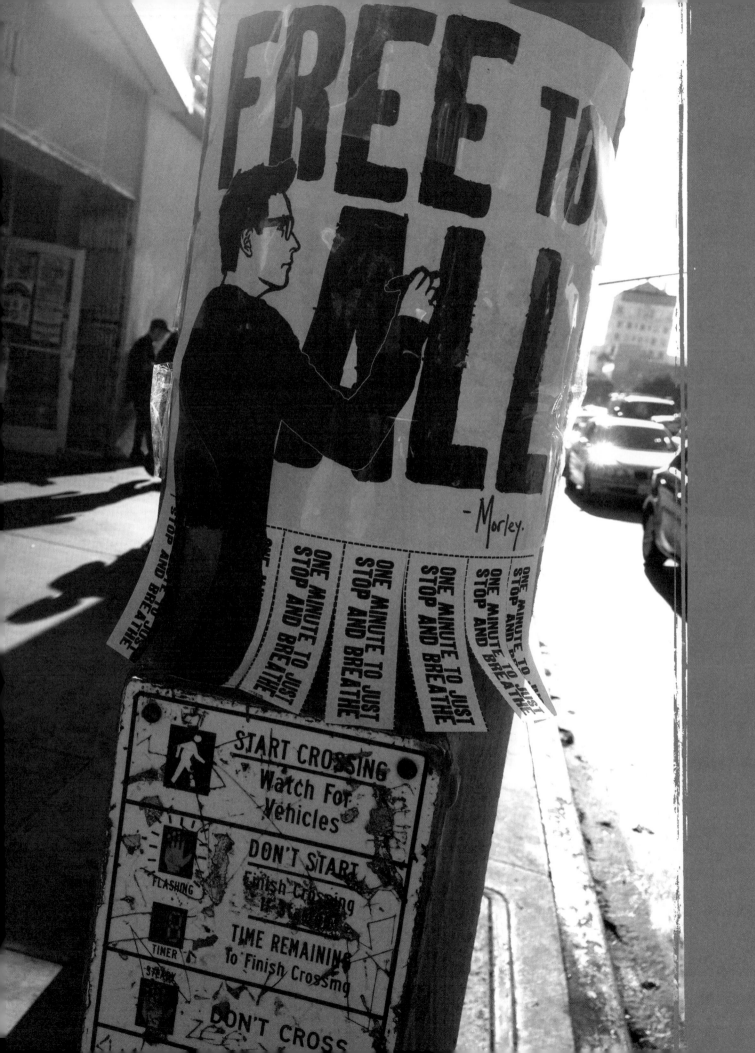

"Look not mournfully into the past, it comes not back again. Wisely improve the present, it is thine. Go forth to meet the shadowy future without fear and with a manly heart".

—Henry Wadsworth Longfellow

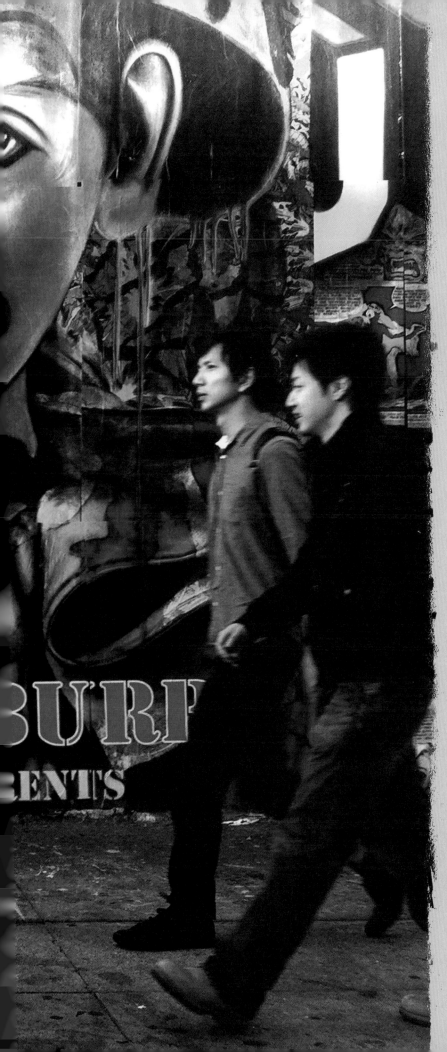

HERO WORSHIP

During my sophomore year in college, Sidney Lumet, the director of such classic films as *Dog Day Afternoon*, *Network*, and *12 Angry Men* (to name a few), came to speak at my college. It was the twilight of his career, but I could not have been more excited. As he spoke, I sat riveted by his stories and anecdotes of creating some of the most important films ever made. When the question-and -answer section began, my hand was the first that shot up. It was all I could do to stutter out a few flattering superlatives and some malformed question about working with actor John Cazale. Afterward, when he stood to leave and the crowd began to disperse, I mustered the courage to approach the director. As I walked over, my quivering hand grasped a copy of a screenplay I'd recently completed. "I'm sorry, I know this is totally unprofessional, and I'm sure you're very busy, but you're a huge inspiration to me, and I was wondering if maybe I could give you a script I wrote?"

He looked at me blankly for a moment.

"That's about the *LAST* thing I have time for!" he said coldly and continued walking. Shuffling behind him, the dean of the film department shot me a glare and muttered, "Stupid, stupid," under his breath. Behind him, an unknown woman exclaimed, "You should NEVER do that!"

Humiliated, I slunk away from the disapproving eyes of any-one who might have overheard the exchange and quickly threw away the script, hoping that disposing of the evidence would allow me to forget that I'd ever been so foolish.

The rejection of someone you admire can be devastating. We look on our heroes not just as people who do stuff we like but as surrogate parents, mentors, and best friends. We assume that because we connect with their work on an emotional level, the connection would extend to the authors as well. They may not know who we are, but they've played an influential role in our lives. Often because of this, they don't grasp the weight of their words. Sidney Lumet may have just been in a bad mood or maybe misunderstood my request, assuming I wanted more than the pleasure of knowing Sidney Lumet had a script I wrote in his possession.

Regardless, he stopped being my hero that day and re-turned instead to being just a man, as susceptible to terse grouchiness as any of us are. I still admire his work but no longer view him as someone above the status of a mere mortal.

Given enough time, every role model will let us down. Either they fail to maintain balance atop the pedestal on which we've placed them, or they refuse to match the fantasy we've ascribed to them. Unavoidably, these men and women we've cast into the sky will come crashing to the ground with a sickening thud and reveal themselves as less than the invulnerable titans we thought they were. This may sound exceedingly bleak, but it's all part of growing up and finding out who you are once you're stripped of the imaginary friends your heroes become. Forgiving them for being flawed makes giving yourself the same grace that much easier.

GAINFULLY DEFINED

For most of my adult life I've been preoccupied with the notion that my value on Planet Earth was defined by my career (or lack thereof). Similarly that my career defined who I was as a person—that when introduced to someone I might as well have said, "Hi, my name is Clerk at Blockbuster. It's nice to meet you, Genius at Apple Store." Actually, the first job I got once I graduated college *was* as a clerk at Blockbuster, and after moving to Los Angeles, the first job I applied for was at the Apple Store, and in a mass group interview we had to make what they called "a heartfelt explanation of why we were passionate about retail." Not Apple products, mind you, just the concept of working in retail. Needless to say my acting skills were not at the level that I could BS my way through that verbal obstacle course.

As I've gotten older, my quest for identity as defined by how I pay my bills has softened. Sure, I still get the desire to prove myself to the world through career accomplishments but at least these days I can safely say that I am more than my job. I am more than the career ambitions that I never reached (or at least haven't yet), and when I meet people, I am not defined by whatever I introduce myself as. Especially when I lie and tell people that I am a professional ghost hunter and part-time wrangler for that monkey that dresses up like a cowboy and rides a dog.

(Sigh) Only in dreams.

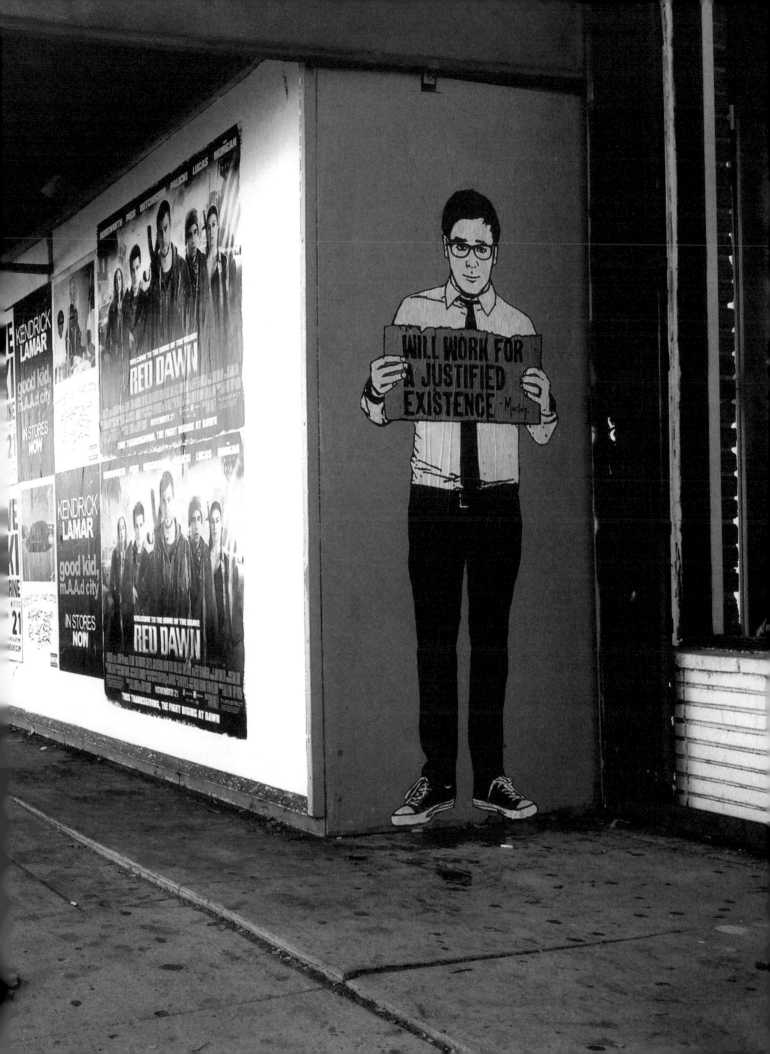

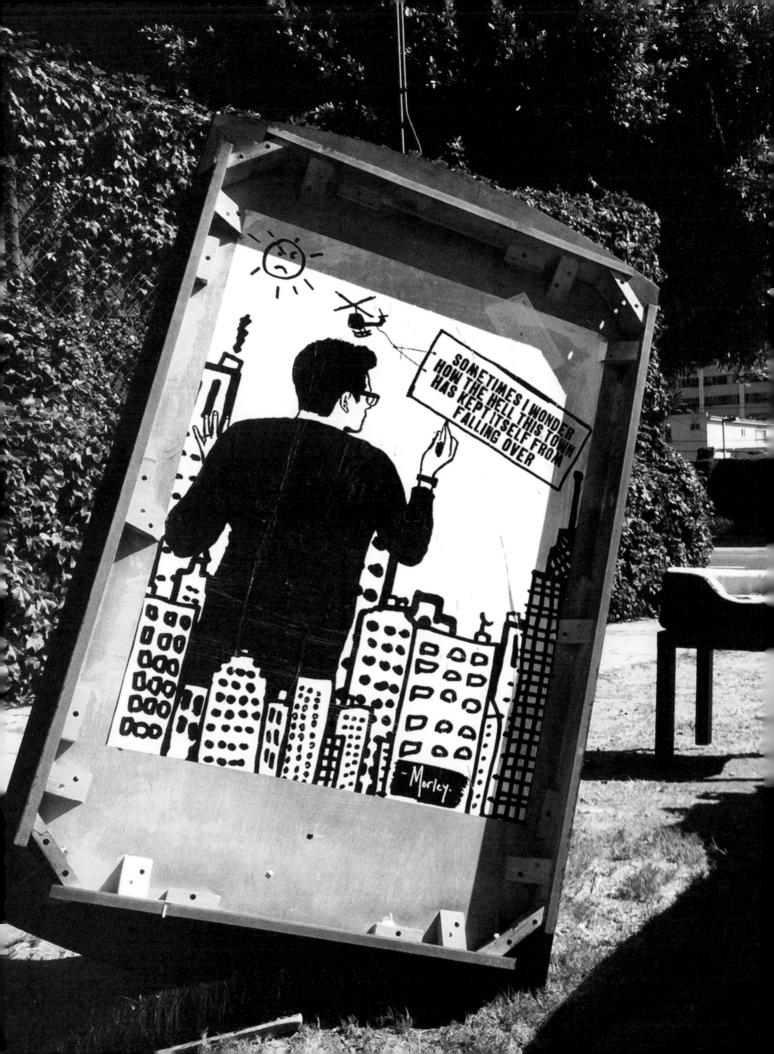

BILLY JAMES WILLIAMS

Discarded furniture is underrated when it comes to street art. While the city seems pretty fastidious about its electrical boxes, someone's forsaken couch could sit on a curb for more than a week without anyone even blinking an eye. One day, I saw this legless table proped next to an old car surrounded by junk. I approached the table and was about to unroll my poster.

"Hey!" said a voice. "What are you doing?"

I turned and quickly traced the voice to the parked car next to me. I hadn't even noticed him: a gentleman sitting on the passenger side, wearing what looked to be sweatpants and a white, crisply pressed, button-down shirt, fully unbuttoned and exposing his chest.

Between his fingers was a Virginia Slim cigarette.

"I'm sorry; is this yours?" I asked.

"Yes," he said gently.

"Oh. I didn't know."

"What's that you got?"

"Just something I put up. For fun."

"What's it say?" he asked, taking another drag off his thin, white cigarette.

I unrolled the poster and showed it to him. He read it out loud and then nodded, taking in the sentiment.

"Well," he said, "that isn't really one of the platforms for my campaign for presidency, but I'll let you put it up."

I laughed hesitantly, unsure whether he was making a joke or not.

Either way, I started pasting.

After I took a photo of the piece, I was preparing to leave when he stopped me.

"Now, I've got something for you!"

As friendly as the man had been, I have to admit that I was definitely thinking, "Oh no, is he gonna try to show me his dick? Because if so, I'm gonna be really bummed."

I walked closer, and he presented me with a gift...a string of papier-mâché chilies.

I thanked him profusely, relieved that it wasn't just a jar of his urine, and shook his hand, introducing myself.

"I'm Morley."

"My name is Billy James Williams, and I'm running for U.S. president! Tell your friends! I'm gonna be on the ballot this November, running below Dianne Feinstein." I smiled and told him I would. I didn't have the heart to question him about the fact that Dianne Feinstein is a senator and not running for president. Nor, for that matter, did I tell him that the presidential election wasn't until November of the following year.

As I drove home, I started to ponder the difference between Billy James Williams, the free spirit living out of his car while running for "president," and me, the main character of my own fiction. We all create our own sense of reality: how people see us versus how we see ourselves, and the truth-smudging that requires. Billy seemed happy enough, living in his delusion. That kind of escape from the shackles of sanity is almost enviable.

Shine on, you crazy diamond! May you win in a landslide!

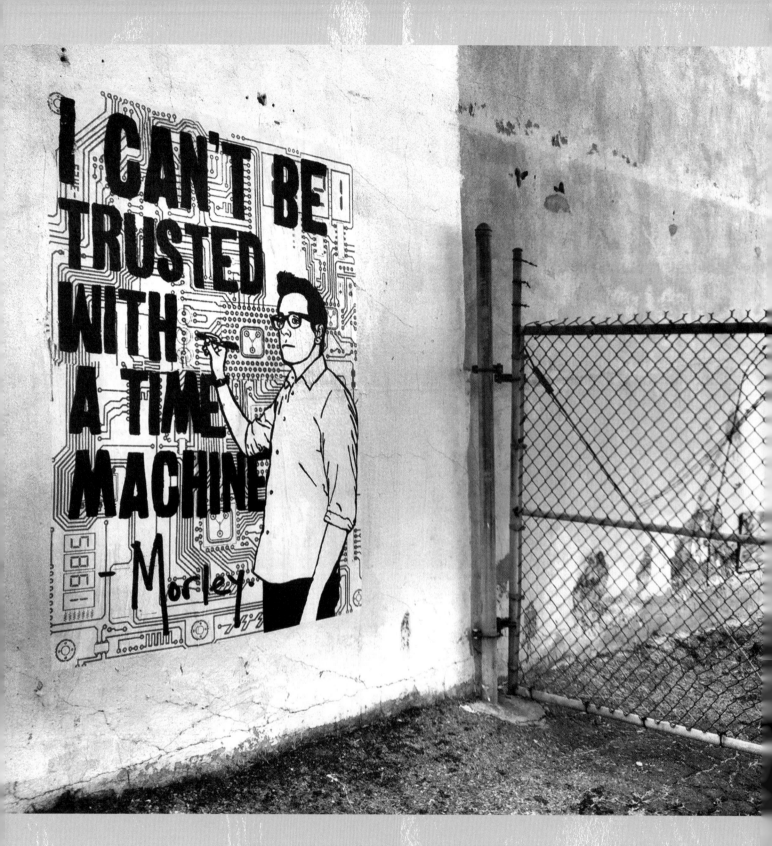

Would I kill Hitler? Maybe. That's a tough one. Would I make sure that the thirteen-year-old version of me didn't trip and fall while holding his *just purchased* slice of cheese pizza in front of Kate Lawrenson at the seventh grade dance? Definitely.

Either way, you can kiss your space-time continuum goodbye.

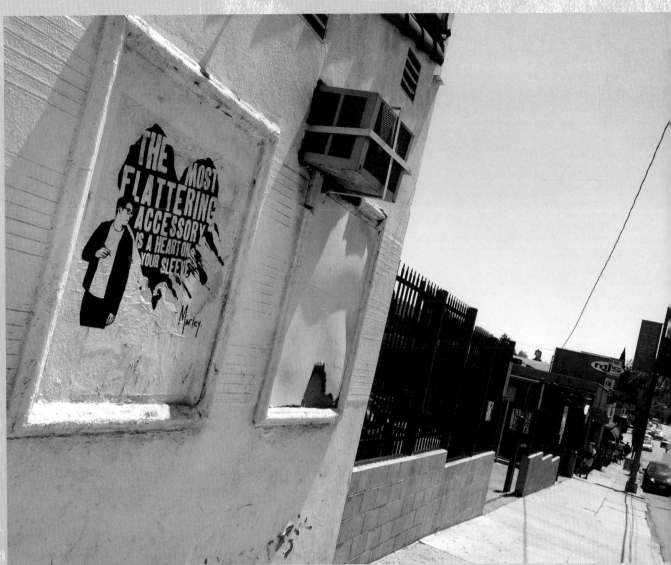

Wear yourself proudly.

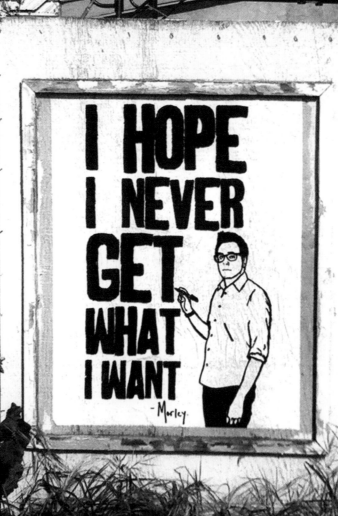

The grass is always greener on the other side of the fence. Usually, though, it's just Astroturf.

Which is worse: accomplishing every goal you set your mind to, only to find each victory hollow and unsatisfying, or spending your life chasing dreams that only retain their purity by remaining forever just out of your grasp? When I look at my life, I rarely see my successes for much beyond the limits they failed to breach. Is the curse of ambition the inability to take pride in the hurdles we've cleared and see only the hundreds that still lie ahead? Is the destination that much more beautiful if we never arrive to see that someone has drawn a dick on the wall? I suppose the answer is the redfinition of how you expect to feel when you get there and how much you've allowed yourself to enjoy the trip.

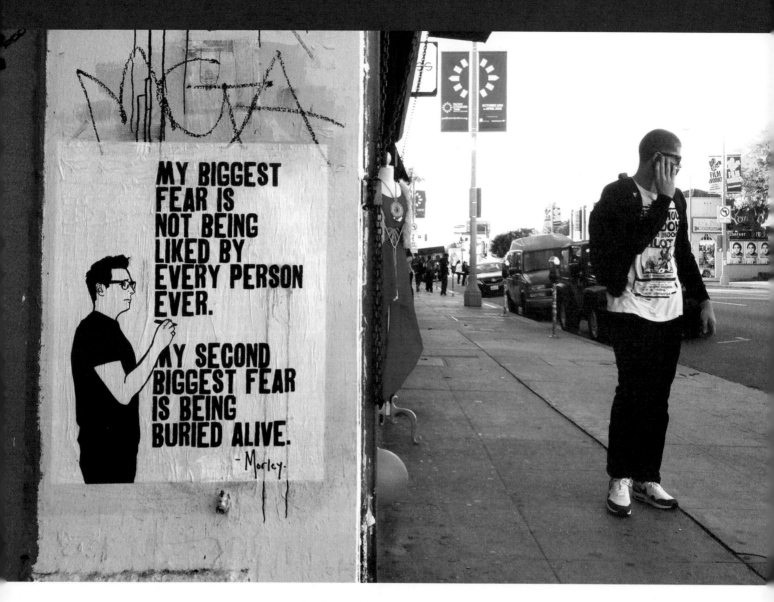

KICKING THE HABIT

When I was in sixth grade, the teachers at my school set aside time from our normal routine for the D.A.R.E program, a police officer–led series of lessons attempting to teach children about the dangers of drugs and how to resist drug-related peer pressure. I don't remember much about the lessons today, other than the impressive variety of drugs they touched on. They covered all the obvious stuff like cocaine, heroin, huffing, steroids, etc., but for some reason felt the need to include quite a few substances that now seem a little outdated and obscure. Were kids my age really doing quaaludes? How many cases are there of people strung out on peyote these days? Was I just lucky to never have friends that pressured me to try powderized Novocaine? Regardless of how complete D.A.R.E. was determined to be, in hindsight there was one drug that the officers missed, and sadly, it was the one drug I've fought an addiction to for most of my life.

The drug of approval. For most people, all it takes is a little taste and we're hooked. A compliment, a gold star, a smattering of applause at a recital, a high five after scoring a point in a Little League game. It all seems harmless, but before you know it, you crave even the smallest accolade and will do pretty much anything to get another hit. Over time, though, you build up a tolerance and a few kind words no longer do the trick, so you begin seeking out new methods of achievement. In the process, you will most likely acquire a few critics or haters. They will range from those who simply aren't fans to those who actively work to tear you down. These people are likely addicts in their own right and are just looking to cop your attention stash. You try your best to ignore them, but because of your addiction, even a minor critique can spark a full-blown identity crisis.

My name is Morley…and I'm an approval-holic.

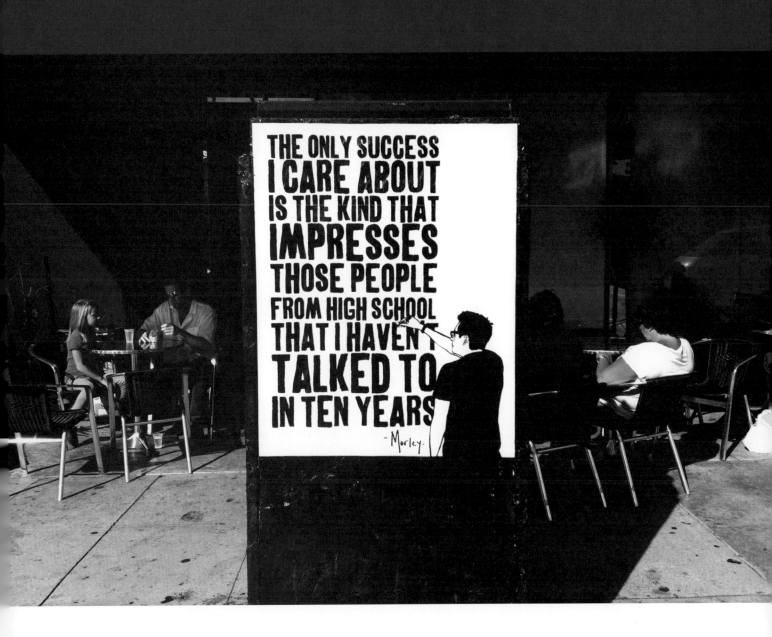

It's funny when you consider that no one in the history of Planet Earth has been universally beloved by everyone (and those who came close were pretty much all murdered). Yet we somehow convince ourselves that we could be the exception. Think about the person you admire most, and I guarantee that there is someone who really hates them. Someone who think that they are overrated, full of themselves, fake, or just annoying for some vague and unspecific reason and this someone feels the undeniable desire to take them down a few pegs. To remind your hero of their own frail, flawed humanity, if they can't manage that, to make sure as many people are aware of said flaws as possible, and if they can't manage that, well they can always just write the word FAG on their locker.

I can accept the basic principle that not everyone will like me or my stuff, so why is it that whenever someone trashes something I've done or makes a snarky comment online, I get the wind knocked out of me? I shouldn't be surprised, and more importantly, I shouldn't let it bother me as much as it does, but I can't help it.

The way I see it, the only way to rid myself of that pain is to kick the need for praise, overcoming the sensitivity to being disliked along with it. If you aren't constantly trying to get people to like you, it doesn't bother you as much when they don't. Is it possible to create art for others and not innately seek the approval of it? I'm not sure. Probably not completely. But we can wean ourselves away from our addiction little by little. I try to limit the amount of time I spend online, I avoid comment sections of blogs or articles about me, I consciously try to focus my thoughts away from myself, the perception people have of me and how many fans I have or don't have. Sure, I suffer the occasional relapse and visit some blog, read some smug comment and foolishly engage the person, only to rediscover, as always, that I can do almost nothing to change someone's opinion. Civilized discourse requires both parties to treat one another like human beings with actual feelings, not verbal punching bags to demonstrate superiority over with juvenile all-caps name-calling.

In the end, as with all addictions, we can only take these things one day at a time, and continually seek the serenity to accept the things we cannot change; courage to change the things we can; and the wisdom to know the difference.

"The aim of art is to represent not the outward appearance of things, but their inward significance."

—Aristotle

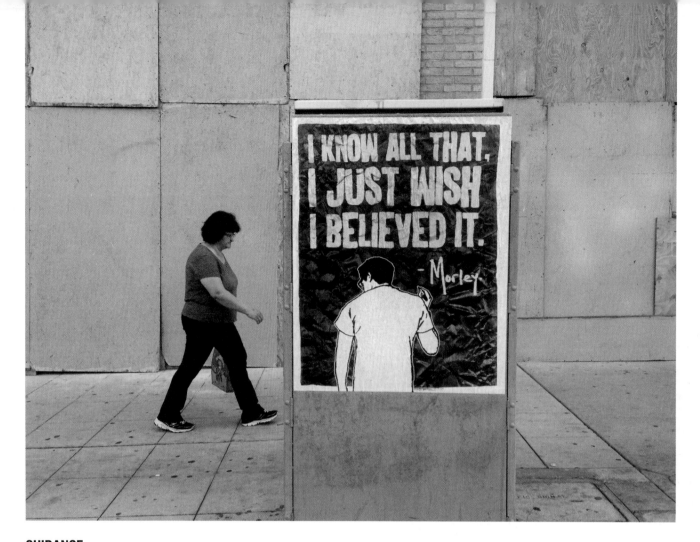

GUIDANCE

Over the years that I've been doing this, I've had more than a few people write to me, thanking me for a message that helped them get through a difficult tragedy. Often the stories will dwarf anything I've ever had to go through myself: lost limbs, lost homes, lost loved ones, struggles with sobriety, struggles with domestic abuse. It's humbling because I barely know what to say in response. Had I known that my messages would be an ambassador for hope in the face of such genuine pain, I might have run them past a grief counselor first.

When I was in seventh grade, my history class read *The Diary of Anne Frank*. I had seen the film prior and was familiar with the story, but nevertheless had a profound reaction to the text. Knowing that the words on the page had actually been written by a real girl, a girl my age, suddenly turned the book into a document, the story into a deposition. Anne Frank stopped being just the literary character in my head and took on flesh and bone. Now I was left to mourn her and I just wasn't emotionally prepared for it. I had what I guess you might qualify as an existential crisis. I just couldn't grasp the horror that humans had perpetrated in relatively recent history. For all the comics I had read with Captain America punching Hitler, suddenly he seemed very different from Darth Vader. The evil he had inflicted on so many, including Anne Frank, wasn't just a figure I needed to remember for a quiz anymore. I wanted to talk to someone, someone who could help me gain some kind of perspective.

In hindsight, I realize how silly it was to visit the guidance counselor. Guidance counselors may serve an important role in the life of a junior or senior in high school, helping them prepare and apply for

colleges, but in junior high they're pretty useless. Still, I was twelve, and took his title at face value. I probably threw the guy completely for a loop. He must have expected something very different when I made the appointment with his secretary, but after I entered his office and sat down, all he had to say was "What can I help you with?" and I went right into it. For probably five minutes I spoke in a stream of consciousness, detailing my emotional journey and every cerebral diversion along the way. After I finished, I wasn't sure what I wanted him to say, but after a long pause he cleared his throat.

"Those Nazis were bad dudes." I waited for him to elaborate, but got nothing. In fairness, he may have said one or two other things before I left his office, but nothing of substance. Walking back to class, I couldn't have felt more alone, wondering (ridiculously) if I was the only person on Planet Earth who realized just how awful the Holocaust was.

The e-mails I get are so kind, so encouraging, and yet often leave me feeling like I'm no better than my seventh-grade guidance counselor. "What a sad story! I'm so glad my little phrase did some good! Don't forget to make up that gym class you missed last week!" Ultimately, I have to remind myself that if my work helps people whose problems go beyond my pay grade, it's because those people decided it can. I'm sure that to the people who can speak from authority when it comes to loss, there isn't really a "right" thing to say. Real loss is healed only with time and some magical part of our soul that figures out a way to regenerate. If something I've written trips some synaptic salve to help that process along, I'll take that as a win.

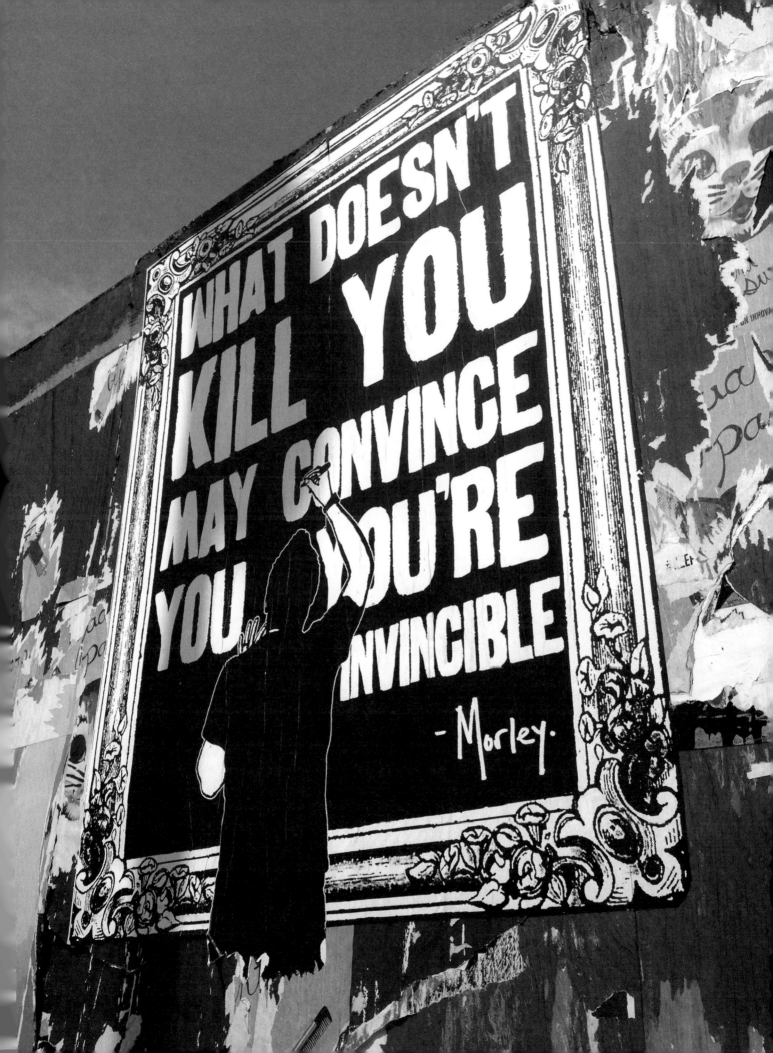

THE HUMAN BEING AWARD

In 2009 the Nobel Peace Prize was awarded to President Barack Obama. The Nobel Committee's decision drew mixed reactions, many questioning exactly what Obama had done to deserve such an award, having only become president the previous year. The notion was arrived at by some that the award was given to spur Obama to pursue peaceful leadership, and perhaps encourage him to *earn* the honor.

This gave me an idea for "The Human Being Award," an award for people who are able to behave like decent human beings who live in a society and can treat others with basic kindness and respect. Sadly in this day and age, this is not as common a behavior as it should be, and as such deserves to be acknowledged.

I decided to dress up in appropriate medal-presenting attire, and hide my medals throughout Los Angeles. While I can't know for sure who would find them, or if they did indeed deserve "The Human Being Award," I hoped that whoever stumbled across the medals would, if nothing else, be encouraged to earn the distinction.

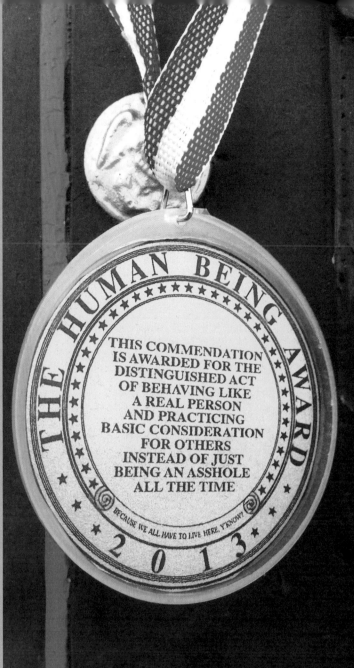

THE HUMAN BEING AWARD

★ ★ ★ ★ ★ ★ ★ ★ ★ ★

THIS COMMENDATION
IS AWARDED FOR THE
DISTINGUISHED ACT
OF BEHAVING LIKE
A REAL PERSON
AND PRACTICING
BASIC CONSIDERATION
FOR OTHERS
INSTEAD OF JUST
BEING AN ASSHOLE
ALL THE TIME

BECAUSE WE ALL HAVE TO LIVE HERE, Y'KNOW?

★ 2 0 1 3 ★

This Marine mannequin was standing outside of an army surplus store in Silverlake. He looked so regal, it just seemed right to give the soldier one more decoration.

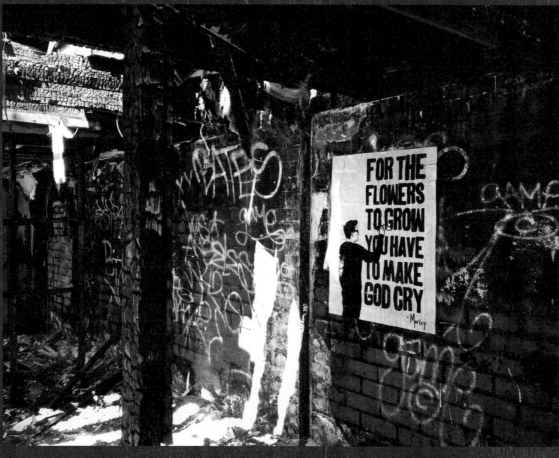

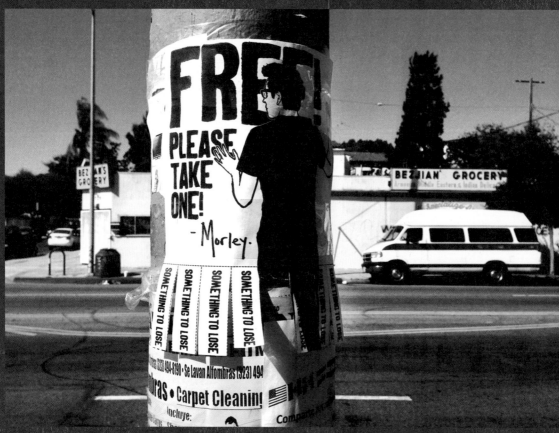

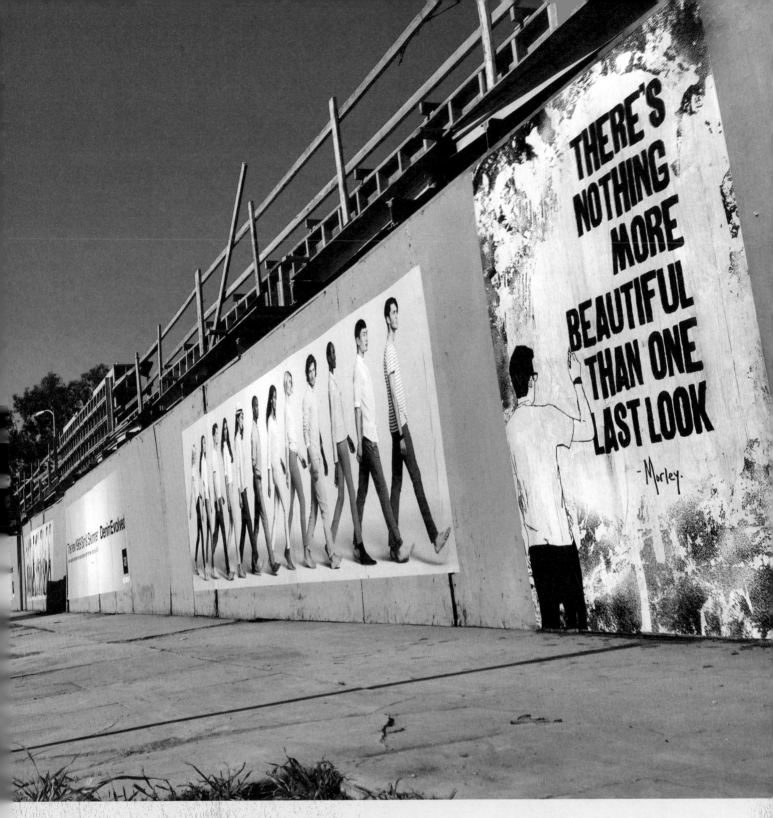

What posters can fans expect to see in a post-apocalyptic L.A.?
—C. Maye

Here's a few…

"LET'S FALL IN LOVE LIKE BOTH OUR PARENTS DIDN'T JOIN A GANG OF ROVING CANNIBALS"

"I LOVE YOU ENOUGH TO SPLIT MY RATIONS WITH YOU"

"I'M SOSO SORRY THAT I HAVE TO KILL YOU BUT YOU WERE BITTEN BY A ZOMBIE AND COULD TURN ANY MINUTE"

I saw this deer lying helplessly in a pile of trash on the side of the road and was struck with the sudden desire to set him free in the wild. I loaded him into my car and took him up to Griffith Park, where I carried him off the path to a nice spot overlooking downtown Los Angeles. He was pretty banged up, so I left some words of encouragement to help keep his spirits up as he mended in his new home. His disposition seemed to improve immediately!

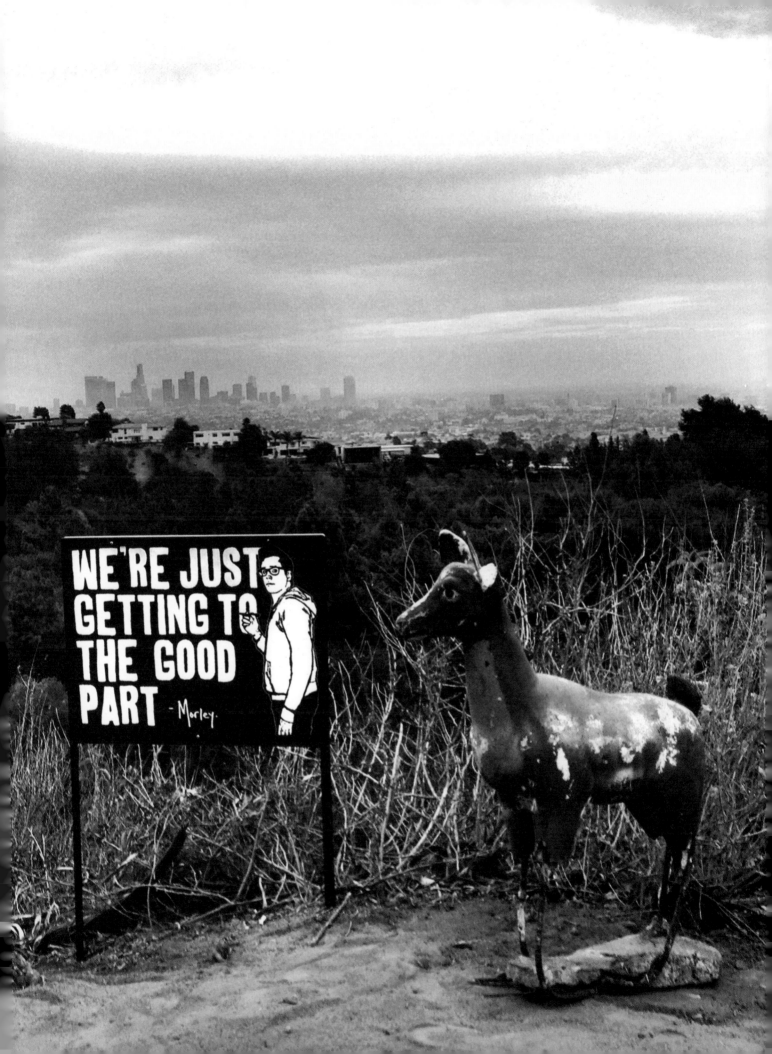

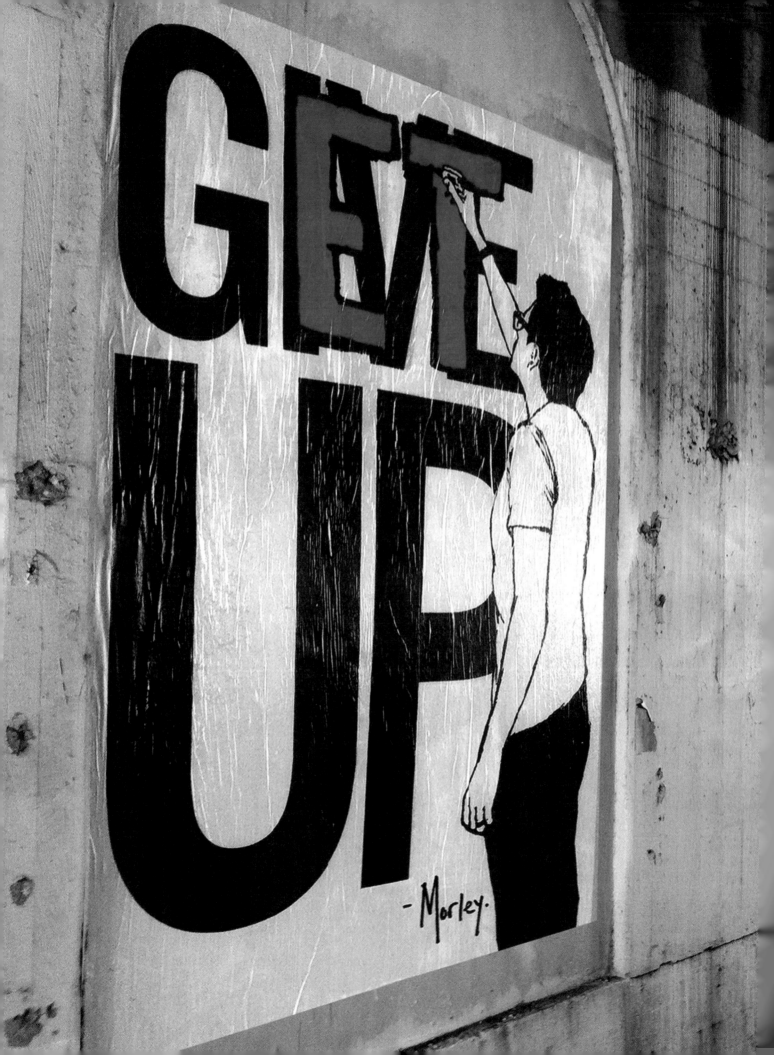

"Tho' much is taken, much abides; and tho' we are not now that strength which in old days moved earth and heaven, that which we are, we are; one equal temper of heroic hearts, made weak by time and fate, but strong in will to strive, to seek, to find, and not to yield."

—Alfred Lord Tennyson

217

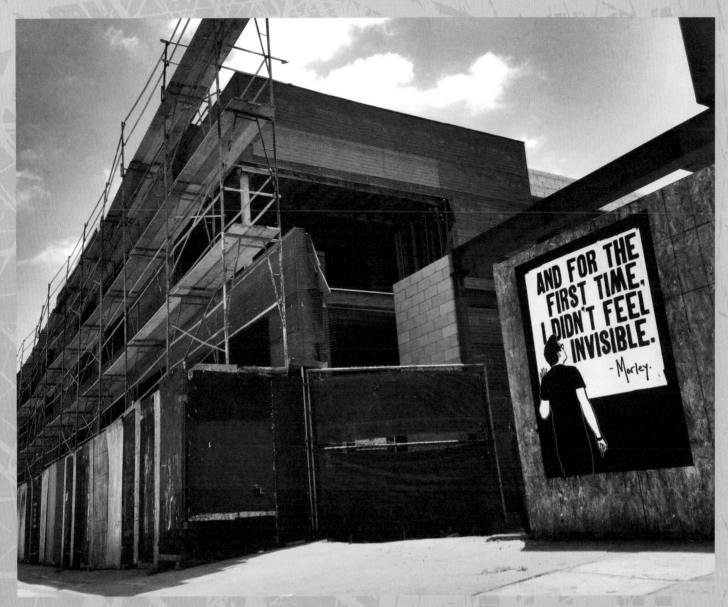

I never quite got used to the sight of this poster for my first solo gallery show (*left*). Probably because I'm so unaccustomed to having permission to install my work from the *inside* of a building. Luckily the title of the gallery seemed to set things straight.

What are the differences between art on the street and art in a gallery? —Isaac Escoto

Just so it's clear, I have nothing against art in a gallery. My stuff has been in a couple galleries, and I've always considered it a privilege. The biggest difference between art in the street and art in a gallery is that in a gallery, the focus is usually on the artist and what he or she has created. People walk around and admire the art and consider if it's something they would want to hang in their homes. On the street, the focus shifts to something a little more immediate.

People see the art as something someone wanted to give away, and it affects how they look at it. Hopefully, people will see my posters as public messages but also private ones meant only for them.

It's the difference between being moved by a song a band plays at a concert and one you hear from a busker playing in the stairwell of a subway station.

ONE LAST THING . . .

At this point, I assume you've made up your mind about me and what I do. Perhaps you find it a positive contribution. Or perhaps you think I'm a "self-important hipster asshole." It wouldn't be the first time I've had that phrase thrown at me. Either way, I appreciate that you've read this far. Any self-importance (of the hipster asshole variety or otherwise) was unintentional. It's my hope that at least one of the statements in the previous pages resonated with you and made some small difference in your day. If not, hurry back to the bookstore; you might still be able to exchange this for that one by Snoop Dogg where all the text is printed on rolling paper!

Still reading? I'll take that as a compliment.

So here we are, at the end. A book like this seems to call for some kind of epic closing speech. The kind that cues a sweeping orchestra in your head and ends with three exclamation points as it reminds you to live life to the fullest. The kind that if you said it in front of a big group of people, their response would be shocked silence—before one lone, slow clap would echo from the back of the room. Soon others join in and before you knew it, you were being carried out of the room on people's shoulders. Then a freeze frame and the credits would start, rolling over your frozen expression of triumph. Alas, that kind of expectation is the perfect setup for me botching it by dropping my notecards and reading everything out of order, so I'll just try and sum this up without all the fanfare.

I wish I could say that I had a master plan when I started doing this, but I didn't. It was just something I found gratifying. I had some stuff I needed to say and enough paper and glue to say it. But the trick of it is—I wasn't just talking about myself. I was talking about you. And her. And him. And them. And us. We live in a bitter world, and while adopting an attitude reflecting that may provide a shelter from its cruelty, it won't offer any solace to a broken heart, a limping dream, or a crappy day. It's OK to be angry with the world. It's OK to be pissed off that nothing seems fair or makes sense. I'm not offering the vacant "just stay positive" sentiment we've all come to dismiss. I'm only asking that you not mainline the poison of cynicism. It may numb the pain a little, but before long, you count on it to keep you from doing anything with your life that could make you happy. Pain is normal. It's all part of the whole thing, but I'd rather say that I tried to help someone along in my own way than regurgitate more mean-spirited bile. A poster I put up may not change the world, but if it helps someone summon the strength to face just one more day, maybe that's worth the quart of paint it takes the city to cover it up. I'd like to think so.

Then again, maybe that just sounds self-important. I promise to work on that.

Oh—and don't forget…live life to the fullest!!!

Sincerely,

— Morley.

- Morley.

ACKNOWLEDGMENTS

Layout & photography by Morley.

Additional design by Iain R. Morris

Additional photography by:
Andrew Bowser (*page 12*)
Kate Ryan (*pages 64-66*)
Tim Venable (*page 160*)
Alaric Hammond (*page 162*)
Greg Linton (*page 111*)
David Kalani Larkins (*pages 40, 86, 147, 184, 210, 221*)

SPECIAL THANKS TO:
Everyone at The Outsiders, Matt Ackerson, Shawn Adamski, Jennifer Bell, Steve Beale, Peter Bennett, Allison Binder, Mark Brewer, Ben Broome, Andrew Bowser, Emily Bowser, Jordan Bratman, Josh Bratman, Ryan Burgess, Laura Burton, Adam Campbell, Common Cents, Andrew Cleary, Beatriz Clemente, G. James Daichendt, Sarah Dale, Ramon De Larosa, Sean Dennis, Geoffrey Dicker, John Wellington Ellis, Ron English, Brody Engelhard, Lars Fassinger, Jess Feavel, Nathan Firer, Sarah Fountain, Ashley Fox, Naama Givoni, GuneMonster, Ben Hagarty, Dan Hagarty, Amber Haley, Alaric Hammond, Maggie Harvey, David Kalani Larkins, Joe Kapp, Armen Karaoghlanian, Stephanie Keller, Moses Keshishian, Gary Kordan, Steve Lazarides, Iskander Lemseffer, Greg Linton, Jordan Lovato, Brian Maillard, Jessica Maillard, Chris Maye, Jayma Mays, Hector Mojica, Doug Morganstern, Chay Morley, Brent Morley, Taylor Morris, Jacqui Munger, Kathleen Nishimoto, Steve Parkin, Dennis Pascual, Pablo Perez, John Petrick, Tom Rice, Linsey Romero, Alicia Ryan, Kristen Ryan, Marie-Terese Ryan, Mary Ryan, Septerhed, Jay Sharples, Brian Snyder, Tomas Staub, Jennifer Leigh Strauss, Annie Steingard, Matt Steingard, Joanna Suhl, Keith Sumner, Victor Teran, Simon Trewin, Tim Venable, Olly Walker, Nadine Wendell-Mojica, Ruby Wendell, and all of the other artists I share the streets with.

www.IAmMorley.com

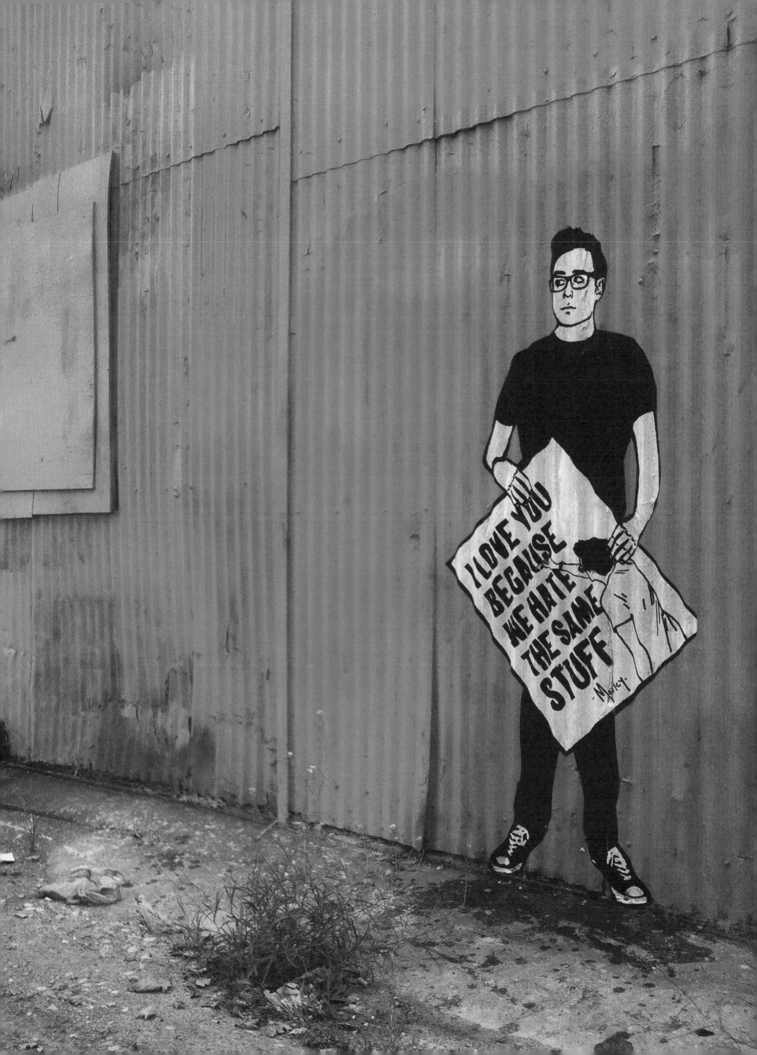

CAMERON + COMPANY

6 Petaluma Blvd. North, Suite B6,
Petaluma, CA 94952

(707) 769-1617
www.cameronbooks.com

CAMERON + COMPANY
Publisher: Chris Gruener
Creative Director: Iain R. Morris
Copyeditor: Michelle Dotter

The publisher would like to thank Morley for the opportunity to
provide another medium for his message; Frank Warren for
his personal and thoughtful foreword; Iain Morris for his expert
design eye; and Michelle Dotter for her keen editorial eye.

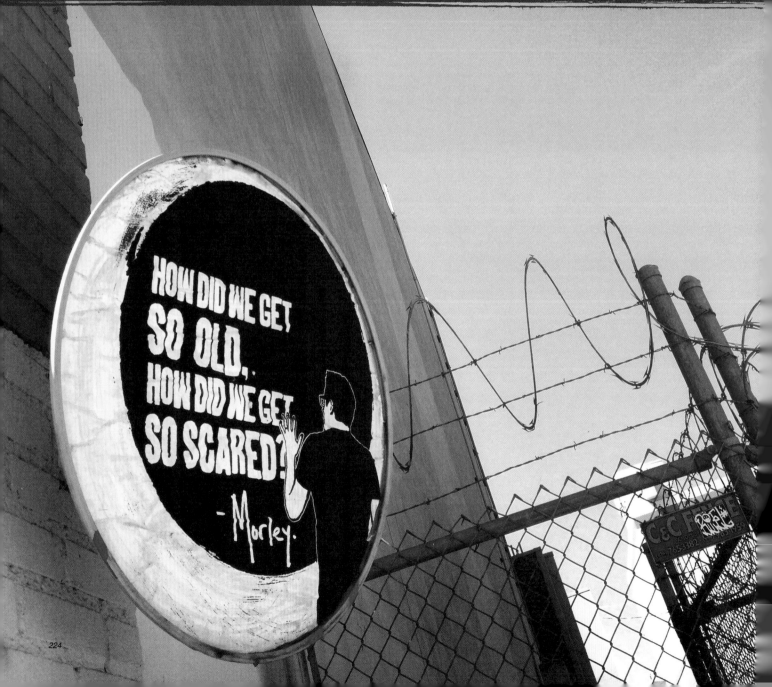